At the Margins of the Renaissance

At the Margins of the Renaissance

LAZARILLO DE TORMES
and the Picaresque Art of Survival

Giancarlo Maiorino

THE PENNSYLVANIA STATE UNIVERSITY PRESS
UNIVERSITY PARK, PENNSYLVANIA

*Publication of this book has been aided by a grant from the Program for Cultural Cooperation
between Spain's Ministry of Culture and United States' Universities.*

Library of Congress Cataloging-in-Publication Data

Maiorino, Giancarlo, 1943–
At the margins of the Renaissance : Lazarillo de Tormes and the picaresque art of
survival / Giancarlo Maiorino.
p. cm. — (Penn State studies in Romance literatures)
Includes bibliographical references and index.
ISBN 0-271-02279-5 (cloth : alk. paper)
1. Lazarillo de Tormes. 2. Spain—Social conditions—To 1800. 3. Picaresque
literature, Spanish—History and criticism. 4. Survival in literature. 5. Poverty
in literature. 6. Literature and society—Spain. I. Title. II. Series.

PQ6409 .M35 2003
863'.3—dc21 2002153403

For

Benito Brancaforte,

teacher and mentor,
homebound to the culture of our Mediterranean Renaissance

CONTENTS

ACKNOWLEDGMENTS

THIS PROJECT HAS its immediate roots in the Spanish lifestyle of southern Italy, where, for better or worse, dispossessed *scugnizzi* still body forth picaresque palimpsests amid the resilient culture of *spagnolismo*.

I am grateful to Ann Doyle-Anderson, Edward Friedman, Howard Mancing, and Benito Brancaforte for reading different versions of my manuscript. Nicholas Spadaccini was the first to spur me to publish on the picaresque.

As always, Grace Farrell has been my most critical reader.

A shorter version of Chapter 5 has been published in my *The Picaresque: Tradition and Displacement* (Minneapolis: University of Minnesota Press, 1996).

For plates and permissions, I acknowledge Art Resource.

In the case of the anonymous author of the picaresque novel, references are to *Lazarillo de Tormes,* edited by Francisco Rico (Madrid: Cátedra, 1989), with page number indicated in the text. For the English translation, I refer to *Two Picaresque Novels,* translated by Michael Alpert (New York: Penguin, 1986), with page numbers indicated in the text. The Alpert translation also contains Francisco de Quevedo's *The Swindler.* For the Spanish edition of *El Buscón* I have used the text edited by Carlos Vaíllo, with text by F. Lázaro Carreter (Barcelona: Bruguera, 1983). For *Guzmán de Alfarache,* I refer to the edition by Francisco Rico (Barcelona: Planeta, 1983) and to the English translation by James Mabbe, *The Rogue or the Life of Guzmán de Alfarache,* vols. 1–4 (London: Knopf, 1924). Although dated, this is the only translation available. Where necessary, corrections have been made, but the antiquated spelling has not been modernized.

ILLUSTRATIONS

IN THE BELLY OF INDIGENCE

1 · Econopoetics and the Great Chain of Handouts

The novel . . . is part of the discursive totality of a given epoch, occupying a place
opposite its ideologically authoritative core. Its conception is itself a story about an
escape from authority, which is often its subplot.
—*Roberto González Echevarría*

I

This study centers on econopoetics, a term that considers how socioeconomic factors are central to the poetics of literary works. Although they may appear to be unrelated, *mimesis* and *oikonomia* bear on the legitimacy no less than on the marketability of art. From food and gifts to onomastics and fashion, parallels between economic and literary modes of production turn mimesis into "econo-mimesis," which brings to the fore those precapitalist aspects of the Renaissance that spurred exchanges between economic signs and noneconomic signifiers.

Much has been written about the art and literature of the culture of affluence, which, from Florence to Amsterdam, upheld standards of academic excellence as well as material wealth. This study claims that not enough has been written about the much broader culture of Renaissance poverty. Although indigence was widespread everywhere, only in sixteenth-century Spain did low-life art and literature give voice to impoverished noblemen and roguish youths—known as *pícaros*—who stood at the margins of the grand narrative of the imperial Golden Age. The discourses of poverty were social, religious, and economic. They encompassed, to quote Anne J. Cruz's recent study (1999, xi–xiii), reformist treatises, state documents, and ecclesiastical writings. "From Lazarillo de Tormes, who arrives in Toledo when the Poor Laws are enforced, to Estebanillo Gonzáles, whose hunger compels him to join the Hapsburg armies, the *pícaros* contend daily with both social disenfranchisement and physical deprivation."

Mateo Alemán, Francisco de Quevedo, Ribera, Murillo, and Velázquez brought to the fore folks who begged at street corners, worked for low wages, and starved in destitute hamlets. Literary texts made room for the best and the worst, but not for the average or mediocre. History teaches us that destitution has always shaped the

lifestyle of what we now call "popular culture." Orations on human dignity and praises of folly aside, no one wrote about the dispossessed existence of common folks until the novelist gave them a voice. Appropriately, Michel de Certeau (1988, v) dedicated his critical study of everyday life "to the ordinary man," who is "a common hero, an ubiquitous character, walking in countless thousands on the street." Because it downsizes "great men" theories of history, I extend his emphasis to narratives that brought a new set of images to novelistic texts.

Metaphorically speaking, Florentine anatomies of plenitude yielded to the physiology of survival in Toledo and Seville, where artists and writers took up the task of representing people who were never "reborn" to the better life of material comfort. Thus I focus on the prototype of the art of survival, the autobiographical and yet anonymous *La vida de Lazarillo de Tormes y de sus fortunas y adversidades* (written in 1530–34 and published in 1554).[1] This text stands out as the first modern European novel, appearing almost two centuries before the genre became a commonplace production of the English middle class. *Lazarillo de Tormes* is also the earliest narrative about the low culture of a vagrant who became a protagonist in the emergent genre of the picaresque, which grew out of a culture of utter indigence on the arid plains of Castile.[2]

In post-Renaissance landscapes, picaresque descriptions of poor people, empty spaces, and absent objects—furniture, tools, food, clothes—often traded the necessary for the wishful; even mimesis was starved to death. Miguel de Unamuno (1976, 25) reminds us that "The land which fed Don Quixote is a poor land, so swept and lashed by the downpours of centuries that its granite entrails have cropped out at the surface." The accomplishments of capitalism and the industrial revolution notwithstanding, poverty remains a central feature of most societies, so much so that the picaresque has cast its long shadow over the twentieth century and beyond. At the beginning of the third millennium, the rise of global capitalism leaves no doubt that it still is with us.

Lazarillo de Tormes is about a destitute youth. Very much like the *pícaro* of folklore, he embodies the lifelong toil of an outsider who rarely transcends his impoverished circumstances.[3] Lázaro, the protagonist, leaves his native hometown of Tejares after his father is arrested and sent to prison for stealing wheat. Antona Pérez, the boy's mother, is left

without an income and decides to move to the academic city of Salamanca. Her hope is to mix "with respectable people"—*"arrimarse a los buenos"*—on the assumption that people who own goods are good; her standard of goodness is economic, not moral.

Things do not work out; good people are not good enough to Antona. Finally she gives her son away to a blind beggar whose brutal ways introduce the boy to the art of survival. "I won't make you a rich man," says the blind man, "but I can show you how to make a living." Once he outsmarts his master, Lázaro moves to commercial Toledo, where he tests will and wits, first in the service of a stingy priest and then with a dispossessed *escudero* who introduces him to such values as honor, pride, and social status. Having served a mundane friar *(fraile de la Merced)* and a seller of false indulgences *(buldero)*, Lázaro is hired by another priest *(capellán)* who gives him the job of water carrier. Finally he becomes town crier *(pregonero)* and marries the mistress of the local arch-priest, a woman who turns out to be the source of much of Lázaro's "good luck":

> *Y, así, me casé con ella, y hasta agora no estoy arrepentido, porque, allende de ser buena hija y diligente servicial, tengo en mi señor acipreste todo favor y ayuda. Y siempre en el año le da, en veces, al pie de una carga de trigo; por las Pascuas, su carne; y cuando el par de los bodigos, las calzas viejas que deja. E hízonos alquilar una casilla par de la suya.* (131–32)

> We got married and I've never been sorry because, besides her being a good and attentive girl, the priest is always very kind to me. Every year I get a whole load of corn; I get my meat at Christmas and Easter and now and again a couple of votive loaves or a pair of old stock-ings. He arranged to rent a house next to his. (78)

Job and marriage are intertwined, and Lázaro accepts the assets and lia-bilities of a "profit-sharing agreement" that makes cuckoldry profitable.

After years of modest prosperity, a high ecclesiastical authority, iden-tified as Vuestra Merced, levels a vague indictment *(caso)* against Lázaro, presumably having something to do with his unusual marital arrange-ment. Lázaro answers the charge by writing his life story, producing in the process the first extant picaresque novel. His defense, in short, is that individual responsibility cannot be assigned without also acknowledging the collective guilt of society. He narrates his social ascent as the

inevitable by-product of an economic system in which a parasitic aristocracy exploits workers by using its hereditary privileges and the religious institutions of Christendom to its advantage.[4] It would be unjust to indict a lowly town crier, Lázaro argues, without indicting the culture in which he was allowed first to starve and then to prosper.

As it deals with a blind man's boy who becomes the town crier, the story is one of unrelenting toil and modest achievement within a population that has turned expediency into a way of life.[5] The protagonist's journey begins in Salamanca, the city of learning, and ends in Toledo, the city of business.[6] The picaresque narrative thus depicts the common migration from the peripheral countryside to the commercial hub of society, where an enterprising "new Christian" bourgeoisie began to erode the power and privilege of the landed aristocracy.[7] It was in the city that resourceful outcasts stood a chance to build a better future for themselves.

Street smarts were needed to survive in neighborhoods where economic improvements were modest and education was a luxury that few could afford. At the periphery of *accademie, studioli,* and patrician palaces, the picaresque art of survival represented a popular kind of humanism, which Boccaccio introduced in the opening words of his Decameron: *"Umana cosa è"*—"It is human." Here *umano* meant humane at the ground floor of existence, not humanist in the academic enclaves of learned scholarship. In this world of the streets, we roam with Andreuccio through the Malpertugio neighborhood in Naples (Decameron II, 5), witness Celestina pointing out familiar whorehouses, and wander by the *escudero*'s ghostly lodgings in a Toledan district crowded with weavers and prostitutes. This is the world of Cervantes's Seville, the criminal underworld of Rinconete and Cortadillo.[8] Against all odds, Lázaro masters the art of survival and goes on to lead a secret life of learning. His mimesis of "life-as-is" yields unhoped-for dividends in the world of literary currency.

Especially in Spain, the literary corollary to the life of the street included *poesía cancioneril, teatro primitivo, refranes glosados, diálogos,* as well as imitations of Fernando de Rojas's *La Celestina,* which gave tragicomic form to the bleak view of human life as mere doing. We thus confront a *literatura desesperanzada* rooted in philosophical pessimism and economic dispossession.[9] In fact, material and artistic modes of production were as intertwined in the pit of economic destitution as they were

in the high culture of mercantile affluence and aristocratic privilege.[10] As Michel Butor (1964, 96) put it, the new genre exposed "the guts, the underside, the margins of society." Because it was known as the fountainhead of the real as well as of the literary picaresque, Toledo represented Spanish society at its cultural "lowest" as well as at its unproductive "worst."

<div align="center">II</div>

In 1492, the Catholic kings discovered the future on a new continent where indigenous people had to pay dearly for the dubious gifts of a new language and religion. Like the great navigators of this era, picaresque writers charted journeys through the vast geography of poverty, giving literary form to the indigent humanity that nobody wanted to discover because everybody knew it. It took a long time to map the outer reaches of the picaresque on the home front, where Lázaro and Guzmán, the most popular of the *pícaros,* made omelettes with eggs as rotten as their corrupt society. In the same year that Christopher Columbus set out to discover new routes to old markets, a whole population of productive non-Christians was forced into exile unless it denied its religious beliefs. Accounts of imperial conquest were popular, but few attempted to justify the materialist enslavement of indigenous Spaniards on Spanish soil. Arab peasants and Jewish craftsmen and merchants who became Christian to avoid persecution were called *conversos,* and it is generally agreed that the nameless narrator of *Lazarillo de Tormes* was one of them. These indigenous people were as radically marginalized as their counterparts in the New World. In *The Unfortunate Traveller* (1594), Thomas Nash wrote of picaresque vagrants who roamed the seedy back alleys of derelict neighborhoods. Their tribulations proved that the longest journeys often take place in the shortest distances.

While the economic base of society was changing throughout Europe, aristocratic privilege rested on nobility of blood, which was anchored at the unproductive center of the Spanish monarchy, where old Spanish Christians enjoyed a kind of twilight splendor. The Holy Roman Empire had vanished, and Charles V's ecumenical mission proved to be a bankrupt myth. At least for a while, the wealth coming from the New World kept dreams of grandeur alive for the ruling class, and voyages of discovery gave way to expeditionary armies whose mis-

sion was to conquer new territories. The upshot was the creation of imperial languages, empires without sunsets, and Christian kingdoms that gave an altogether modern resonance to experiences of, and escapes from, authority.

While they lasted, imperial dreams were built on the exploitation of the working classes and on the ingenuity of bankers and businessmen. While the workers never got to share the wealth they produced, the bankers never gave up on profitable ventures. A mercantile elite as wide as Western Europe and more powerful than states and empires emerged in the down-to-earth republic of money—*republica del danaro*. Its heritage was in Florence and dated back to financial powerhouses such as the Peruzzi, the Bardi, and the Acciaiuoli, whom the historian Giovanni Villani (Cronica xi) called the "pillars of Christendom." Bankers such as the Medici, Welser, Hoechstetter, Lomellini, Centurione, Grimaldi, Spinola, and Ruiz introduced a commercial mindset that challenged the old, aristocratic concept of wealth as rooted in land ownership.

Spain was less receptive to such a development. By the turn of the seventeenth century, Sancho de Moncada recommended that trading companies should be organized according to the Dutch or Italian model. Even the all-powerful Conte de Olivares conceded that Spaniards had better learn to become merchants—this at a time when Jakob Fugger was so powerful that Spain under Charles V became known as the Age of the Fuggers. In spite of precious metals coming from the New World, Spain eventually plunged into an unstoppable decline.

Having visited Spain, the Italian historian Francesco Guicciardini (1971, 32–34) wrote between 1512 and 1513 that Spaniards did not "care to dedicate themselves to commerce—*non si danno alle mercatantie*" because they scorned business activities that were censored by the Church.[11] While most artisans at court were foreigners, people in the countryside "till the land and engage in trade only to satisfy need—*così li artifici loro lavorano quando la necessità li caccia, di poi si riposano che abbino speso il guadagnato.*" Prejudice against commerce and lack of mercantile ingenuity spawned impoverishment. The population toiled in great poverty—*"con una somma strettezza"*—and living conditions were harsh. People "are extremely stingy, and, because they have no commercial skill, they also are prone to stealing." Modern scholars such as Castro and Maravall have made less severe appraisals. According to Bennassar

(1979, 118), "Francesco Guicciardini—who wielded a venomous pen, to be sure—wrote that Castilians although subtle and astute, were not distinguished in the mechanical or liberal arts; all the artisans at the court, if we believe him, were foreigners. He obviously exaggerated when he claimed that Castilians regarded commerce as shameful, for at the time he wrote the merchants of Burgos were looked up to in Flanders. But his claim that the country's poverty sprang not from the quality of its soil but from the dislike of its inhabitants for labor has the support of Spanish witnesses." And Gonzáles de Cellorigo wrote at the time, "the things that most hinders our people from engaging in the legitimate activities so important to the public weal is the great honor and authority enjoyed by those who shun labor."

> When the merchant, lured by the certain profits which the bonds will yield, gives up his business, the artisan his craft, the laborer his field, and the shepherd his flock; when the nobleman sells his lands in order to exchange the amount they are worth for five times that sum in Government bonds, then the real income from their patrimonies will be exhausted, and all the silver will vanish into thin air, at the same time as for his own needs, for those of the lord of the estate, the rentier, the tax-farmer and so many others who have some claim to make on the land. Thus, from the bottom of the scale to the top, one may calculate that the ratio of those who work to those who do nothing is of the order of one to thirty. . . . Wealth has not taken root because it has remained, and still does remain, etherialized in the form of papers, contracts, bonds, letters of exchange and gold or silver coinage, and not in the form of goods able to bear fruit and to attract wealth from abroad by virtue of the wealth within.[12]

Guicciardini spoke in the name of economics, whereas most Castilians spoke in the name of Christian righteousness and imperial pride. The socioeconomic landscape was split along the divide that separated the tradition-based caste from the modern class structure. In a legalistic culture that was vastly parasitic, the values of caste and ghost money were pitted against those of class and material goods. The concept of commercial profit is alien to the caste system, which places ultimate value on social hierarchy. The Spanish social system, writes Anthony Cascardi (1997, 1–3), slowed the pace of cultural change at a time when the emergence of capitalism in the rest of Europe "tended to reorient social

differences along class lines." And Américo Castro (1971, 365–66) asserts that "the caste-determined condition was not a temporary or accidental phase of Spanish life, but an introverted mode of perceiving that one existed that way, as a person of one faith, of one law."

On the mainland, the ostentatious display of wealth was prized over the commercial ingenuity and diligence that characterized the bourgeoisie in other European countries. The arrogance and lack of productivity of the Spanish nobility created negative perceptions abroad that generated what came to be known as the Black Legend. Commenting on the materialist background of the "Age of Discovery," Jules Michelet, the nineteenth-century historian who gave critical currency to the term Renaissance, liked to quote Christopher Columbus, who believed that gold could buy paradise itself. In Spain the "golden century" drew strength from the "cycle of gold" that financed it.[13] Many Spanish soldiers spent most of their lives in Italy and the Low Countries defending the grandeur of the golden century, but they never got to know what was so precious about the age in which they lived.[14] Similar experiences took place on both sides of the Atlantic.[15] In spite of military conquests, the gold and silver coming from the New World quickly lost their luster and raised the rate of inflation, to the financial ruin of many *escuderos* and *hidalgos*. There were times when the king himself could not pay the bills—not that this curtailed the conspicuous consumption of the court and the nobility. Scholars have probed the role that wealth has played in the creation of a "high culture" based on the alliance between business and aristocracy under the blessing of the Church. This powerful elite ignored the mediocre, overlooked the normal, and exaggerated the best.[16] The parasitic nobility was bound to tumble, and tumble it did.

III

Guzmán de Alfarache, at the apex of the picaresque genre, set out to describe

Un hombre perféto, castigado de trabajos y miserias, después de haber bajado a las más ínfima de todas, puesto en galera por curullero della. (467)

A man, perfect in his parts and person, punished with troubles, and afflicted with miseries, and falling afterwards into the basest roguerie. (3, 5)

But the travails of existence dragged him to the Gallies, "where his wings" were clipped. Guzmán had no choice but to trust the "basest roguerie" amid the *trabajos y miserias* of existence, which reduced the perfect man to a poor wretch weighed down by the same *fortunas y adversidades* that Lazarillo had endured. Whereas the Renaissance writers Leon Battista Alberti and Pico della Mirandola glorified human perfection in treatises and orations far removed from life at street level, Mateo Alemán opted for the novel; theory gave way to practice, and grand ideas were abandoned in favor of life as it was lived by the majority:

> *Es el pobre moneda que no corre, conseja de horno, escoria del pueblo, barreduras de la plaza y asno del rico. . . . Nadie le ayuda, todos le impiden; nadie le da, todos le quitan.* (353–54)

> The Poore man is a kinde of money, that is not currant; the subject of every idle Huswives chat; the off-scumme of the people; the dust of the street, first trampled under foot, and then throwne on the dung-hill. In conclusion, the Poore Man is the Rich mans Asse. . . . None helpe him, all hinder him; none give him, all take from him. (2, 128)

Alemán's subject is not man in general, but man as an economic subject: *homo oeconomicus.*

The discourse of money is the discourse of both empowerment and enslavement, which weigh one's social standing on the scales of appreciation and depreciation. In *De subventione pauperorum,* the pious Luis Vives, whose Jewish family had migrated to Bruges, called for a sharing of basic goods in the belief that God had given everything in common to everybody. On more practical grounds, he also recommended that the poor should be registered and interrogated as to why they begged. Linda Martz (1983, 9) tells us that "anyone who claimed infirmity as a cause for begging was to be inspected by a doctor, and anyone who resisted these proceedings was to be put in jail." Fray Domingo de Soto, Fray Juan de Medina, and Miguel Giginta argued that riches carried moral responsibilities, and their writings on the culture of poverty included arguments against the Poor Law (1540), which ruled on the expulsion of the poor from the cities.[17] Poor laws were one more burden on the poor throughout Europe.

Historical and fictional writings by Procopius of Cesarea, St. Basil,

Angelo Beolco, Raimundo Llull, and Giovan Battista Segni have high-lighted the role of hunger in the dynamics of history.[18] Throughout the Renaissance, people starved to death. Pieter Bruegel the Elder painted the *Battle between Carnival and Lent,* and Tommaso Garzoni wrote about "Re di Cuccagna" in *Piazza Universale,* in the knowledge that poverty, not prosperity, was the rule of life. Luigi Pulci and François Rabelais linked food to outsized figures with outsized appetites. Literary descriptions of the poor concerned themselves with food intake, whether food actually eaten or only conjured up by the imagination. Because food defines humanity in itself as well as in relation to life at large, picaresque diets have been indicators of social status.[19] In fact, the economics of food consumption are an apt, if pitiless, barometer of communal habits. What Italo Calvino has called the dialectic of *sapore* (flavor) and *sapere* (knowledge) has been central to a genre as complex and eclectic as the novel.

However bright the veneer of imperial grandeur, more than one-third of the Spanish population was destitute. Mateo Alemán called Seville the *Babilonia de pícaros,* and the new genre alerted readers to the causes of poverty as well as to the exploitive thinking of those who bore some responsibility for it. Even Erasmus (1965, 1:251, 211) wrote, "for living well, it's particularly important that a man accustom himself to being content with little." To Erasmian praise of folly, the picaresque added its own praise of the low-life world of *vida buscona.* Since no rhetorical currency was available for sketching a portrait of the "value-less" as such, the poor were presented as the negative of the socially "valuable." Without calling for open revolt, the picaresque was both parodic and revolutionary in its depiction of strategies of survival that turned humanist education on its head.[20]

By and large, paupers took deprivation as a fact of life, and Peter Dunn (1993, 295) writes that, among picaresque texts, *Lazarillo de Tormes* "makes us stare at" poverty, which the majority of people accepted as the given lot of humankind. In the consumption-oriented economy of Renaissance Spain, the power of labor never gathered enough strength to instigate changes of any consequence for the lower classes. When legitimate employment was not available, people resorted to temporary, if not clandestine, work, which introduced the world of beggars, cutpurses, parasites, and the seedy humanity of *germanía.* In their midst, the culture of the picaresque broke ground and produced

artworks about people who spent most of their lives on the edge between the lawful and the lawless. While Francisco de Quevedo instructed anyone who would "attend to the lesson" of low-life behavior *(género de Picardía),* picaresque and Cervantine characters proclaimed that stealing was "a free trade," and some of them played center stage in the Prologue of Fernando de Rojas's *La Celestina* (1499). For Buscón's father, Clemente Pablos, *"esto de ser ladrón no es arte mecánica sino liberal"* (being a thief isn't just a job, it's a liberal profession) (86).

At issue here are ingrained attitudes toward work itself. Throughout the Middle Ages society was divided between *maiores et potentiores* and *minores et infirmiores.* Physical work and mechanical arts were held in low esteem vis-à-vis intellectual ingenuity and moral strength. The Spanish nobility lived on inherited wealth and enforced socioeconomic discriminations. Thus we can pit the profitable *arte della mercatura* (art of business) and the aristocratic *arte della cortigiania* (art of courtiership) against the *picaresque arte de furtar* (art of stealing), which also produced a mock encomium on the freedom of the beggar's life.[21] The traditional rhetoric of praise was based on exaggeration. Its counterpart, the rhetoric of blame, reversed direction without mitigating its intensity.

In Spain the anticanonical discourse of the picaresque gave voice to criminals, prostitutes, water carriers, town criers, and outsiders at large. Without uprooting either economic privilege or social injustice, the anonymous author of *Lazarillo de Tormes* started a novelistic discourse that pushed the material concerns of the lower classes to the forefront of art. At its most prosaic, the semantics of picaresque "insignificance"[22] described the economic condition of the underprivileged. Ordinary folks survived the rise and fall of empires as well as the waning of the Renaissance exactly because they had mastered the art of survival under the most adverse circumstances.

In his recent study of Cervantes's material world, Carroll Johnson (2000, 16–17) confirms that *labradores* and *villanos* represented 80 percent of the total population. While treatises and dictionaries associated them with "everything gross, malicious, and lowly," Fray Benito Penalosa de Mondragón wrote that such common folks "are the objects of city people's amusement, and they are depicted on the stage in a way that makes them seem even more unfit for society, with their coarse mannerisms exaggerated for the amusement of the audience." More educated readers were perhaps less amused. Then as now, not everyone read pica-

resque texts as comic stories. What is funny to some can be deadly seri-
ous for others; in Lázaro's own words, "one man's meat is another man's
poison—*lo que uno no come, otro se pierde por ello*" (23, 4). Mikhail Bakhtin
(1981, 23) also warns us that laughter itself "means abuse, and abuse
could lead to blows." Likewise, José Antonio Maravall (1990, 156)
agrees that picaresque laughter has worked as an instrument of social dis-
integration. And we know that parody and satire mark the first lines of
attack against the established order. The "abused" may have been slow
to see themselves as such, but when they did, picaresque literature
helped them to become conscious of socioeconomic discrimination in a
new way. Even those in charge of the master narratives must have real-
ized that Lázaro's autobiography was more than a simple "comic" story,
or why else was it placed on the index of forbidden books in 1599?[23]

Lazaro's story exposed and at times discredited the wealthy and pow-
erful at a time when nobody paid much attention to the lives of ordinary
people. Picaresque novels tested "canonical" boundaries by celebrating
the unremembered, their joys, pains, and struggles to survive. Yet the
poor looked at their ordinariness as the negative sign of the humanist
ideal described in Florentine panegyrics or in those chivalric romances
which, to Don Quixote's dismay, were printed by the hundreds in
Barcelona.

Popular culture stood beneath the exclusive center of aristocratic
privilege. But the materialist "flowering" of the Renaissance was rooted
as much in mercantile ingenuity as in profiteering off manual laborers.[24]
George Boas's (1969, 74) reminder is instructive: "The People are not
always the poor, but the poor are usually an important part of the
People. . . . If the People are the plebs or the *vulgus* or the *multitudo*,
they will almost by definition be those men who have no inherited
property, no individual political power or influence, no experience of
the arts or pastimes of the leisure class, and none of the prestige that
comes from wearing the proper clothes." Praises of poverty were at
once inspirational and incongruous. By blending together the discourse
of social privilege with that of religious purity, Petrarch (1991, 3:35)
sounded rather awkward when he put his rhetorical skills at the service
of religious propaganda: "She [poverty] is an ever watchful sentinel
against burglars and pleasures . . . against the shame of greed or extrava-
gance which seldom dwells anywhere else than in the doorways of the
rich." Both the acquisition and the ownership of things encourage theft,

vice, and sin. As long as poverty occupies one's house, Petrarch went on, "there will be no space for pride in it, nor for envy, nor for disastrous losses . . . nor for deceit, indigestion, and the gout, which are permanent guests in the house of the rich." In its alleged deliverance from moral shortcomings, indigence drew on biblical references in which temptation upheld the dualism of survival and steadfastness. Having equated material loss with spiritual gain, these rhetorical strategies were meant to convince the poor that poverty was a blessing after all.

Affluence, conversely, was an institutional attribute of the nobility and, however disguised, of the Church. The clergy preached the rightness and naturalness of social and economic inequality, and promised a heavenly reward for the dispossessed poor. Ordinary people accepted poverty as their reality, and the rich viewed it as a social disease that was to be kept under control; it could be alleviated but not eliminated. And, of course, charity was the approved means of dealing with poverty, which conveniently kept the poor poor and created a cheap labor force.[25] At the same time, the institutionalized practice of begging was a reminder that one could fall into destitution. In Spain and elsewhere, workers and artisans were seen as crowds to be flattered or to be threatened—but always to be taken advantage of. As a source of cheap manpower, the poor were crucial to everyone else's prosperity. Charity was the flip side of exploitation; the hand that gave a little had taken a lot to begin with. Compassionate reformers such as Luis Vives, Juan de Medina, Miguel Giginta, and Cristóbal Pérez de Herrera favored employment over charity, which would have the benefit of curing idleness. But theirs were the proverbial voices in the wilderness. By and large, the poor accepted that life without physical and cultural hunger was beyond their reach.

IV

As the sixteenth century unfolded, the materialist heterogeneity of life-as-is made time biological and space phenomenal. Once artists and writers responded to the demands of existence, picaresque humanity began to operate in "chronotopic" conditions, a term that highlights the diversity no less than the dynamics of life in the making. Michael Holquist defines the Bakhtinian chronotope as "literally 'time-space.' A unit of analysis for studying texts according to the ratio and nature of the tem-

poral and spatial categories represented. The distinctiveness of this concept as opposed to most other uses of time and space in literary analysis lies in the fact that neither category is privileged; they are utterly interdependent. The chronotope is an optic for reading texts as x-rays of the forces at work in the culture system from which they spring."[26] To put it in Bakhtinian terms (1981, 388, 84), "the testing" of Lazaro's survival as well as his pursuit of a place in society set off "the most fundamental organizing idea in the novel." And "testing" occurs in spatio-temporal conditions in which "time, as it were, thickens, takes on flesh, becomes artistically visible; likewise, space becomes charged and responsive to the movements of time, plot and history."[27] Textuality thus responds to the external pressures of laughter, parody, the plurality of high and low genres, the diversity of languages, and, last but not least, the never-ending contest between canonization and heteroglossia.[28] The dynamics of chronotopic interactions guide my approach to *Lazarillo de Tormes,* which, published in the mid-sixteenth century, bridged the gap between a waning humanism and an emergent baroque. The humanist treatise and the system of linear perspective gave way to picaresque and quixotic novels, illusionistic perspectives, and the phenomenal spaces of Caravaggio and Velázquez.

Keeping in mind the novelistic lessons of nineteenth-century Realism and Naturalism, we must view the emergence of the novel with an awareness of its socioeconomic complexity. If we read Dickens or Zola without paying attention to econopoetics, we will miss much—perhaps too much. The traditional tendency to exclude economic factors from works of art mystifies their very nature, and few would deny that the concept of value is contingent upon one's material milieu.[29]

After Werner Sombart singled out luxury as one of the engines of capitalism, Richard Goldthwaite (1987) found in conspicuous consumption an opening into processes of cultural change.[30] I focus on the opposite; it is conspicuous destitution that makes Lázaro de Tormes dream of becoming a consumer amid laborers who toil at the periphery of affluence.[31] Since I question the privileges that "high culture" enjoyed at the exclusion of "popular culture," my aim is to call attention to those layers of society that fall outside the bounds of humanist learning and aristocratic elitism. Thus I intend to explore how a network of material practices called on human ingenuity to cope with indigence. My econopoetics weaves together literary narrativity with the politics of

narrativity, and the picaresque offers historical evidence for probing into the nomenclature of poverty.

Since it would be difficult to deny that "official" history has represented the past in a way that flatters and celebrates the attitude of the dominant class, the texts that have come down to us are those that reinforce establishment ideologies. The sheer fact that the poor have been "established" as much and as long as the rich gives priority to the issue of dominance over that of longevity. By drawing on treatises on mercantile affluence that financed the humanist best, as well as from the novelistic indigence of the Darwinian fittest, econopoetics takes a step toward a more comprehensive assessment of the Renaissance.

Because it was so self-righteous, humanist elitism raises fundamental questions: Was the literature that outlined "ideal types" truly representative of society at large? How inspiring could such hypothetical figures be for the population at street corners? Successful merchants, scholars, and courtiers aside, what did humanist literature say about ordinary people? Above all, how much of culture, and how many people, did humanist texts exclude? We must keep these issues in mind before we raise questions about the "other" Renaissance of picaresque indigence. When the voices of "low" culture are silenced, we must probe the range and depth of their silence. And economic concerns can effectively test the scope of their absence.

STARVED TO DEATH

2 · The Mousetrap

THE PRICE OF STAYING ALIVE

Fear and only fear made Sancho see—makes the rest of us simple mortals
see—windmills where impudent giants stand. . . . Those mills milled bread,
and of that bread men confirmed in blindness ate.
—*Miguel de Unamuno*

I

In the neighborhoods of Toledo, famished clerics and starved rogues
never relented in their pursuit of food. Its conspicuous absence was
pervasive, and those who owned the goods devised entrapments to
thwart any challenge to their possessions.[1] It is thus not surprising that
picaresque literature would highlight the image of the mousetrap,
which, having made its appearance in the second *tratado*, hovers over
Lázaro's misfortunes from beginning to end. By combining the concepts
of hunger, parasitism, cunning, theft, punishment, and inequality, the
mousetrap stands out as a central metaphor for the economics, no less
than for the ethics, of society at large.

Traps work on the principle of deception, and they affect Lázaro's
growth as soon as the blind beggar begins to play tricks that leave an
impression on the *mozo*'s psyche and skin. When Lazarillo first steals
wine by putting a rye straw into the mouth of a wine jug, the *ciego*
becomes suspicious and keeps a more vigilant watch. Lázaro, in turn,
devises a new strategy and makes

> una fuentecilla y agujero sotil, y delicadamente, con una muy delgada tortilla
> de cera, taparlo. (31)

a little hole in the base of the jug which let out a thin jet of wine. I
filled the hole very delicately with a wax plug. (30)

Deceit works, but only for a while.

> Sintió el desesperado ciego que agora tenía tiempo de tomar de mí venganza,
> y con toda su fuerza, alzando con dos manos aquel dulce y amargo jarro, le
> dejó caer sobre mi boca, ayudándose, como digo, con todo su poder. (32)

The pitiless old man saw that he had the chance to take his revenge
and with all his strength he lifted the jug, which had been the source

of pleasure and was now to be the instrument of pain, and from high over his head he let it fall straight on my mouth, helped with all the strength he could muster. (30)

This painful method of education marks other episodes of the *tratado*, until the *mozo* outsmarts the *ciego*, once grapes and sausages yield to coins.

Whenever alms are given in exchange for prayers, the boy executes an "unfair trade" that takes advantage of the old man's blindness by switching half *blancas* for whole ones:

> *Mas con todo su saber y aviso, le contaminaba de tal suerte, que siempre, o las más veces, me cabía lo más y mejor.* (27)

For all his experience and craftiness, I caught him out so often that I always, or nearly always, got the most and best of what was going. (9)

The old beggar fails to understand that, however unwillingly, he is teaching Lázaro skills that can be turned against him. At the beginning of the *tratado*, the *ciego* leads the boy to put his ear against a stone bull, only to smash Lázaro's head against it. Roles are reversed at the end of the chapter, when Lázaro rushes his blind master into a stone post. The fox has been outfoxed. The youth has nearly completed his education in the basics of survival. "Outsmarting" stands out as a picaresque counterpart to the humanist topos of "outdoing."[2]

While the individual was godlike for Pico della Mirandola and Luis Vives, life taught that most people never got a chance to shape reality into an ideal "likeness." Humanist similes pointed toward divinity, whereas antihumanist analogies presented animal images that favored elementary forms of survival. Vives himself examined the discomfort that "a single flea" can cause the "human giant," who should learn to "interrupt his dreams of conquest."[3] In fifteenth-century humanist treatises on the family and the arts, Leon Battista Alberti made of the spider a symbol of human mastery over the environment *(I libri della famiglia)*. Like the spider, which weaves webs of geometric order, the mercantile family leader *(padre di famiglia)* imposes a code of behavior on his household as well as on the management of his business.

Homologies between the animal kingdom and human society have been part and parcel of Western literature since antiquity, and Lázaro so describes his master:

En su oficio era un águila. Ciento y tantas oraciones sabía de coro. Un tono bajo, reposado y muy sonable, que hacía resonar la iglesia donde rezaba. (25–26)

He was as sharp as a needle [an eagle] at his trade; he knew hundreds of prayers by heart and he said them in a low, relaxed and sonorous voice which made the church vibrate. (28)

Since the eagle's sight is exceptionally sharp, the aviary analogue is deceptive. By stretching truth beyond plausibility, the boy "praises" blindness through a hyperbole that betrays his childish naïveté. At first, Lázaro succumbs to the *ciego*'s "sharpness"; in the end, the young *mozo* prevails. But Lázaro will learn the hard way that society will set ever more elusive traps on his path out of indigence.

Symbolic entrapments can be traced back to Fernando de Rojas, who addressed man's despicable deeds in the Prologue of *La Celestina*. In the conclusion, Pleberio describes life as a trap, a kind of bait we take without realizing that we have swallowed the hook.[4] Animal similes are rhetorical traps that describe a society in which growth imitates the slow pace of change typical of natural species.[5] The slow pace of zoomorphic evolution thus stands as a counterweight to the quicker dynamics of human values. On balance, Lázaro learns to cope with more snakes than he suspected. A kind of self-effacing mimesis reverses the "higher" and the "better" into the "lower" and the "worse."[6]

II

Especially in the second *tratado,* the narrative focuses on the pit of the stomach, where instinct starves ideas and spurs efforts to gather food. In the materialist discourse of affluence and indigence, the acquisition of food weighs on matters of artistic representation.[7] Hoping for a better future after he leaves his first master, Lázaro is hired by the *clérigo de Maqueda,* a stingy priest who makes survival even more painful.

In his hunger Lázaro steals a key to the chest where the priest keeps the bread:

Lo más que yo pude hacer fue dar en ellos mil besos, y, lo más delicado que yo pude, del partido partí un poco al pelo que él estaba, y con aquél pasé aquel día. (58–59)

The most I could do to the bread was to kiss it over and over again and, gently as I could, to scrape off a few crumbs from the loaf which had already been started on. I spent the day on that. (42)

The *clérigo* suspects that mice or snakes are responsible for the theft and sets up a *ratonera*.

Luego buscó prestada una ratonera, y, con cortezas de queso que a los vecinos pedía, contino el gato estaba armado dentro del arca. Lo cual era para mí singular auxilio, porque, puesto caso que yo no había menester muchas salsas para comer, todavía me holgaba con las cortezas del queso que de la ratonera sacaba, y, sin esto, no perdonaba el ratonar del bodigo. (65)

Got a mousetrap, borrowed, of course, and begged the neighbours for pieces of cheese-rind, and kept a trap baited all the time inside the chest. This was very helpful to me. Although I did not need anything to make the bread go down easier I still enjoyed the cheese-rind that I got out of the trap and apart from this the "mice" still ate the bread. (45)

The priest persists in his search; Lázaro continues to try and outwit him.

Ibase a mis pajas y trastornábalas, y a mí con ellas, pensando que se iba para mí y se envolvía en mis pajas o en mi sayo; porque le decían que de noche acaescía a estos animales, buscando calor, irse a las cunas donde están criaturas y aun mordellas y hacerles peligrar. (66)

He came up to my pile of straw or in my coat, because he'd been told that those reptiles were cold at night and looked for warm places and often went into babies' cots and sometimes bit them and nearly killed them. (46)

Lázaro stores the key in his mouth and falls asleep, but his breathing causes the key to make a whistling sound that arouses the suspicion of the priest.

Pues, ansí como digo, metía cada noche la llave en la boca y dormía sin recelo que el brujo de mi amo cayese con ella; mas cuando la desdicha ha de venir, por demás es diligencia. Quisieron mis hados, o, por mejor decir, mis pecados, que, una noche que estaba durmiendo, la llave se me puso en la boca, que abierta debía tener, de tal manera y postura, que el aire y resoplo que yo durmiendo echaba salía por lo hueco de la llave, que de cañuto era, y silbaba,

según mi disastre quiso, muy recio, de tal manera que el sobresaltado de mi amo lo oyó y creyó sin duda ser el silbo de la culebra, y cierto lo debía parescer. (67–68)

My bad luck, or rather my sins, arranged that one night while I was asleep, my mouth fell open and the key worked itself into such a position that my breath passed over the hollow part of the key, which was like a small tube. I began to whistle very loudly, and of course my master, who was a bundle of nerves by now, heard me and was quite convinced that it was the snake hissing. It must have sounded very like it. (46–47)

The clergyman thus uncovers the culprit that has been stealing his bread. The boy is betrayed by his own animal-like behavior, proving that role-playing can be a liability whenever people try to imitate beasts.[8]

However effective, the trap is not meant to exterminate the rat race but to limit losses by keeping rodents away from grain bins. The inference is that traps are set for people who, because they toil in enclaves where production is insignificant, have no choice but to test them. Ironically, people who have enough to eat are not interested in changing the unequal distributions of goods, which is bound to spawn parasitic forms of survival such as begging and thieving.[9]

Mice run to mousetraps out of hunger; their search is humankind's own. Yet, whereas mice do not know that traps are traps, people usually do; and they test their wits because starvation leaves them no choice. From a mouse's point of view, wealth consists of a single morsel, and hunger determines the value of life itself. At the lowest level of picaresque existence, scarcity requires mastery of the "minimalist" art of survival, which steers behavior toward "cat-and-mouse" competitions for a few crumbs. In an endemically unproductive society, a gap exists between the demand and supply of basic goods. One may wonder whether the priest's stinginess was innate or acquired. In a world where survival is at stake day in and day out, some set traps, a few avoid them, and many get caught. Traps create the illusion that goods are within reach, so long as one operates with a limited range of sight and smell. But in impoverished conditions, the powers of sight and smell often fail.

Food is so scarce in the priest's house that a string of white onions in the room at the top of the stairs presents at once a heavenly vision and a hellish temptation:

Solamente había una horca de cebollas, y tras la llave, en una cámara en lo alto de la casa. Déstas tenía yo de ración una para cada cuatro días, y cuando le pedía la llave para ir por ella, si alguno estaba presente, echaba mano al falsopecto y con gran continencia la desataba y me la daba, diciendo: "Toma y vuélvela luego y no hagáis sino golosinar." Como si debajo della estuvieran todas las conservas de Valencia, con no haber en la dicha cámara, como dije, maldita la otra cosa que las cebollas colgadas de un clavo. Las cuales él tenía tan bien por cuenta. (48–49)

There was only a string of onions and that was under lock and key in a room at the very top of the house. My ration was one of them every four days. If I asked him for the key to go and get it, and if anyone was present, he used to put his hand into his inside pocket and untie the key very slowly and say as he gave it to me: "Take it and bring it back straight away but don't indulge your greed too much." He said this as if the key could open the storehouse of all the fruit and vegetables in Valencia, although the room I've mentioned had all in it except the onions hanging on a nail, which he kept well-counted. (38–39)

Bread is the primal symbol of the gastronomy of poverty. A few crumbs suffice to feed a vision of things that are substantial only by standards of utter privation. Hunger affects the stomach no less than the mind, to the point that Lázaro no longer knows whether he *"veví o, por mejor decir, morí"*—"lived, or rather died" (51, 40). The priest himself, however privileged in comparison with the starving boy, must content himself with the luxury of a sheep's head once a week.

Aquélla le cocía, y comía los ojos y la lengua y el cogote y sesos y la carne que en las quijadas tenía, y dábame todos los huesos roídos. Y dábamelos en el plato, diciendo:—Toma, come, triunfa, que para ti es el mundo. Mejor vida tienes que el Papa. (50)

He boiled it and ate the eyes, the tongue, the neck, the brains and the meat on the jawbones and then gave me all the bones he'd been gnawing on a plate and said: "Take them, eat and be happy. The world's your oyster. You live better than the Pope himself!" (39)

The sequence *toma-come-triunfa* flaunts the cleavage between words and things. Since the scene opens with food for the priest and ends with bones for Lázaro, it enacts a code of ingrained cruelty that magnifies the

priest's abusive conduct. Of course, the cleric represents his stinginess as a sacrificial virtue:

> *Mira, mozo, los sacerdotes han de ser muy templados en su comer y beber, y por esto yo no me desmando como otros.* (52)

> Listen lad, priests have to be very temperate in their eating and drinking habits and so I don't make a pig of myself like others do. (39–40)

While praising his own temperate habits, the priest eats "*como lobo*—like a wolf" at funerals. Death opens the way to heaven for the deceased, but it also allows the *clérigo* and his *mozo* to nourish life on earth. In the natural world, death sustains life, and so it does among the poor.

Yet people do not die often enough to solve the problem of steady nourishment for Lázaro, who averages a full meal every three weeks. The intervals are painful:

> *Que si el día que enterrábamos yo vivía, los días que no había muerto, por quedar bien vezado de la hartura, tornando a mi cuotidiana hambre, más lo sentía.* (53)

> I suffered even more through having known what it was to have a full belly and having to get back to my daily hunger. (40)

The priest even "prayed to God that each day should kill its man"— "*Deseaba y aun rogaba a Dios que cada día matase el suyo*" (40, 53). His pastoral role is turned on its head. Instead of a shepherd who provides for his flock, the clergyman is made into a predator. When secular needs are at stake in an unproductive society, where one's gain is another's loss, even prayers will focus on materialist concerns. In sixteenth-century Toledo, *mozos* and *escuderos* dreamed of meat that only higher prelates could afford. Most families ate fresh meat no more than a dozen times a year.[10] The staple diet of the time was farinaceous—wheat, rye, barley, oats, millet—and bread floating in vegetable soup was a typical meal.

Lack of food and other necessities dominates the picaresque narrative, which sustains itself through wishful descriptions of a well-appointed home. The discourse of poverty unfolds as a parodic counterpart to that of affluence:

> *Y en toda la casa no había ninguna cosa de comer, como suele estar en otras algún tocino colgado al humero, algun queso puesto en alguna tabla o, en el armario, algún canastillo con algunos pedazos de pan que de la mesa sobran;*

que me paresce a mí que, aunque dello no me aprovechara, con la vista dello me consolara. (48)

There wasn't a thing to eat anywhere in the house. After all there's usually something: a piece of bacon hanging up in the smoking room, a piece of cheese on a shelf in the pantry, or a basket with a few bits of bread left over from a meal. I felt that, even if I couldn't eat it, at least the sight of it would make me feel a bit happier. (38)

In such a ghastly place traps work because scarcity makes the bait desirable. And any bait qualifies in the priest's wretchedly inadequate larder. Against all odds, picaresque landscapes bring out the dismemberment of things. Readers face mimesis by subtraction, and consciousness itself survives on words whenever lack of nourishment makes Lázaro's body lethargic and existence doubtful. But words can turn the poorest everyday behavior into a crowning achievement; language can thrive in spite of physical demise.

The priest's neighbors help him catch a rodent. By the end of the last *tratado,* the town crier has become both predator and prey; and neighbors remind him that he has been trapped in a shameful arrangement. The image of the *ratonera* thus bears on the structure and meaning of the whole novel. The priest catches Lázaro, but how many other *pícaros* escape the trap only to starve again the next day?

Hunger also led Guzmán de Alfarache to illustrate his roguish philosophy with animal metaphors:

Todos vivimos en asechanza los unos de los otros, como el gato para el ratón o la araña para la culebra. (325)

We all live in ambush, lying in wait one for another, as the Cat, for the Mouse, or the Spider for the Fly. (2, 19)

Animal life is based on need, strife, and hierarchy, which remain constant because mere survival is the goal. Among humans as among animals, survival cannot be taken for granted, and picaresque narratives make it clear that those in power have institutionalized a system of traps meant to keep the have-nots forever indigent.

The underprivileged have always seen the parallel between themselves and the mice who get caught in traps. To illustrate the extreme hardship that starving people must endure, Quevedo (151) presents in *El*

Buscón an impoverished nobleman who compares himself and his kind to "mice in eating-houses."

> *Otro decía que a mi padre le habían llevado a su casa para que la limpiase de ratones, por llamarle gato. Unos me decían "zape," cuando pasaba, y otros "miz." (15)*

> Another called my father a cat-thief and said his family had employed him to kill mice. Others called "puss, puss" after me and others hissed. (88)

The recurrent imagery of mice and snakes is loaded with negative connotations. Some of Pablos's cohorts in Madrid fake extravagant eating habits when they gather in their rooms to eat "mutton and poultry bones and fruit peelings. . . . Most of this we scrounge from the city dustbins at night and use it to show off the next day" (151). Predatory deeds secure only disgusting leftovers. We need only add that the analogy between mice and men informed John Steinbeck's classic, which takes its title from the Robert Burns poem:

> The best-laid schemes o' Mice an' Men
> Gang aft a-gley,
> An'lea'e us nought but grief an' pain,
> For promis'd joy!
> (*To a Mouse*)

In the unfolding story of mice and men, the mousetrap remains a matter of concern for rodents of all sorts.[11] Animal similes, therefore, tend to be life-denying.

Because they relate to an allegedly lower species, zoomorphic comparisons point to an existence of inferior quality, and identifications with mice, wolves, and reptiles unmask correspondences that foster abusive conduct and moral depravity. Robert Alter (1964, 9) alerts readers of the picaresque to look for "the flash of the fang in every smile and the tightening of the prehensile paw in every handshake." In the Renaissance tradition of theriophily (which Montaigne and La Fontaine cherished), analogies between animal instinct and human parasitism heighten what students of nineteenth-century realism have called the fear of desire.[12] The "human beast" metaphor had a long lineage before Honoré de Balzac grounded his representation of French society on the comparison

between humanity and the animal world—*"comparaison entre l'Humanité et l'Animalité" (Avant-Propos* to *La Comedie Humaine).*[13] The lesson we can draw is that, once the "signaling" system of zoosemiotics crosses paths with the picaresque,[14] zoomorphism can be as troubling as anthropomorphism.

<div style="text-align:center">III</div>

The second *tratado* spells out the voiceless language of the parasite. He is a silent type who does not live alone, because it is vital for him to have a host. The word comes from the Greek *parasitos,* a compound of *para,* beside, and *sitos,* grain. The parasite stands beside the grain, beside a source of sustenance. This typology well fits the personalities of Tomé, the thief, and Lázaro, the town crier. Both literally and metaphorically, their hosts own the grain. We can agree with J. Hillis Miller (1979, 20) that the social organization of "a curious system of thought" is implicit in the word parasite, at least insofar as it points to an enclave where both change and expansion are nonexistent.

From beginning to end the narrative shows how bait takes on different guises and disguises. Since he is determined to hide a scandalous relationship, the archpriest uses the job of town crier *(pregonero)* to trap Lázaro in the final *tratado:*

> *En este tiempo, viendo mi habilidad y buen vivir, teniendo noticia de mi persona el señor arcipreste de Sant Salvador, mi señor, y servidor y amigo de Vuestra Merced, porque le pregonaba sus vinos, procuró casarme con una criada suya. Y visto por mí que de tal persona no podía venir sino bien a favor, acordé de lo hacer.* (130–31)

> Soon after I got the job, the Archpriest of St. Salvador's heard about me and saw how sharp and ready-witted I was, because I used to announce that his wines were for sale. So he arranged a marriage for me with a maid of his. I saw that only advantages and good could come from being associated with the reverend gentleman, my lord, and Your Honour's servant and friend, so I decided to marry the girl. (78)

Lázaro bit into the bait knowing full well that he would survive. In a milieu in which prelates wielded both spiritual and economic power, what "better" future could await human beings who had become what

Américo Castro (1967, 121) calls *"hijos de la nada social"*—"children of social dispossession"? As husband of the archpriest's mistress, the *pregonero* becomes a cuckold, which makes his submissiveness mandatory. Yet when people try to tell him the truth, Lázaro pretends to uphold his wife's unstained honor by threatening to kill anybody who contradicts him:

> *Que yo juraré sobre la hostia consagrada que es tan buena mujer como vive dentro de las puertas de Toledo. Quien otra cosa me dijere, yo me mataré con él.* (134–35)

> I swear on the Sacred Host itself that she is as good a woman as any in Toledo. If anyone says the opposite I'll kill him. (79)

Need and subordination uphold a counterfeit view of human values, and the narrative feeds on "verbal gestures" that mimic the "activist" rhetoric of pride. The fact is that Lázaro is incapable of direct physical violence. By his own admission, he should bite the blind man's nose off, but the most he can do is "lead" him to crash against a stone post. The parasite saps but does not combat whomever, and whatever, serves as his host.[15] In other words, a rebellious parasite is no parasite at all.

Having played the role of mouse while neighbors identified him as a snake, Lázaro has learned hard lessons, and he is ready to adapt his ambitious goals to the milieu in which he operates. The result is neither revolution nor reform, but the preservation of the status quo. In the early *tratados,* blind men and priests test Lázaro's physical resilience. Toward the end, economic threats, moral blackmail, and psychological abuse strangle protagonist and plot. In a culture in which lack of opportunity makes the future wretchedly predictable, Lázaro gets to sell wine and to wear the horns of the cuckold who has traded pride for profit. Lázaro knows that he can "make" himself into a better individual only by trading animalism for humanism, *feritas* for *humanitas.*[16] To make his case, the narrator thus probes the "reasons" that nurture parasitism.

The parasite reacts only when survival is at stake. Vuestra Merced baits the *pregonero* on legal grounds, whereas the *caso* makes a threat more lethal than any previous bait. But Lázaro handles it by coming up with a masterly countermeasure that nobody could have predicted. The symbolism of the mousetrap is synecdochic of social mores that eventually victimize masters and servants alike. The prologue makes it clear that

even the archpriest can be trapped, and picaresque narratives support the argument that institutional power is inherently repressive. Having established a point of view different from that of the mouse,[17] Lázaro uses learning to trap his superiors. The inner and the outer man are not the same, nor are the facts of the *caso* and the language of the novel.

In literary terms, the parasite has become a revolutionary, and he upholds the ascendancy of literature to nonliterary cases. By exploiting the rhetoric of blame, the novel emerges as an investment at once ideological and utilitarian. Lázaro, Guzmán de Alfarache, and Ginés de Pasamonte took up writing either as a literary project, a legal brief, a rebellious task, or all three together. Much low-life literature was written in jail, and it is revealing that the prototypical novel begins with the criminal activities of Lázaro's father, who steals grain at the mill. Later, in the fifth *tratado,* the narrative reports the underhanded deeds of a *buldero* who sells false indulgences. Constables are stoned in the streets at the beginning of the seventh *tratado.* Like the indictment, the trap stands out as a "mechanism of control" that forces the anonymous narrator to bring a revolutionary defense document to the light of day.

It would seem that both the lawful and the lawless are central to the realistic narrative of the picaresque. In the Aristotelian sense, rhetoric was born on juridical grounds, and its purpose was to "veil" or "unveil" the truth according to one's best interest. Lázaro takes advantage of rhetoric by making the presentational re-presentational through a narrative strategy that makes everyone vulnerable. His reply to Vuestra Merced's request is a legal deposition that shows "a real life enmeshed in the society of the times." In fact, Roberto Gonzáles Echevarría (1993, 55, 57) has traced picaresque originality to its roots in law. By borrowing from the forensic *carta-relacíon,* the anonymous author of *Lazarillo de Tormes* began a novelistic discourse on the dualism of material gain and spiritual loss, a dualism that also lies at the heart of Spanish experiences with *engaño* and *desengaño.*

Such a complex background outlines a social landscape that did not hide the less attractive aspects of heritage and education.[18] While merchants went about the business of capital investment,[19] *pícaros* defended the business of human resilience.[20] Whenever Lázaro settles into a somewhat better condition of life, the presence of beggars and vagrants continues to warn him about the precariousness of his own *buena fortuna.*[21] One of the *pregonero*'s duties is to escort criminals to prison and beggars out of town:

*Y es que tengo cargo de . . . acompañar los que padecen persecuciones por jus-
ticia y declarar a voces sus delictos: pregonero, hablando en buen romance.*
(129)

I also accompany criminals being punished for their misdeeds and
shout out their crimes. In other words, or in simple English, I'm a
town-crier. (77)

Rather than being led, like his father, the best Lázaro can do is to walk
the wretches of society to their fate. There is always something to
remind him of the poor enclave from which he came. The *pícaro* is
trapped by a kind of hereditary determinism that shapes his "good luck."
At the periphery of a culture where the aristocratic *cristiano viejo* values
lineage, nobility, honor, and *limpieza de sangre* above all else, picaresque
destitution begins by the river Tormes and comes to rest in Toledo,
where Lázaro proudly displays the worn-out accouterments of his social
climb. At the border between begging and earning, Lázaro remains a
"half outsider." At every stage of his painful journey out of poverty, the
ambitious *pícaro* learns that outsiderism is typical of low-born people and
is central to a genre crowded with folks caught up in survival.[22] Since it
stands between center and periphery, outsiderism can be set on a par
with literary marginality.[23] Both concepts focus on reciprocity, which
the picaresque enacts through binary oppositions: rich/poor, extrane-
ous/integrated, country/city, rank/money, master/servant, and
prince/pauper.[24] This kind of dualism adds to the parodic makeup of an
emergent genre that thrives on the interplay between autobiographical
textuality and socioeconomic subtextuality.[25]

At the turn of the seventeenth century, *Guzmán de Alfarache* was pop-
ularly known by the shortened title *El Pícaro*. Lodged as it was amid
treatises, orations, and romances about mercantile ingenuity and aristo-
cratic prosperity,[26] the novel played a disruptive role embedded in the
hardships of the "rest" of society. Because the picaresque stands outside
as well as beneath more affluent social layers, one can infer that margin-
ality is as much a matter of depth as of latitude. Ordinary people of lim-
ited economic means struggled in the hovels of the city's underside, in
the world of *la mala vida* in its several variations: *picaresca, rufianesca, ger-
manesca,* and *celestinesca.* Since the beginning of time, poverty and crim-
inality have fed on each other, and the Renaissance was no exception.
Under such conditions, parasitism found a more "activist" counterpart

in delinquency.[27] To curb it, prisons and watchtowers became common features of the picaresque.[28]

Mateo Alemán introduces the watchtower in the very title of *La vida de Guzmán de Alfarache, atalaya de la vida humana (The Life of Guzmán de Alfarache, Watchtower of Human Life).*[29] As the picaresque novel unfolds,[30] the author's own point of view becomes that of the *atalaya.*[31] Guzmán stands watch over human morality, for his role is to *"descubrir—como atalaya—toda suerte de vicios y hacer atriaca de venenos varios"* (467)—"serve as a sentinell to discover all sorts of Vices, and to draw treacle out of divers poysons" (3, 5). If the *pícaro* was a half-outsider, there were people who, like slaves and *conversos,*[32] had been marginalized altogether.[33] In spite of such odds, the picaresque took steps, if small ones, toward the future. By the time Quevedo wrote about "Don Pablos," the genre had become exhausted and stylized. Yet the picaresque mode of representation endured well beyond the Renaissance, becoming an important heritage of what we now call popular culture.

<div align="center">IV</div>

To a mouse, cheese is cheese, and that is the reason why mousetraps work.[34] Michel Serres (1982, 165) believes that "preying and hunting need more energy and finesse than sponging. Thus the latter is more probable." In Toledo sponging describes forms of exploitation that spawn derivative aspects of prosperity. The advantages that Lázaro gains in the last *tratado* are forms of bait. "Gifts" from the archpriest and "favors" from so-called friends set up a network of obligations that steer parasitism toward the center of society, where Lázaro profits from convenient, though less than honorable, opportunities. In Seville and elsewhere a *deposito de fianza* was required for the job of *pregonero*. To secure it, Lázaro needed the kind of financial backing that comes with strings attached. The bureaucracy itself was a trap that fed and punished people from top to bottom. Viceroyalties allowed aristocratic families fallen on hard times to refurbish their wealth by taking advantage of the gold and silver that came from America. Theirs was a parasitic wealth based on colonial exploitation. By 1600 Gonzáles de Cellorigo noted that gold and silver had created a false sense of wealth. Real wealth, by contrast, was grounded in industry, trade, and agriculture. By the time Philip II ascended to the throne, the grand narrative of imperial history was quickly becoming a Quixotic mirage.

Insofar as the narration of Lázaro's everyday travails is concerned, the exchange of things is underhanded rather than evenhanded, and its price tag is silence as a way of muting moral concerns:

Desta manera no me dicen nada, y yo tengo paz en mi casa. (135)

As a result, nobody says anything and there is peace at home. (79)

Talk means self-deception, and so the active language of social exchange is traded for a voiceless peace of mind. The *pregonero* writes to defend his *buena fortuna,* and his goal is to denounce, but not destroy, the fountainhead of his income. He sponges all over Toledo until the *caso* forces him to sharpen his talents. To make ends meet at the margins of society, "sponging" and "begging" take precedence over more dignified alternatives.

Consumption always trumps productivity in picaresque narratives, and parasitism is one of the most effective strategies of survival. Having developed acquisitive—if not productive—skills, Lázaro proves that threats alone can force parasites to be assertive. Because the archpriest is the source of his livelihood, the anonymous author cannot be overtly confrontational toward him. For the parasite will not bite the hand that feeds him,[35] and his whole struggle is aimed at remaining "attached" to his source of sustenance. From economics to government, the parasite cannot exist without a host, and he readily trades words for things.[36] Some believe that this unequal exchange is the source of most evils in society. It certainly was so in Toledo, where Lázaro crossed paths with an *escudero* who had never experienced, whether by choice or by accident, the world of mercantile exchange.

3 · Inconspicuous Consumption

OF TOOTHPICKS AND LEFTOVERS

> They say, and in this I hold my tongue, that such, Sancho, my friend,
> was the error into which your country fell: refusing to understand that
> honor lasts as long as a full purse.
> —*Miguel de Unamuno*

I

Evil has always had a way of crossing boundaries in order to keep everybody within its reach, and the third *tratado* draws into the picaresque a dispossessed *escudero* who can no longer meet the demands of his aristocratic heritage. Perhaps he is a member of that *caballeria villana*, or low-ranking nobility, whose possessions often do not exceed a horse and armor.[1] He upholds memories of a better world but survives in the pit of poverty, where a rift exists between what he pretends to be and what his material circumstances force him to do.

Once Lázaro asks him to share his meal, the *escudero* so inflates the gastronomical value of cow's feet that they become *"el mejor bocado del mundo"* (90)—"the tastiest thing I know" (57). Hyperbole transforms the cheapest bite of food into a delicacy. The traditional rhetoric of praise is retained, but its object has been turned upside down. Aristocratic and picaresque "codes" coexist only by exposing their shortcomings. The signifier, whether food, clothes, or real estate, is under attack, and it often seems to have lost track of its signified. Among the poor, only crumbs of food and shreds of things have been left around for the taking. The world above starvation thrives on the semiotic lexicon of fragments, leftovers, and handouts. In a way, the picaresque begins where value and function have undergone irreversible *adversidades*. Even literary resources strive to cope with minimal conditions of representation. Yet *mozo* and *escudero* resist hunger without giving up on life. They choose to endure, and they do it without blaming others or becoming criminals. Their choice contributes to a lifestyle that has value, at least insofar as it has rejected a heritage of delinquency, abandonment, and, perhaps, prostitution (a recurrent feature of picaresque narratives).

Having left family and fortune in Valladolid, the *escudero* ends up in a

poor neighborhood of Toledo, where he lies in order to secure lodging where he cannot pay the rent because he has no inheritance and cannot hold a job. As empty as his stomach, the *escudero*'s purse contains neither a copper coin "nor any trace of one having been there for a very long time"—"*ni señal que la hubiese tenido mucho tiempo*" (89, 59). Through this nameless nobleman whose wallet is always empty, the text mocks the topos of the inexhaustible purse of plenty, which would otherwise create rank and sustain authority. Unlike Midas or the medieval Fortunatus, the *escudero* embodies the *"hombre español como tipo del homo inoeconomicus,"* and his role-playing is only a series of inconsequential postures.[2] In the words of the latter-day *pícaro* Estebanillo Gonzáles, the very identity of low-level noblemen implied permanent poverty and persistent hunger—"*pobreza eterna*" and "*hambre perdurable.*" It was socially unbearable "to have to play a role in the world when one is poor!"[3]

The third *tratado* of *Lazarillo de Tormes* explores the theatrics of false pretenses.[4] The narrative tells us that the *escudero* chose to leave old Castile because a higher-ranking nobleman never deemed it appropriate to tip his hat when they met in the street. Whether verbal or physical, the rhetoric of ostentation was but one aspect of an inflexible code of conduct based on social hierarchies. Both conspicuous consumption and conspicuous munificence reinforced cultural superiority. In Spanish-ruled southern Italy, this conduct was called "Hispanism"—*spagnolismo*.

Embodying the lowest rank of the old feudal aristocracy, the *escudero* roams around Toledo as if waiting to spend the deficient balance of his miserable life. Ironically, religious texts about indigence only validated literary fictions. In 1545 Domingo de Soto wrote in his *Deliberación en la causa de los pobres* (chapter 8): "There are some of good stock who are poor, either because they lost their property or because they are squires; they did not learn a trade, nor do they have skills for making a living; therefore, they are forced to accept lowly jobs, and struggle to support themselves, to the point that they can rightfully ask for alms."[5] This passage describes some of the steps that led many a nobleman to his demise. The *escudero*'s ideological assets are out of currency in the world of literal deeds. He has been disinherited by the caste to which he belonged and cannot find a place among working people.

Yet the *escudero* plays a crucial role in the narrative because he introduces Lázaro to a set of ideological values that will spur ambitious plans.

Insofar as survival is concerned, the relationship between master and servant is quickly reversed, and the narrative tests the boy's sympathy for his poor wretch of a master. Heritage is burdensome for both; but while Lázaro shakes it off, the *escudero* lets it become his undoing. The narrative thus pits the ameliorative plans of the adolescent *mozo* against his master's shameful demise. If the *pícaro* stands at the periphery of the class system, the *escudero* embodies estrangement from an aristocratic system that is steadily weakening on both economic and cultural grounds. José Antonio Maravall (1990, 124–28, 63) locates the shift from feudal to precapitalist society in types such as the *pícaro* and the *criado,* a fallen nobleman who stands on the lowest rung of the social hierarchy.

However poor, the *escudero* cannot bring himself to work. He enters the picaresque narrative when he no longer can afford to be what he once was. He can neither uphold nor ignore the standards of a military class that took pride in the *Reconquista* on the home front and in the conquest of the New World overseas. In his case, the discourse of poverty sets picaresque parody next to the bankrupt currency of the nobility itself.[6] In his encounter with Lázaro, parasitic exploitation becomes a method of survival that is temporary for the servant but terminal for the would-be master. Having taught Lázaro to discriminate between things and ideas, the *escudero* has no choice but to walk away from life itself; he can afford neither things nor ideas. In the Bakhtinian discourse of polyphonic voices, he speaks the obsolete language of chivalry. Like Don Quixote, he has no future.

<div align="center">II</div>

Having met his new master in the morning, the boy is hopeful about lunch.

> *A buen paso tendido comenzamos a ir por una calle abajo. Yo iba el más alegre del mundo en ver que no nos habíamos ocupado en buscar de comer. Bien consideré que debía ser hombre mi nuevo amo que se proveía en junto, y que ya la comida estaría a punto.* (73)

> We began to walk down a street very slowly. I was as happy as could be when I saw that we hadn't bothered to buy anything to eat. I reckoned that this new master of mine probably bought his provisions in bulk and that dinner would be ready cooked. (50)

Hours pass with no mention of lunch. The *escudero* prays in church, the only place where material need takes a back seat to spiritual nourishment; he certainly needs heavenly support to curb his craving for a meal. Once the service is over, the *escudero* falls back on deceits meant to "cover up" his inability to provide food for himself and his *mozo*. At least for a while, the boy tries to believe that his new master does not purchase goods at the market because rich people buy them in bulk and store them at home. By inference, home is a horn of plenty where meals can be enjoyed in a leisurely way.

For the first time, discourse pits what Lázaro sees against what he would like to see. Ignoring the wisdom of the *ciego,* who has taught him painful lessons about appearance and reality, Lázaro puts his faith in the *escudero*. He is too young and inexperienced to appreciate the old Cervantine proverb: "A man's pretty unlucky if he hasn't broken his fast by two in the afternoon" (*Don Quixote* II, 33). Hunger drives the *escudero*'s existence, which pits bodily needs against the socioeconomics of dispossession. The rest of the *tratado* educates the boy in matters of economic counterfeiting and the unreliability of appearances.

Lázaro understands that the *escudero* is an impoverished nobleman who feeds on memories of things lost, which force him to endure indigence beyond what the stomach can tolerate.

> *Es regla ya entre ellos usada y guardada. Aunque no haya cornado de trueco, ha de andar el birrete en su lugar. El Señor lo remedie, que ya con este mal han de morir.* (92)

> This sort of people have an old and well-kept rule. They may not have a penny in their pocket but they've got to keep up appearances. There's nothing anybody can do about it. They're like that until they die. (58)

Appearance alone sustains the poor chap, who lingers too long out of his cultural station. The text gives us the final act of a life that demeans higher standards of living by trying to fake them under the guise of *antihonor, nobleza al revés,* and *hidalguía negativa.*[7] Martin Green (1979, 24) tells us that a caste society that remains alien to profit as a means of social mobility is bound to be "overtly moral in its evaluations, but only covertly economic." The *escudero* embodies a parodic "travesty" of bankrupt economics, and the text draws him into an enclave where he

stands at odds with the reality of things. Among weavers and prostitutes, his behavior discredits his rhetoric. By living off his *mozo*'s alms, the *escudero* makes a parody of marginality itself, and the narrative plays up the exponential parasitism of one who is poorer than the poor.[8] When nobility makes its appearance in the world of the picaresque, it does so in the picaresque's own terms; indigence brings together the penniless upstart and the disinherited aristocrat. For all practical purposes, nobility is derelict in the underprivileged world of popular culture, to which the *escudero* belongs only by unfortunate circumstance. It is only under conditions of total poverty that the nobleman and the pauper meet, break bread together, and befriend each other before parting ways.

As provider of his master's meals and guardian of his secrets, Lázaro grows to a point where he can patronize him.

Con todo, le quería bien, con ver que no tenía ni podía más. (91)

Even so, I was quite fond of him because I saw he owned nothing and couldn't do anything more. (58)

Lázaro's discretion in treating the *escudero* as if he were a nobleman seems to echo a social practice of the time. To alleviate their humiliation, aristocrats who had fallen on hard times were respectfully called *envergonzantes,* the shamefaced poor. In this context, Linda Martz (1983, 175) mentions Doña Escolestia de Montesonos, who lived on alms in the house of a man who had once been apprentice to her husband. The *escudero* is bankrupt in every sense, but he tries to hide his condition behind a screen of noble words.[9] In his case, pride functions as an anesthetic.

Since men of honor neither beg nor steal, the *escudero*'s worthless nobility cannot save him from starvation. Unable to embrace the picaresque life, he is an example of poverty's consequences for the "unpoor." Wealth belongs to a lost world that the *escudero* has survived, if only for a while. He can confront reality only as what "might have been"; like a ghost, he speaks in the long lost mode of remembrance. Ghosts appear but do not stay; their presence is fleeting as well as doubtful. And so is everything about the *escudero,* who cannot speak in the indicative mode of certainty; instead, a wishful grammar of "ifs" and "might have beens" sets the nostalgia for wealth against the experience of loss.

The *escudero*'s estimates of the value of his real estate back in Valladolid make the memory of former wealth all the more painful.[10]

> *No soy tan pobre que no tengo en mi tierra un solar de casas que, a estar ellas en pie y bien labradas, dieciséis leguas de donde nací, en aquella Costanilla de Valladolid, valdrían más de docientas veces mil maravedís, según se podrían hacer grandes y buenas. Y tengo un palomar que, a no estar derribado como está, daría cada año más de docientos palominos.* (102–3)

> I'm not so poor that I haven't got a few houses at home. They're fallen down and are in a terrible state, but if they weren't they'd be worth more than two hundred thousand *maravedis*. They're twenty leagues away from where I was born, in the Main Street of Valladolid. They could be built up again and made to look absolutely magnificent. I've also got a dovecot which would give me more than two hundred pigeons every year if it weren't in ruins. (62)

Distinctions between *tierra* and *casas* stem from roots at once economic and epistemological, while descriptions of would-be dwellings begin with lands—*solar de casas*—on which houses can be built. As "houses-buildings," the plural noun *casas* describes ubiquitous shelter. Only monetarily can they be worth *docientos mil maravedis,* just as the squire's *palomar* might yield *docientos palominos.* Actually, *solar* refers to the grounds of a homeland on which people are likely to locate origins and relationships. However virtual, the value of *tierra* exceeds that of *casas* insofar as the singular "home-homeland" describes a person's nation, which poverty has taken away from the *escudero*. The ruin of his buildings raises issues of income and depreciation. There is no doubt that he refers to houses as "given" assets of a land-based estate, but their decayed condition exposes his bankrupt status. If he is ghostlike, so is his real estate.

Because it creates something out of nothing, money-as-language constitutes the *escudero*'s only asset. But it is "ghost money" based on defunct ownership. Language at once sustains and betrays the illusion of affluence, as if an excess of words could offset loss of property.[11] In pre-capitalist societies, visible things are trusted more than invisible money.[12] By providing monetary equivalents for his real estate, the *escudero* shows familiarity with the numerical details of a financial counterlanguage that cheapens his "noble" status. When property in land is demeaned by

monetary estimates, noble origins are likewise degraded. Because he no longer owns a building, the *escudero* seeks "invisibility" by moving to a neighborhood of Toledo that is unfamiliar to "better" equals.

From the wishful real estate in Valladolid to the rented dwelling in Toledo, the *escudero* lives in a place where bare walls convey emptiness and bespeak the demise of habitability itself. Lázaro's initial impression is validated.

> *Todo lo que yo había visto eran paredes, sin ver en ella silleta, ni tajo, ni banco, ni mesa, ni aun tal arcaz como el de marras. Finalmente, ella parescía casa encantada.* (75)

> I hadn't seen anything but walls, not a chocolate grinder or a block for chopping meat or a bench or a table; not even a chest like the one the priest had. In fact the house seemed to me like a ghost's hideout. (50)

The absence of pots and pans warrants the belief that ghostlike people do not eat, nor do they assume that houses stand for family and community.[13] The narrative bears witness to the experience of dehumanization:[14]

> *A los menos en casa, bien los estuvimos sin comer; no sé yo cómo o dónde andaba y qué comía.* (94)

> At least, I can assure you we didn't have anything to eat at home. I haven't the slightest idea what he did, where he went or what he ate, if anything. (59)

Lázaro's lament amounts to a eulogy for a world of things either lost or impossible to attain. He approaches cooking equipment and other goods with the same set of preconceived ideas he has applied to their would-be owner. In the absolute absence of culinary activity, thought feeds on itself by producing a narrative that continues even when mimesis has nothing to offer. Literary expression sustains itself on words alone. The rhetoric of indigence is twofold inasmuch as it is based on absence and longing rather than presence and attainment. The picaresque text at once denies and confirms the theory that no semantic field can claim more euphoric vocabularies than those of food and sex.[15] Although food and sex are important to the novel, they are utterly deficient when measured by elitist standards of plenitude.

Should we agree with Louis Marin (1986, 116) that "along with language, the art of cooking defines humanity in its appropriation of itself and the world," we can say that the *escudero* utters the discourse of people plagued by unsatisfied needs. After a reading not of Rabelais or Perrault but of picaresque texts, the "food for thought" topos can alert us to the verbal quality of much food intake. The *escudero* feeds Lázaro nothing but words. Later on, in Segovia, Pablos moves amid people who gladly "breakfast" on the nominative by "swallowing the words" (*El Buscón*, 95, 97). At once explanatory and illusory, language unravels a narrative even though nothing "happens." Below the remembrance of things lost, the belly churns words as the only activity that can somehow measure human survival. As the symbolic site of existence, the stomach seems to speak in a novelistic lexicon that is meant to secularize reality. In fact, language appears to be the only thing that is as ubiquitous as hunger itself. The art of survival thus foregrounds icons in which the literal and the symbolic—gold and golden—coincide, just like bread and Eucharist on the altar.

When the nonnative poor are escorted out of town because of the meager harvest, Lázaro curtails his begging. Starvation affects both language and food:

Nos acaesció estar dos o tres días sin comer bocado, ni hablaba palabra. (93)

Sometimes we went two or three days without eating a thing or saying a word. (59)

Whenever the stomach is not fed, the narrative lapses into ominous silence. Life goes on, but words are not spoken and things are not used. The biology of existence keeps up a narrative of physiological idleness in a society where the procurement of food exhausts much human potential.[16]

There are days when master and servant have very little to eat and much time to spend staring at each other.[17] When production is nonexistent, consumption has a way of drawing animal-like equations between greyhounds gnawing on bones and the *escudero,* who appeases pride and hunger by praising dietary restraint:

Porque el hartar es de los puercos y el comer regladamente es de los hombres de bien. (77)

Stuffing oneself is natural for pigs but decent people eat with moderation. (32)

While magnifying the symbolism of culinary abundance, the reference to pigs degrades the *escudero*'s persona.[18] If we give any value to the dictum that "man is what he eats,"[19] then the escudero can be seen as a literary parody of the *homo historicus,* who performs heroic deeds without ever bothering with water, food, and other details of existence.[20] One is reminded of Karl Marx's distinction (1973, 92): "Hunger is hunger, but the hunger gratified by cooked meat eaten with a knife and fork is a different hunger from that which bolts down raw meat with the aid of hand, nail, and tooth. Production thus produces not only the object but also the manner of consumption."

Lázaro finds comfort in the memory of food. Abstinence is painful, but he does not despair. For his master, by contrast, the memory of food only increases his pain and alienation, a reminder of his "living death." Only verbal objects fill the *escudero*'s house with what is not there, but might be found nearby. Rhetoric affords provisions of a similar kind in a Segovian dwelling where students conjugate the verb that is most apt to relieve hunger:

> *Cenaron y cenamos todos, y no cenó ninguno.* (27)

> They had supper, we had supper, in fact nobody had supper. (97)

The world of things has vanished, but its lexical index has survived. The house belongs to Dr. Goat—*licenciado Cabra,* who is *"el archipobre y protomiseria"*—"The High Priest of Poverty and Avarice incarnate." By drawing from its own resources, language acts out a mimesis that has no object. Having gone to class more famished than ever, Buscón tells himself:

> *Mandáronme leer el primer nominativo a los otros, y era de manera mi hambre, que me desayune con la mitad de las razones, comiéndomelas.* (28)

> I had to read out the first declension nominatives aloud to others. I breakfasted on half of them, swallowing the words. (97)

When physiological needs cannot be satisfied, the imagination supplies verbal equivalents. One of Pablos's cohorts adds:

> *Somos gente que comemos un puerro, y representamos un capón.* (105)

> We can eat a leek and imagine it's a capon. (151)

The transformation of lesser things into better things leaves no doubt that language plays a compensatory role whenever reality disappoints one's hopes. The organ used for both speech and eating, the mouth calls forth words and food. An old Basque forgot how to eat— *"olvidado ya de cómo y por dónde se comía"* (95) after he stopped talking about it. At the same time, doctors decided that nobody should speak in a loud voice to Don Diego and his servant for nine days, because every word echoed in their hollow stomachs. Above all else, Dr. Goat wanted to deny *"la hambre, pues parecía que tenía por pecado el matarla, y aun el herirla"*— "appetite; he seemed to consider it a sin not only to satisfy it but even to encourage it" (101, 34). Denial of food implies loss of knowledge as well as loss of expressive powers. The rhetoric of negative associations feeds on the mimesis of objects that are either unavailable or inaccessible.

We might ask, should narrativity stop just because no apparent action takes place? Rest, sleep, inanity, laziness, physical exhaustion, and other ways of doing very little or nothing at all are part and parcel of human existence; in fact, they sustain human life. The picaresque thus is lodged in an unselective time-space that is the opposite of the self-congratulatory "staging" of humanist literature.

Incapable of purchasing food, the *escudero* also fails to pay rent for a tomb-like house where cooking never takes place. His socioeconomic displacement is as extreme as his ideological rootedness, and adjustments are impossible because he can neither afford to live as a patrician nor bear to live as a pauper. The *escudero* lives among the poor, but he does not look like one of them. Since he cannot feed his servant, the only thing he can do is try to enchant Lázaro with his make-believe nobility. To be, and especially to remain, the boy's master, he cannot afford to look just as poor. He lacks novelistic flexibility, and his chivalric integrity is obsolete.[21]

According to popular wisdom, the true Castilian serves *"a Dios y a su Rey con el corazón y con las manos*—God and his King with heart and hands" (Albornoz, 1573, 73). While he prays to God, however, the *escudero* has no king to serve. As for his hands, they ought to be used for things aristocratic and spiritual. In the world of survival, however, "animalism" remains a measure of comparison, and Lázaro describes his master in terms that are at once heartfelt and unmerciful:

> Póngole en las uñas la otra . . . royendo cada huesecillo de aquellos mejor que un galgo suyo lo hiciera. (90)

I put the cow's paw into his . . . [he] began to eat as if he meant it, gnawing every little bone like a dog. (57)

Aristocratic concerns with "clean hands" come to the surface.

Yo lleguéme a él y mostréle el pan. Tomóme él un pedazo de tres que eran, el mejor y más grande. Y díjome:

Por mi vida, que paresce éste buen pan.

¿Y cómo, agora—dije yo—, señor, es bueno?

Sí, a fe—dijo él—¿Adónde lo hubiste? ¿Si es amasado de manos limpias? (77)

I walked up to him and showed him the bread. He took a piece of it from my hands. Actually it was the best and the biggest of the three I had.

"I say," he said. "This bread looks pretty good."

"I'll say it is. So you think it's good, do you?"

"Yes, very good. Where did you get it from? D'you think it's been kneaded by someone with clean hands?" (51)

"Clean hands," a recurrent theme, mean hands unsoiled by manual labor. While touching on the privileges of the idle aristocracy, the *escudero*'s detachment from physical activity suggests a detachment from existence itself. His idle hands have lost touch with both the use and the exchange value of things. Like everything else about him, his clean hands are ghostlike, for they point to a body that has relinquished the manual function of either doing or taking things. He no longer enjoys property or possession. By contrast, Lázaro's hands are always busy. In the heart of Toledo, everything passes through his hands— *"pasan por mi mano,"* which enforces the exchange value of things in the last *tratado.* Only by dealing with him can people hope to make profitable deals— *"hacen cuenta de no sacar provecho"* (130). His statement points to work, income, and security. One man's shame can be another man's pride.

For the *escudero,* life in Toledo is a preparation for death, and he so phrases his moribund hierarchy of values:

Que más vale pedillo por Dios que no hurtallo. Y ansí El me ayude como ello me paresce bien, y solamente te encomiendo no sepan que vives comigo, por lo que toca a mi honra. Aunque bien creo que será secreto, según lo poco que en este pueblo soy conoscido. (88)

It's better to beg than to steal. I only hope God will help me through you as he sees fit. But there is one thing I want you to remember: nobody must know that you're living with me, it's a question of honour you see. Mind you, I don't think anybody will find out as I'm hardly known in this town. (56)

Material indigence is commensurate with spiritual poverty; their clash is bound to be tragic, and he knows it. For aristocrats whose pride is rooted in ownership, rent payments entail the devaluation of personality. There is no doubt that *que el no vivir de rentas, no es trato de nobles*—he who does not live on rents is not a nobleman. Even less noble is fraud, by means of which he tries to uphold what neither rank nor income can afford. Once he is asked for two months of unpaid rent, all his cleverness boils down to one last trick:

Y él les dio muy buena respuesta: que saldría a la plaza a trocar una pieza de a dos y que a la tarde volviesen. (106)

He said he'd just walk down to the market to change a doubloon and would they mind coming back in the evening? (64)

Throughout the Renaissance, poverty was equated with life without "style." More than that, it was life without any awareness that style could be attained by those who had not been born with the means to afford it. At least for a short while, circumstances forced the *escudero* to somehow show off honor in the midst of coarseness. As long as it was not tested, his demeanor was impressive; but the moments of "proof" turned out to be heartbreaking, whether they involved *mozos,* landlords, or prostitutes by the river.

El estaba entre ellas, hecho un Macías, diciéndoles más dulzuras que Ovidio escribió. Pero como sintieron dél que estaba bien enternecido, no se les hizo de vergüenza pedirle de almorzar, con el acostumbrado pago. él sintiéndose tan frío de bolsa cuanto estaba caliente del estómago, tomóle tal calofrío, que le robó la color del gesto, y comenzó a turbarse en la plática y a poner excusas no validas. (85–86)

He was acting as a real lover-boy, chatting them up better than Ovid. When they saw he was a soft touch they were brazen enough to ask him for the price of lunch on the usual terms. As his purse was as empty as his desires were full, he started to go hot and cold and went as white as a sheet. He began to stammer and make all sorts of excuses. (55)

His future is his past, and both are doomed. Fashioning, therefore, does not exceed a futile display of cloak and sword, that is to say, the vestiges of long-lost nobility.[22] Even the Latin language ties honor to clothes that assign their wearers a place in the community. Luis Vives (1968, 91) asks: "What else is clothing but the trappings of pride? . . . Necessity first invented the useful garment; luxury, the precious one; vanity, the elegant one." Having turned such an inquiry into a lifestyle, the *escudero* cannot but parody the culture of *hidalguía*. Although it is well tempered and it cuts through wool, his sword is the honorable sign of a signifier that has lost its intended usage.

Either fortune or inheritance secured the *escudero*'s privileges until misfortune took them away:

> *Después que en esta casa entré, nunca bien me ha ido. Debe ser de mal suelo, que hay casas desdichadas y de mal pie.* (89)

> Nothing's gone well for me ever since I came to live in this place. It must be cursed; there are unlucky houses, you know. (56)

Intangible circumstances outrank material causes. In his mind, neither history nor economics adheres to principles of cause-and-effect linearity. Since the *escudero* cannot cope with the demands of everyday life, the *real* he finally gets hold of comes to him *"no sé por cuál dicha o ventura"*— "by some fantastic piece of luck" (95, 59). No one knows how he one day got his small piece of money. Did he beg or steal? Are his lengthy thoughts about employment based on experience, or mere speculation? Only as a wishful gesture does he raise the possibility of working for a minor nobleman—*señor de título*. But he would never see fit to be compensated in the form of *"un sudado jubón o raída capa o sayo"*—"a sweaty doublet or a worn-out jacket or cloak" (104, 63), the kind of clothes that start Lázaro's own ascent toward the rank of *hombre de bien!*

Narration in the third *tratado* enacts a parody of the "good counselor" topos. Castiglione's courtier puts his best talents at the service of his

prince, whereas the *escudero* is ready to lie, flatter, and spy for prospective employers. The goal is to please at any cost, for it is assumed that employers neither know nor deserve better. Whenever basic needs lie in the balance, virtue is shortchanged, and clever men—*los astutos*—get the best of titled aristocrats who remain unwilling to master the *arte de negocios.*

Half a century later, Francisco de Quevedo (1932, 433) wrote a memorable sonnet in which the sword became the central metaphor of his own physical decay:

> I saw my weakened staff, curved like my spine,
> Stricken, like me, by unrelenting change.
> Finally I saw my sword—it too was aged
> And like myself looked forward to its death.

A symbiotic bond ties the poet to the things he owns. Steeped in picaresque materialism, the protagonist of *El Buscón,* Pablos, learns more practical lessons, and has no doubts that

Sin pan y carne no se sustenta buena sangre. (173)

There's no such thing as blue blood, and you can't be somebody if you haven't got anything. (149)

A cheat at heart, Pablos fakes nobility once he calls himself Don Ramiro de Guzmán. To root his pretense on the more solid ground of toponomastics, he adds "Squire of Valcerrado" and "Vellorete" to his name.

III

To frame the *escudero*'s anachronistic pride, one might refer to the Florentine humanist Leon Battista Alberti, who wrote in his treatise on family management, "We shall ever give ground to honor. It will stand to us like a public accountant, just, practical, and prudent in measuring, weighing, considering, evaluating, and assessing everything we do, achieve, think, and desire. With the help of our honor we shall grow if not wealthy in goods at least abundantly rich in fame, in public esteem, grace, favor, and repute. All these things are to be preferred over any degree of wealth."[23] The businessman makes a statement of faith in economic success and civic pride, which is at once personal, professional, and cultural. Because it is subordinated to honor, wealth is personified

by a just, prudent, and practical accountant. In its Florentine guise, honor is commercial, and it demands that successful merchants be stirred by a kind of philanthropic activism. Because their honor was out of currency, old landowners could not halt a process of economic decadence that dated back to what has been called the "economics of Romance."[24] Medieval culture in postmedieval Spain was not yet obsolete, though its power structure was weakening. Loss of rank, however, did not entail the possibility of change in a society that was still dominated by the caste system. To shift toward the more productive but less honorable class system was unthinkable for a nobleman, who would see social mobility as a sign of social disintegration.

By mixing among strangers in Toledo, the *escudero* walked a path familiar to downtrodden knights throughout Europe. Even Erasmus (1965, 1:429, 431) recommended exile in his discussion of faked nobility: "When you're simply head over heels in debt, find an excuse to move on to some other town, and then another, and so on. . . . In large and crowded cities there's more freedom." As always, urban living offers the refuge of anonymity from the shame of public disgrace. In the city clothes and gestures create a "front" that historical anthropologists have found typical of the picaresque.[25] By the turn of the seventeenth century, sumptuary laws forbade workers and artisans from wearing silk fabrics. Fashion made sociocultural distinctions tangible, and the old stockings that Lázaro wears in Toledo flaunt dependence much as they reassure the *pregonero* that he enjoys the protection of the archpriest.

By contrast, the Knight of the Sorrowful Countenance is crushed when he realizes that "two dozen stitches" in one of his stockings have burst. Picaresque pride turns into aristocratic shame once Don Quixote is forced to wear sewn-up pieces of clothing.[26] And the shame intensifies when he has to use a thread of another color to repair his clothes. This is as overt a sign of poverty as a gentleman can exhibit. Just as the *escudero* "lowers" himself into accepting food from his *mozo,* so does Don Quixote resolve to wear "a pair of traveling boots" that Sancho Panza leaves behind (*Don Quixote* II, 44). To borrow from Unamuno's commentary on the master text (1976, 228): "The most terrible enemy of heroism is the shame of appearing poor. Don Quixote was poor, and when he beheld the stitches in his stockings undone, he was afflicted." For the *escudero* as for the *hidalgo,* role-playing is paramount in shaping one's identity. The gap between spiritual wealth and sartorial destitution

makes the knight self-conscious. But questions are not asked as to why the poor are poor or whether the rich have played any "role" in keeping them poor.

To paraphrase historical anthropologists, the Mediterranean world is one in which life is paraded in public with a passion.[27] When poverty is all one can display, simulation becomes crucial to acting out social pretenses on the world's stage.[28] Cervantes's discourse on poverty addresses the indignities that poverty forces on the well-educated individual. How wretched is he who makes "A hypocrite of his toothpick by going out into the street with it, though he has eaten nothing which obliges him to clean his teeth!" (*Don Quixote,* II, 44). Half a century earlier, the *escudero* used his own toothpick as a theatrical prop:

> *Y por lo que toca a su negra que dicen honra, tomaba una paja, de las que aun asaz no había en casa, y salía a la puerta escarbando los que nada entre sí tenían.* (94)

> And to satisfy that ridiculous honour of his he took a straw (there weren't even enough of them in the place) and went and stood in the doorway picking his teeth which had nothing stuck between them. (59)

The *escudero*'s gesture is a sad commentary on the futility of false pretenses. To borrow from George Kubler's reflections on the "shape of time" (1962, 9), the toothpick embodies the "material" culture of physical artifacts, what was called in the early 1960s the "history of things."

When all is said, the *escudero* feeds on memories that are bound to starve him out of existence. Literally and metaphorically, narrativity brings forth a *nonada* inasmuch as his toothpick gives form and function to an act that is utterly insubstantial. At issue here is a code of aristocratic appearances to which the *escudero* has pledged lifelong loyalty against the facts of his existence.[29] Symbolically, it stands out as an ideological fragment that enacts the ritual of a culinary rhetoric emptied of its contents.[30]

The symbolic implies the death of the literal, and the world of things the *escudero* once owned exists at the level of signification, not of function.[31] "Consciousness of origin" spurs him to reenact the ritual of eating when food is just a memory. Remembrance, we all know, is what sustains ghosts. At the margins of remembrance, the toothpick, as the

ghostlike reminder of a life plagued by starvation, would pick at the *escudero* to life's end. Lázaro tests the *escudero*'s verbal and physical languages with caution. Even when his pursuit of a standard of living entails the remembrance of his master's statements about "values," Lázaro never forgets that any act must be, first and foremost, utilitarian. In other words, he would not use a toothpick without first having eaten a meal. To do that, he must find a job.

Lázaro's social ascent is bound to translate valuable concepts into marketplace currencies. For him, pride does not lie in the concept of honor but in the honorable experience of work, an activity that becomes a lifelong project once begging yields to steady employment as a water carrier.

OUT OF LACERIA

4 · The Water Carrier

FROM SUBSISTENCE TO PROSPERITY

The devil of fiction does not need to have all the best stories.
—*Stephen Bann*

I

Increases and depletions of Lázaro's *buena fortuna* are part and parcel of a narrative in which water sustains life and generates income. The young lad gets his first break when a *capellán* gives him the job of water carrier. In fact, much of the narrative is set within reach of water, whether it be a jug or the river Tormes by which Lázaro is born.

> *Mi nacimiento fue dentro del río Tormes, por la cual causa tomé el sobrenombre.* (12)

> I was actually born on the river Tormes and that's why I took that surname. (25)

Having traded amniotic for fluvial waters, the journey downstream turns the boy into neither a leader of people nor a valiant knight. Along the way, however, he learns just about everything one would want to know about indigence.

Paid employment forces Lázaro to discipline himself. He adapts his street smarts to a profitable routine that yields steady earnings, and is able to pay his employer thirty *maravedís* at the end of each day. Lázaro does so well that he works for himself on weekends. While selling water, he plans for a future of learning and leisure. His appearance, no less than his demeanor, improves to the point that he decides to give up his job after four years of hard work. At this point, two lifestyles are pitted against each other; the first hereditary and the second shaped by the pursuit of cultural comforts. The first we associate with minimum cost of subsistence, the second with a higher standard of living, which, as an unfolding achievement, can be both actual and potential.

To gauge the picaresque dynamics of these two lifestyles, let us compare Lázaro as water carrier to Velázquez's pictorial version of the same subject (*The Water Carrier of Seville*, c. 1619, plate 1).[1] For the youth of

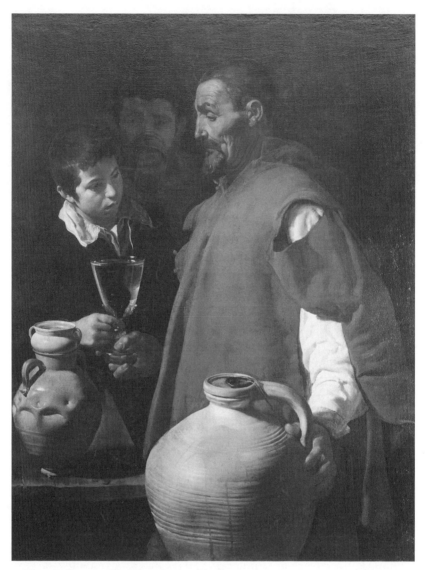

1. Diego Velázquez, *The Water Carrier of Seville*, c. 1619

the novel, selling water is a temporary occupation; for the old man in the painting, it is his lot in life.

II

Velázquez's water carrier is represented in an image of stark humility. The old aguador dispenses a life-giving commodity in what seems to be

an enclosed space. Because of spatial foreshortening, a sense of closure draws the viewer toward the large clay jug, whose pot-bellied shape echoes the water carrier's own rotund figure. They complement each other and meet through the large handle, which, in George Simmel's words (1978, 272), lets "the world approach the vessel; with the spout the vessel reaches out into the world." In the foreground, the old man's grip on the jug's handle points to the symbiotic closeness of skin and clay surfaces. One hand claims possession, and the upright stance asserts authority. The other hand holds the goblet and reaches out toward the youth in an act of transference that seems to be more compassionate than commercial.

The hands thus convey exchange and usage at the primal level of existence-in-the-world. In spite of the *escudero*'s objections to manual labor, the painting gives credence to Lope de Vega's verses:

> *Reyes los que viven son*
> *Del trabajo de sus manos,*

> Kings are those whose hands
> Are the source of their living.
> *(El villano en su rincón)*

The emergence of what we might call the picaresque work ethic gained some ground at least as a corrective to socioeconomic immobility.[2]

At the level of subsistence, the theme of the hands—clean or otherwise—follows the circularity of possession, transmission (to the youth), and consumption (on the part of the adult who is drinking in the background). The circularity of things reflects the circularity of humankind through the symbolism of the three ages of man.

Literally, the old *aguador* keeps the motion of his hands within an act of dispensation that is as transparent as the solemnity of his upright posture. Metaphorically, the young Lázaro "carries" water around town. To this extent, pictorial title and literary text converge in the common emphasis on the basic, even archetypal, activity of "carrying" water, even though the painting is by definition more static than the literary text. The painter depicts distribution within a closed space, whereas the writer portrays an itinerant routine that measures distribution against profit. This shift in emphasis paves the way for a radical alternative.

Tears in the fabric of the old water carrier's cloak suggest heavy use,

while the straight profile chisels out a towering presence rooted in that place and among those objects. We are reminded of an old man in Francisco de Quevedo's (1989, 186–87) *Sueños:*

> *Mi hábito y traje dicen que soy hombre de bien y amigo de decir verdades, en lo roto y poco medrado, yo soy el Desengaño.*

> "The torn and poverty-stricken state of my clothing," he replied, "should indicate that I am a man of honest deeds and given to speaking the truth . . . for I am called the Undeceiver."

Here poverty is associated with moral purity. The old aguador stands for moral rectitude, and it is fair to guess that greed has not sullied his personal integrity or ideal of social service. He is unmoved by the commercial world to which Lázaro de Tormes is drawn. Person and character are one and the same in *The Water Carrier,* where the old unity between the inner and outer man has withstood the challenge of new economic relationships and ways of thinking grounded, one might argue, in the Machiavellian play between being and seeming—between ser and parecer.

Grooves in the clay jug echo the wrinkles on the *aguador*'s forehead, just as the blemishes on the smaller pitcher repeat the rough texture of his cheeks. The painting reveals a subdued play of clay glazed and unglazed, of wrinkles and skin, of wool and linen. People are caught in a moment of "stilled" action; carrier and vessel are bound together in the portrait of the old man's life story.[3] With ease but without banality, Velázquez has juxtaposed a life-giving archetype to the economics of the trade. The smaller pitcher on the table is a more practical dispenser than the large jug, because it is apt to pour out its contents in quick gushes. The transfer of water is acquisitive for the youth and dispensational for the old man. Water is the primal substance of a ritual activity that the old man performs with pride. He holds the bottom of a miracle-bestowing goblet while the youngster secures his grip on its stem. Generations join hands around the glass goblet, which dissolves the life-giving liquid into a reflection—at once visual and spiritual—on the sustenance of human relationships.

The water carrier's life story is represented as the pouring of the wisdom of age into the emptiness of youth. The water carrier performs with dignity a kind of eucharistic deed that echoes contemporary

proverbs: "People of Toledo, people of God, water belongs to him, and we only sell it." The painting recalls Luis Vives's belief that "pure water" is God's gift to "all living creatures." Popular culture speaks in proverbs, songs, maxims,[4] and legends of a kind that the *ciego* and *aguador* are likely to pass on to younger people.[5] The youth and the adult will journey away, but the old man will keep watch at the fountainhead of a way of life. For him, selling water is a job that enhances personal pride and social respectability. For Lázaro, by contrast, it is a business activity, and he wastes no time in weighing its assets and liabilities.

The rounded shape of Velázquez's jug recalls the grain bins and the maternal womb that open the picaresque narrative under the aegis of abundance. In Salamanca begging still yields bread, sausages, and onions. Such an array of things belongs to what the nomenclature of art has called rhopography. Its etymon, *rhopos,* points to trifles and small wares that were the subject of genre pictures known as *bodegones* in Spain and *bamboccianti* in Italy. Typical examples are Annibale Carracci's *The Bean Eater* (plate 2) and Velázquez's *Old Woman Cooking Eggs* (plate 3). This *bodegon* seems to share a way of life with the water carrier. The old woman and the old *aguador* belong to the same social enclave, where the same youth first gets a drink and then waits while two frying eggs make time culinary. Thus we move from one *bodegon* to another, around dinner tables where people gamble, eat beans, and play music day in and day out.

Interest in eating scenes increased once Baroque culture began to favor "popular" subjects, such as the many versions of the *Supper at Emmaus* by Caravaggio, Velázquez, and their followers. Cheap items such as cow's feet, innards, and tripe punctuate the prosaic base of *Lazarillo de Tormes.* The *pícaro* is an errand boy—*esportillero* or *ganapán*—who hangs around places of food consumption and stands ready to carry loads, take on odd jobs, and seize any opportunity that might yield either money or food at the edge of stoves and around dinner tables.[6]

The picaresque genre is crowded with errand boys, as we see for example in Murillo's paintings (plates 4 and 5). For Norman Bryson (1990, 61–63), rhopography reminds us that "all men must eat; there is a leveling of humanity, a humbling of aspiration before an irreducible fact of life, hunger." The picaresque exposes basic aspects of existence, what Miguel de Unamuno (1958, 9:49–50) calls *"los abismos subhistóricos, bajo la historia"*—the subhistorical depths at the bottom of history. In the

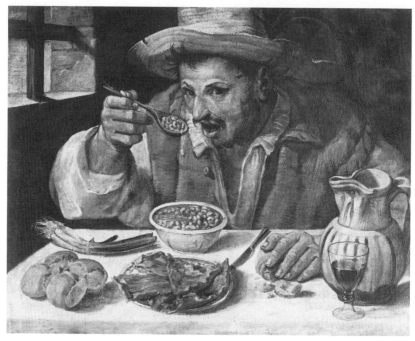

2. Annibale Carracci, *The Bean Eater*, c. 1583

anticanonical mode of ordinary existence, Velázquez's *Water Carrier* presents the subheroic world of sheer existence.

Ordinary existence in *La Celestina* gives unprecedented emphasis to the protagonist's chores, which Pármeno spells out down to the last detail. Picaresque textuality makes a wholesome meal out of bits and pieces of proverbs, lies, borrowed plots, business transactions, legal jargon, folkloristic echoes, and learned references. From a literary standpoint, rhopography points to those *petites histoires* that New Historicists have linked to anecdotes and quotidian activities.[7] At issue here is the artistic depiction of what Victor Shklovsky (1965, 12) calls "habitualization," that is, those daily routines—dressing or housekeeping—not previously treated as worthy subjects of art.

Artists committed to megalography take little interest in depicting everyday life, taking as their subjects upper-class life, great battles, and other concerns of the nobility, as represented in Velázquez's *The Maids of Honor* and *Surrender of Breda* (plates 6 and 7). Economically speaking, megalography concerns the conspicuous expenditures one reads about in Alberti's *I libri della famiglia*. A parallel can be drawn between mega-

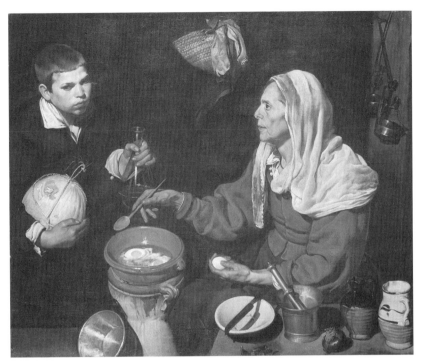

3. Diego Velázquez, *Old Woman Frying Eggs,* 1618

lography and the *grand récit* of an idealized concept of history, which feudalism and humanism applied to epics, treatises, and orations.

Between rhopography and megalography, the writer paired *pícaros* with *escuderos* and Sancho with Don Quixote, while the painter paired weavers with aristocrats in *The Spinners* (plate 8) and peasants with divinities in *The Drinkers* (plate 9). The common thread that runs through these works is the Counter-Reformation search for more earth-bound images of Christianity as well as the recognition of the diversity of the "human condition," as Michel de Montaigne and John Donne put it.

It is worth noting that even Alberti (1984, 80) pitted the exemplary humanism of the successful merchant against the prosaic antihumanism of the *micrologus,* or person interested only in small things and ordinary behavior, the *res quotidiana.*[8] In fact, realism refers to *res,* that is, to things. Etymologically speaking, realism is "thingism."[9] But what does thingism mean in the destitute world of the picaresque, where people own very little or nothing at all? To be sure, we are bound to confront

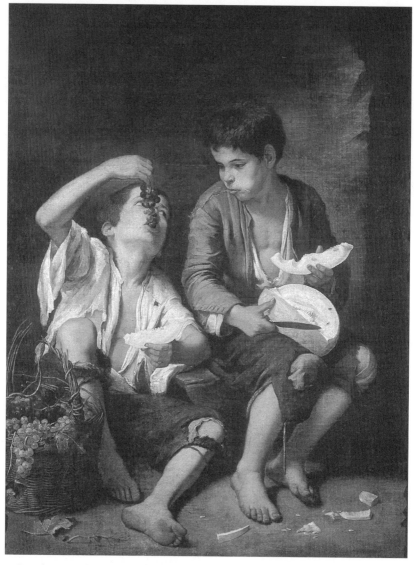

4. Bartolomé Esteban Murillo, *Melon and Grape Eaters,* 1645–46

in picaresque art minimal forms of representation, because the rhetoric of indigence thrives on fragments, silence, absence, the memory of things lost, or fantasies about things that are out of reach. Presence and function are so curtailed in the picaresque that narrativity tests its own resilience. To describe the *escudero*'s starvation, Lázaro focuses on a water jug:

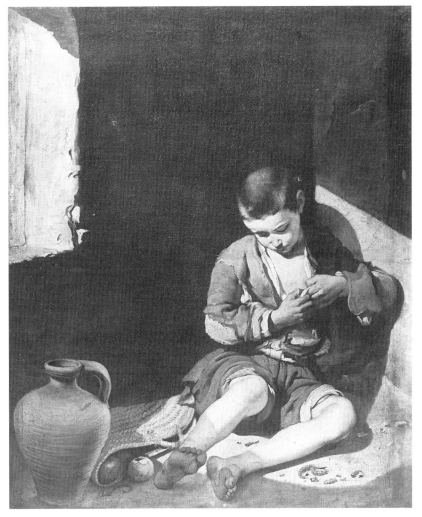

5. Bartolomé Esteban Murillo, *Boy Picking Off Fleas*, 1645–50

Pidióme el jarro de agua, y díselo como lo había traído: es señal que, pues no le faltaba el agua, que no le había a mi amo sobrado la comida. Bebimos y muy contentos nos fuimos a dormir, como la noche pasada. (90–91)

He asked me to get the water-jug and when I brought it, it was as full as when I had come back from the river. That told me quite clearly that he hadn't eaten very much that day. We drank and went to bed very happily. (57)

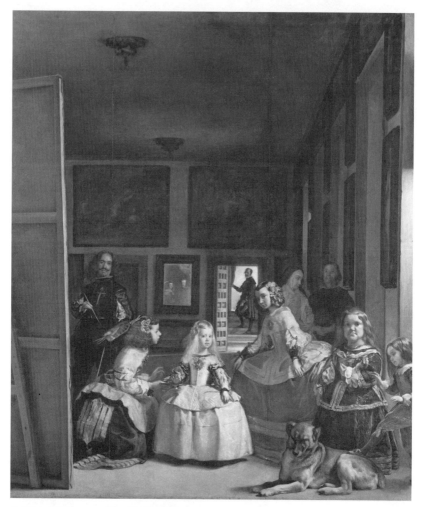

6. Diego Velázquez, *The Maids of Honor*, 1656

Food consumption calls for drink, but starvation does not. The undis-
turbed water level betrays an ominous pause in the process of existence,
and Lázaro understands that his master has not eaten since he left. Even
the literary description seems to lapse into a stasis akin to pictorial still
lifes in the sense of French *nature morte* and Italian *natura morta*. In that
sense, Caravaggio and Sánchez Cotán (plates 10 and 11) foreground a
world of things that includes the insignificant no less than the symbolic.[10]

At the edge of the Baroque, the art of the later *Cinquecento* revealed a
wealth of objects that could be represented without serving a narrative.

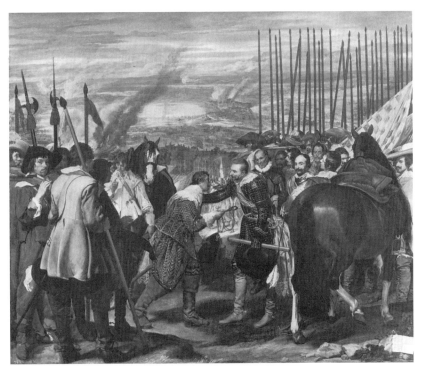

7. Diego Velázquez, *Surrender of Breda*, 1634

We verge here on the divide between the humanist emphasis on the *istoria,* which Alberti viewed as the most important element in a pictorial composition (*Della pitura,* 1436–38), and the antihumanistic tendency to foreground human scenes, which became ever more popular toward the turn of the seventeenth century. Svetlana Alpers associates this development with the emergent emphasis on the description of things rather than the narration of events,[11] and Georg Lukács asserts that "biological and sociological life has a profound tendency to remain within its own immanence."[12]

The picaresque concentration on the immanence and rhopography of existence raises a question. When life is reduced to the quotidian, should narration lapse altogether? Or should it still operate under disguises that traditional concepts of mimesis dismiss as irrelevant?

III

The water carrier comes to believe that he can overcome his marginality by turning time into an economic asset. The *ciego* had exposed him to

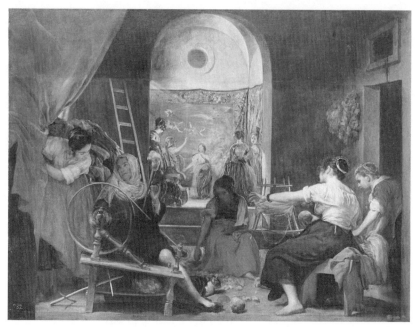

8. Diego Velázquez, *The Spinners*, c. 1657

time as experienced by the beggar, who, waiting on street corners as he
must for people's charity, has no control over it:

> *Y venimos a este camino por los mejores lugares. Donde hallaba buena acogi-
> da y ganancia, deteníamonos; donde no, a tercero día hacíamos Sant Juan.*
> (35)

> On the road we travelled through the best towns. When he found a
> welcome and good takings he stayed. When he didn't, we cleared off
> on the third day. (32)

This is the time of the parasite, who cannot take charge of events.
Lázaro must learn on his own to take advantage of the pace of everyday
work, which quickens the tempo of his life. The pace of the boy's earli-
er tasks echoed the medieval practice of dividing the day into categories
such as "at dawn," "about noon," or "toward sunset." This kind of time
followed the diurnal and seasonal rhythms of nature. The new monetary
economy changed all that. Clocks replaced the movement of the earth
as the teller of time, and what resulted was a mindset whose concept of
time became distinctly commercial.[13] The inference is that biological

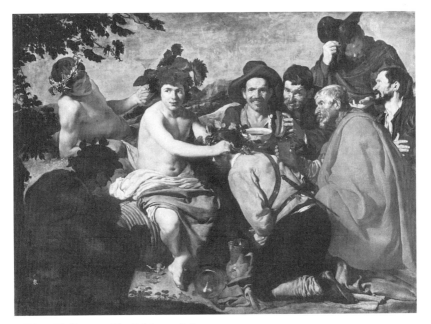

9. Diego Velázquez, *The Drinkers*, 1628–29

time, which is continuous in its demand for nutrition, should be commensurate with economic time. The equation ought to yield an income sufficient to exceed the demands of survival. And here is where the reliable water carrier (who trades water, so to speak) makes room for the resourceful water seller who may better his lot by working overtime.

Once the *ciego* had taught Lázaro that words produce income, the *mozo* learned quickly that money is the most valuable of languages. He soon learned to shortchange the blind man with half *blancas* rather than whole ones. Unlike food, half *blancas*, whole *blancas*, and *maravedís* could be exchanged at great speed. Having received alms since childhood, Lázaro empowers himself by giving *(daba)* thirty coins every day to the *capellán*:

> *éste fue el primer escalón que yo subí para venir a alcanzar buena vida, porque mi boca era medida.* (126)

> That was my first step towards becoming a respectable citizen because now my hunger was satisfied. (76)

Lázaro succeeds in coping with the clock-paced time of a monetary economy in which numbers spell out the temporal and fiscal vocabu-

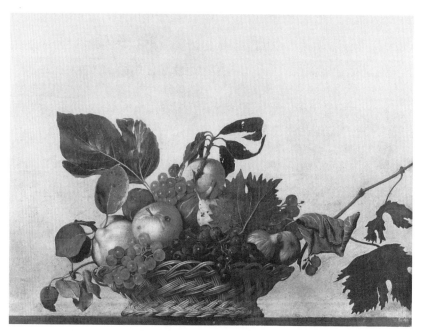

10. Caravaggio, *Basket of Fruit,* 1596?

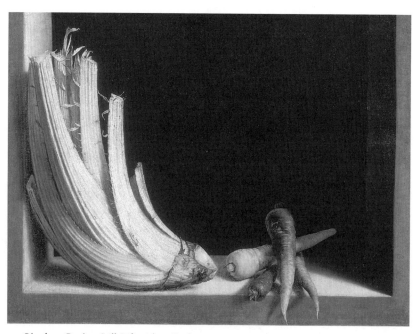

11. Sánchez Cotán, *Still Life with a Cardoon,* 1602

lary of the mercantile language. Alberti's maxim that time is money spoke for a whole age. For water carriers and merchants alike, numbers measured growth, indexed profit, organized double-entry bookkeeping, and quantified prosperity. The *escudero* estimated the monetary value of houses, and the water carrier counted the money he earned. As the popular saying had it, merchants spoke through numbers, which became all the more important during what Vittore Branca has called the business culture of writers of things rather than words—*scrittori non di parole ma di cose*. In Spain such an *economía dineraria* was introduced through the literary fictions of *La Celestina* and *La lozana andalusa*.

Of course, temporal units of measurement framed work activities quantitatively as well as qualitatively, and José Antonio Maravall (1990, 128–32) links this phenomenon to a semantic shift in the very concept of labor. Myth and chivalry associate *trabajo* with the strenuous efforts of superior individuals, from the *trabajos de Hércules* to medieval warfare. Throughout the sixteenth and seventeenth centuries, however, *trabajo* came to mean manual labor, and Lázaro himself describes his previous jobs as *trabajos y fatigas* (128) in the last *tratado*.

Insofar as work yields compensation, the water carrier's job approaches a salaried position. *Salario,* in fact, was a sixteenth-century neologism that replaced personal with professional relationships. In this case, the employer gets a fixed income, whereas the employee takes risks that may yield variable profits. This arrangement recalls medieval work obligations, even economic practices typical of slavery. Antonio Domínguez Ortiz (1971, 165) tells us that, especially in Andalusia, some slaves were allowed to live at liberty and follow any calling as long as they handed over a fixed part of their earnings. The remainder was at their disposal. While slaves used profits to buy some measure of freedom, Lázaro used them to buy his way out of poverty amid what Pedro Salinas calls the *infrahumanidad* of those who toiled at the furthest periphery of affluence.

Lázaro's understanding of time as an economic asset has social implications inasmuch as it empowers him to improve his physical appearance. He gradually begins to buy clothes that lead him to appreciate "role-playing." The reader has no idea that he has never worn footwear until the friar of the Order of Mercy gives him his first pair of shoes in the fourth *tratado*:

éste me dio los primeros zapatos que rompí en mi vida; mas no me duraron ocho días, ni yo pude con su trote durar más. (111)

He gave me the first pair of shoes I ever went through in my life. They didn't even last me a week, and I couldn't take the running around any more. (66)

For the first time in his life, Lázaro finds out what it means not to walk barefoot. Fernando de Rojas drew on proverbial wisdom when he referred to a servant who, having walked barefoot a whole year, "wished to kill the shoemaker because he did not finish a new pair in one day" (*La Celestina,* act 8). Lázaro de Tormes is less impatient. Shoes in the fourth *tratado* are not symbolic of work. In fact, the picaresque narrator does not even clarify what kind of work, if any, Lázaro is engaged in. The very idea of aimless walking betrays an unproductive use of time. This kind of aimlessness takes us back to the *escudero* at the beginning of the third *tratado,* where he "walked away" from economic activities, from prostitutes, from the landlord, and from Lázaro himself. In folklore and in *El Libro de Buen Amor,*[14] shoes suggest moral debauchery and sexual appropriation. Morally, they foreshadow the seedier aspects of marital arrangement. Materially, they require a steady income that allows worn-out things to be replaced. It is under these conditions that Lázaro's "self-fashioning" gets under way.

After four years of careful savings, the young water carrier has saved enough to buy some used clothes:

Fueme tan bien en el oficio que al cabo de cuatro años que lo usé, con poner en la ganancia buen recaudo, ahorré para me vestir muy honradamente de la ropa vieja, de la cual compré un jubón de fustán viejo y un sayo raído de manga tranzada y puerta y una capa que había sido frisada, y una espada de las viejas primeras de Cuéllar. (126–27)

I did so well at the job that after four years of careful saving I had enough to dress myself very decently in second-hand clothes; I bought an old fustian jacket and a worn coat with braided sleeves and a vent. I also got a cloak which had had a fringe once, and an old sword made when they used to make them at Cuéllar. (76)

The state of Lázaro's new threads tells us that his progress toward financial solvency is likely to be slow and difficult. Once markers of nobility, the clothes he can afford are secondhand rags fit only for the poor. As one

unfortunate low-life wretch concedes in *El Buscón,* they can be used over and over again. For the poor, old rags can have more than seven lives:

> *No hay cosa en todos nuestros cuerpos que no haya sido otra cosa y no tenga historia. Verbi gratia: bien ve vuestra merced—dijo—esta ropilla, pues primero fue gregüescos, nieta de una capa y bisnieta de un capuz, que fue en su principio, y ahora espera salir para soletas y otras cosas. Los escarpines primero son pañizuelos, habiendo sido toallas y antes camisas, hijas de sábanas; y después de todo las aprovechamos para papel y en el papel escribimos.* (107)

There's nothing on our backs that wasn't once something else and hasn't a story to tell. For example, you see this waistcoat? Well, first it was a pair of wide breeches, the grand-daughter of a cape and great grand-daughter of a long cloak and now it can look forward to a future as footrags and many other things. Our linen socks are handkerchieves and before that they were towels and before that, shirts, descended from sheets, and afterwards we make them into paper. (152–53)

Here words add to the symbolism of the cloak, which has always been one of "masking." By the end of the *tratado,* Lázaro believes that he can seek a more remunerative form of employment. At the height of his good fortune in Toledo, however, the *pregonero* still wears the archpriest's old stockings *(calzas viejas).* By and large, the picaresque reassures the historical school of the *Annales* that sartorial details link up to the "deeper structures" of a society obsessed with appropriate attire—*"vestir muy honradamente."*[15]

In spite of his rhetoric, Lázaro's prosperity is limited. He can buy used clothes but not new ones. Indicators of wealth mock the materialist achievements of a *hombre de bien* who dresses up like a respectable person—*"me vi en hábito de hombre de bien."* Role-playing proves to be at once ludicrous and profitable. In Lázaro's case, the acquisition of things is troublesome, and it makes self-fashioning liable to abuse. The town crier's pretentious secondhand taste is that of a would-be—or never-to-be—gentleman, and the sword he buys in "imitation" of his master's satisfies immaterial needs.[16] Popular belief had it that commoners served the king with money, the clergy with prayers, and the nobility with weapons. Under a parodic disguise, the picaresque covers the whole field, and the mockery of social institutions is quite overt.

Determined to improve his lot, Lázaro is ready to break free of pica-resque existence:

> *Desque me vi en hábito de hombre de bien, dije a mi amo se tomase su asno, que no quería más seguir aquel oficio.* (127)

> As soon as I saw myself dressed up to the nines I told my employer to take his donkey as I did not want that job any longer. (76)

Once the demands of subsistence are met, the young water carrier can survive comfortably at the fringe of business and bureaucracy. What never happened to most *pícaros,* in fact, happens to Lázaro de Tormes. Instead of lamenting opportunities lost, denied, or never taken, Lázaro creates choices for himself in spite of a restricted field of action. The *ciego* has "initiated" his *mozo* in the *carrera de vivir* by teaching him to survive.

The moment it is applied to lifestyles that rest on cultural values, sub-sistence living is found wanting. As a water carrier, Lázaro still lives at the ground floor, as it were, of material life. When he begins to feel that the bottom level no longer is satisfactory, Lázaro takes up the challenge of economic improvement.[17] Now goods take on a metaphorical depth at once humanizing and dehumanizing. To set Lázaro's choice in histor-ical perspective, we may recall one of Don Quixote's "educational" axioms: "I tell you, Sancho, that no man is worthier than another unless he does more than another" (*Don Quixote* I, 18). While this axiom may fall on deaf ears in the Cervantine text, where the *hidalgo* alone does more than most, in the picaresque narrative the *mozo* from Tormes makes himself into a "better" town crier. Determined as he is not to spend the rest of his life trading water, he sets out to pursue what neither the *ciego* nor the *escudero* could give him. That his worth is ultimately deficient cannot diminish his achievement.

In spite of his meager earnings, Lázaro sets ambitious goals for him-self. Money brings regularity to the narrative, and Lázaro's savings are his first approach to wealth.[18] His job affords security, but the young man is not content to carry water for the rest of his life. The text distin-guishes between natural time, which meets the demands of subsistence, and economic time, which promises profit. One is reminded of the *ciego*'s initial promise: *"Yo oro ni plata no te lo puedo dar; mas avisos para vivir muchos te mostraré"*—"I won't make you a rich man, but I can show you how to make a living" (23, 28).[19] Such *avisos* have taught the boy to live, *vivir,* a verb of survival that stands at the semantic core of subsis-

tence. To achieve more than that, Lázaro reaches out for what his blind master could not teach him. He understands that income is instrumental in trading the necessary for the preferable, and profit alone can make psychological needs and cultural values as necessary as subsistence itself.

While in Salamanca, the *ciego* taught Lázaro street smarts; in Toledo the *escudero* taught him that one must guide oneself by principles. Both lessons fail to satisfy an ambitious water carrier who longs for a "better" station in society. The *ciego* is blind literally, the *escudero* intellectually. But Lázaro learns to open his eyes to the facts of existence. By the end of the sixth *tratado,* he is ready to capitalize on both lessons, and he finds in the novel the best instrument for gaining a sharper perspective on life.

IV

At this point the comparison between the literary and the pictorial breaks down. Stylistic and thematic parallels illustrate different choices. While chapters of human history have followed the migratory rhythm of gold and silver across the oceans, other chapters have held on to the timelessness of archetypal ways of life. Tradition and innovation have coexisted, if uneasily. Likewise, the primeval stability of material life at its most basic (subsistence) has paralleled the achievement-oriented growth of economic life (profit). We move here within range of Velázquez's *aguador,* who embodies a socioeconomic culture bent toward the preservation of the selfsame condition—*el estatismo de su esta-do.*[20] At his level, psychological motivations and economic needs are elementary.[21] As Antonio de Guevara wrote at the time, "it is a privilege of villages that those who dwell in them have flour to sift, a bowl for kneading, and an oven for their baking."[22] In this elementary economy, the old water carrier performs a ritual that "redeems" the lowly reputation of his trade.

At the low level of human existence, doubts have been shed on the representation of good-natured water carriers, who in fact enjoyed a bad reputation in the streets as well as in Cervantine references to *gente baja* (*Don Quixote* I, 21). A nobleman, Don Tomás de Avendano, took up "the trade of water-carrier" in Toledo: "With a single load of water he could wander about the city all day long, looking at the silly girls." Selling water was a menial occupation just a few notches above begging. For Luis Vives, the native poor who met the lowest standard of employment "could dig ditches, draw water, or carry things in baskets."[23] By

and large, water carriers were unsavory characters closer to Velázquez's own *Drinkers* (also called *Borrachos;* see plate 9).[24] If one were to describe the old *aguador* in terms of social improvement and conspicuous consumption, it could be suggested that he embodies the mediocre life of unimportant individuals—*hombrecitos*. In fact, he lives in the stagnant "infra-economy" of his trade, and his time frame is one in which the reliability of ritual takes precedence over the unstable world of gain and loss. He is rooted in a traditional culture where one's assigned social role is accepted without question and neither material change nor social progress affects people of his standing.

Proud as he is of his job, the old *aguador* is a human vessel who performs an iconic act. He cannot be a model for Lázaro, who, having become a money-earning subject, cannot accept that indigence is inevitable. Economic progress becomes his goal, and the last chapter recounts his transition from water carrier to town crier. Finally, the *Prólogo* presents a writer who so blurs the world of ritual with that of economics that he links the gift of food and clothes to holy events, much as he juxtaposes bread and Eucharist in the priest's chest—a picaresque *paraíso panal*. The water carrier performs what Theodore Ziolkowski would call a figural transfiguration, the same thing that spurred Rembrandt to raise as dehumanized a form as the carcass of an ox to the tragic level of a crucifixion (*The Slaughtered Ox,* plate 12). In the nineteenth century, Gustave Flaubert's Felicité, the simpleminded maidservant, also transfigured a parrot into the Holy Ghost. On matters of picaresque and realist points view, the French novelist believed that we see God in the details. We must infer, however, that he did not mean all or any details! Rather, details must be substantive enough to endorse symbolic forms of representation that stand out somewhere between the obvious and the memorable.

To qualify as artistic, details must be intensified, which is what novelists do with a passion, from Giovanni Verga's *roba* in his nineteenth-century *romanzi della fame* (novels of hunger) to John Steinback's *Grapes of Wrath* and Ignazio Silone's *Pane e Vino*. Picaresque literature brings to the forefront the struggle between the exemplary type and the faceless average. The practice of everyday life, therefore, must be transfigured if it is to leave a significant artistic impression.

In his search for prosperity, Lázaro quits his job and breaks free from the archetypal life cycle of Velázquez's old *aguador*. Lázaro is one of the

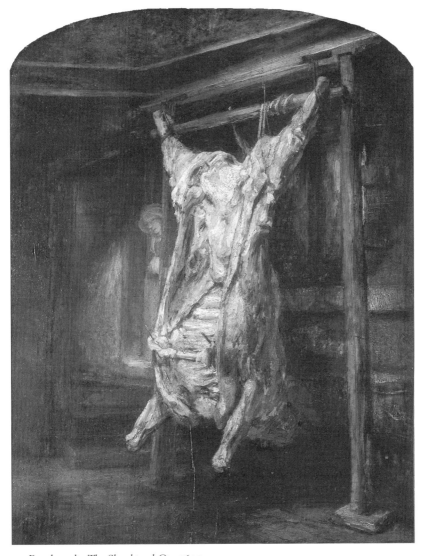

12. Rembrandt, *The Slaughtered Ox*, 1655

few *pícaros* who get away, an illustration of Mikhail Bakhtin's observation that "the center of gravity in this world is located in the future, in what is desired, in what ought to be, and not in the self-sufficient givenness of an object."[25] The old *aguador* lives in the self-sufficient givenness of pitchers and goblets. These objects are always ready to serve an age-old ritual in which the intrinsic use value of water does not exceed its extrinsic exchange value. As a commodity, water has not allowed him

to buy decent clothes even after a lifetime of hard work. The anthropologist would add that the old man belongs to a clan-based society that values personal relationships over the exchange of things.[26] Lázaro, by contrast, maximizes the exchange value of water by increasing the tempo of the exchange itself. For one, selling water is a lifetime endeavor, for the other, a temporary employment.

Although he spends four years at the job, Lázaro never refers to himself as a water carrier. He pursues a future beyond his reach, and water does not yield enough income to enable the leap. Nor does wine, at least not as long as he serves the *ciego,* who warns the boy:

> *A los menos, Lázaro, eres en más cargo al vino que a tu padre, porque él una vez te engendró, mas el vino mil te ha dado la vida.* (43)

> I must say, Lazarillo, you ought to be more grateful to the wine than to your father because he only begot you once but wine's brought you back to life hundreds of times! (35)

Wine satisfies thirst. Its use value is diversified. In one instance, it is used to heal the boy after the old man's beatings. Under the guise of a prediction, wine foreshadows a higher exchange value:

> *Yo te digo—dijo—que si un hombre en el mundo ha de ser bienaventurado con vino, que serás tú.* (43)

> "I tell you," he said, "that if anybody's going to be lucky with wine in this world, it'll be you!" (35)

The prophecy comes true in Toledo, where the *pregonero* announces "the wines that are to be sold in the town"—*"los vinos que en esta ciudad se venden"* (129). In fact, wine has become one of the more expensive goods that "pass through" his hands. In a way, the distinction between subsistence and profit echoes the Aristotelian goal of political life, namely, the support of "life" and the achievement of "the good life" (*Politics* III, 1280b). The preservation of the first is the necessary base for the pursuit of the second. Lázaro de Tormes fulfills the first but, some may suggest, fails the second. Yet the fact that his lot does not improve very much does not mean that he did not try hard enough or that on some level he did not succeed.

While most *pícaros* were lost to the backwaters of history, Lázaro de Tormes changed his lot and empowered himself to write about it.[27] Yet

he was not reborn to a standard of living completely severed from picaresque toils.[28] Old stockings in the last *tratado* point to the world of "has been," a peripheral realm in which markers of social status find new life at the lower levels of human existence, where the novel alone invests literary talent in telling stories about life as it is.

In keeping with the Marxist proposition that money converts representation into reality and reality into representation, Lázaro trades the role of water carrier for a representation of himself as an ambitious youth. His incipient pursuit of wealth begins with the acquisition of worn-out items that betray the volatility of the very concept of wealth. To the end, Lázaro's earnings are based on the archpriest's gifts.[29] His would-be profit—*provecho*—as a modern *mercader* comes not from free-market forces but from the corruption of the class system. It cannot be denied that marriage-as-cuckoldry makes all other exchange values possible for the town crier. Thus he rises from the condition of outcast to that of employee at the lowest bureaucratic level. He secures a steady income at the price of moral devaluation, and trades matrimony for patrimony. At once dishonorable and dispossessed, the picaresque outcast is a parody of the class no less than of the caste system.[30]

When all is said and done, the water carrier's money cannot buy the future, and the past becomes worthless. In a significant way, standards of living in the emergent genre of the novel were bound to measure frustration as much as success. At the threshold, Lázaro had no choice but to trade poverty for profit, *laceria* for *provecho*.

5 · The Economic Culture of Toledan Provecho

The word comes to carry its own ontology, its own reward for being. When one wonders how to begin to talk about something, etymology appears, a way to start an argument that places all of history within the subject at hand.
—*Susan Stewart*

I

The last *tratado* solidifies Lázaro's ability to secure an income-yielding job. His ambition is such that he becomes a *pregonero* and marries his protector's mistress. In a circular way, themes that were introduced in the first *tratado* are brought to fruition in the last. One is the belief that marriage ought to be a profitable investment. Accordingly, the equation of moral "good" with material "goods" proves to be at once exclusive and complementary, shifting as it does between material fulfillment and moral disappointment. In the city of commercial transactions, the water carrier who has become town crier exploits the gap between *hombre de bien* and *hombre de negocios,* because he is convinced that profit alone can bring him the social status he desires. Whatever its etymology, the semantics of *provecho* are numerical, cumulative, and exchangeable. Although a utilitarian concept at heart, *provecho* (or profit) fills the range between purse and prayer in the picaresque mindscape.[1]

On its face, at least, religion showed contempt for *provecho,* which encouraged sinful temptations and deplorable exchanges. Among the seven cardinal vices, Antoninus, bishop of Florence during the first decade of the fifteenth century, included ill-begotten wealth. Having conceded that business is crucial to "the very preservation of life"—"*la misma conservación de la vida,*" Tomás de Mercado (1977, 1:71) insisted that "merchants are very ancient people, who appeared the moment the world itself was created. Since they came forth after the original sin, they have been multiplying with malice." The evils of usury, greed, and hoarding so marketed temptation that its lure could not be resisted; nor could its benefits be denied.

Like other businessmen, the Florentine Giovanni Rucellai resorted to calculating financial as well as spiritual gains.[2] At issue here is a rather wishful analogy between market conditions and human exchanges.

While cultural standards were of a "higher" order than subsistence, religious values were of the "highest" or "ultimate" order. *Provecho*'s etymology implies progress, prosperity, and utility—*progreso, prosperar, ser util*.[3] In a productive society, *provecho* points to deeds meant to yield rewards in all fields of human endeavor, and Tirso de Molina entitled art to spur useful interactions between pleasure and learning in *Deleitar aprovechando* (1635).

Old prejudices against moneylenders did not vanish, and Quevedo fell back on the linguistic nomenclature of the art of business to describe eternal punishment for "rich Genoese." In the words of the devil himself, "These men think to gain by their approach, but this time it is their undoing. Their accounts don't add up, and there are no seats in Heaven for them because they've overdrawn their credit." Mismanagement of account books could be fatal, and professional incompetence earned damnation. From dreams of the last judgment to death itself, the picaresque equated money with evil powers: "What money won't do the devil won't manage either. . . . Money is the only world there is." Modern society at large had to face a new monster that was "many-formed," with "a hundred faces,"[4] by the name of "Sir Money":

> Mother, I humble myself before gold; he is my lover
> and beloved, for he's so much in love that his complexion
> is always pale; and since, whether doubloon or of less value,
> he always does everything I wish, *a powerful knight is Sir Money*
> . . .
> And his majesty is so great (although his griefs are extreme)
> that, even when quartered, he doesn't lose his authority; but,
> since he gives quality to nobleman and to beggar, a *powerful
> knight is sir Money.*

Parodies of chivalrous language held sway much as equations between possession and personality became symbiotic in the discourse of the novel. At best, money was a poison necessary to the continuance of the body politic. All sorts of prescriptions were issued to contain material prosperity, but nobody wanted complete immunity. Not until the later sixteenth century did the Catholic Church accept the legitimacy of charging interest on loans. Previously the "Lombards" had resorted to all sorts of subterfuge to circumvent monetary restrictions, first in Italy and then throughout Europe.

Needless to say, wealthy merchants such as Francesco Datini of Prato did their business in the name of "God and Profit." The conjunctive *and* made of *provecho* an equivalent of divinity at a time when the popular notion of *provecho de las almas* constituted a linguistic hybrid that injected noneconomic values into economic concepts (or the other way around). As a form of secular bliss, *provecho* was worshipped in the rhetoric of religion. Kenneth Burke reminds us that "money is intrinsically universalistic." Since everything can have its monetary equivalent, "men will kill themselves trying to amass more and more of the monetary symbols that represent good living." Money is communicative, redemptive, and substitutive. By blending talent and self-interest, *provecho* also claimed its place among those "logological" God-words that the humanists either coined or empowered as never before.[5] The secular meaning of *gratia* as something given freely *(gratis)* could turn into a godly dispensation *(deus gratia).*[6]

Luis Vives (1968, 87) had no doubt that *virtúd,* "the queen and principal mistress of the world," was spiritual, but it could easily become secular. In fact, the concept of *virtù* is central to the humanist idea of intellectual, political, and spiritual exemplarity. In the Albertian sense of the word, *virtuoso* implies a mode of behavior that is financially successful and ethically correct. The goal of the merchant—*mercatante*—is to master *arte della mercatura* so as to amass material goods—*masserizia.* In the world of the picaresque, *arte della mercatura* makes room for *arte de furtar* (the art of stealing), which is more likely to yield *nonadas.*

The time had come to give older mythologies a new literary currency. By and large, the mythical "fall into commerce" turned out to be a relatively happy one. Adam ate and digested the apple. It was time to get into the earth-bound business of selling apples for profit. Much humanist *otium* gave way to enterprising *negotium.* To the very end of the picaresque narrative, *provecho* remains a source of integration and exclusion, of bliss and damnation; it is apple and host, that is to say, a *pharmakon* at once poisonous and curative. In the fallen city of humankind, rhetoric often relied on threats rather than mere persuasion, much as the language of commerce spelled out the dynamics of human greed. At the most elementary level, *provecho* and its attendant verbs—*ganar, ahorrar, recaudar, comprar, trocar,* and *negociar*[7]—indexed the vocabulary of Lazaro's standard of living.

In the routine of everyday life, whatever is "valuable" carries a monetary sign. The *ciego*'s cynical reflection in the first *tratado* comes back. Since his income is dwindling, he decides to leave Salamanca for the more prosperous city of Toledo:

Porque decía ser la gente más rica, aunque no muy limosnera. (35)

Because people there [are] better-off, though not very generous. (32)

Even proverbial wisdom had it that

"Más da el duro que el desnudo." (35)

"A hard man will give more than a man who hasn't anything at all." (32)

Lazaro echoed that lesson when he judged the powerless *escudero:*

éste—decía yo—es pobre, y nadie da lo que no tiene. (92)

This man . . . is poor and nobody can give what he has not got. (58)

Charity depends on having money, and beggars know that only people who have money can be generous. The issue no longer is whether people are "good" as such, but whether they possess enough goods to be charitable.

At the top of the materialist scale, the good is the profitable, and the *escudero* is there to prove to Lázaro de Tormes that honor is meaningless without a material base. Even proverbial wisdom maintains that honor is nothing but profit—*"honra no es sino 'provecho.'"*[8] Sino makes it clear that *honor* has become synecdochic of a value system in which utilitarian concerns are dominant. Juan de Valdes (1940, 147) confirmed that *"honra sin provecho, sortija en el dedo"*—"honor without profit is like a ring on the finger." To complicate things, however, another popular saying had it that *"honra y provecho no caben en un saco"*—"honor and profit cannot fit into a single bag." As a utilitarian concept,[9] *provecho* privileges "having" over "being." In fact, "being" can be earned, and Lázaro earns it the moment he takes up the job of town crier. At the heart of the corrupt socioeconomic mores of Toledo, *provecho* is bait and trap;[10] instead of creating the kind of productivity that would benefit society at large, it consolidates the status quo. One is reminded of Balzac's question: *"Combien de fois un mot n'a-t-il pas décidé de la vie d'un*

homme?"—"How many times has a word decided a man's life?" *(Modeste Mignon).* In the picaresque text, Lázaro seems to be held hostage by his *provecho,* which, for better and for worse, is bound to determine his fate.

II

In the materialist pit of Toledan society, ambitious upstarts cannot resist opportunities to profit, which quickly come to decide their choices and their conduct. Since greed often gets the best of generosity, honor and shame can easily trade places; and by the end of novel, this is just what has happened. The archpriest spurs Lázaro on:

> *Lázaro de Tormes, quien ha de mirar a dichos de malas lenguas nunca medrará. . . . Por tanto, no mires a lo que pueden decir, sino a lo que te toca: digo a tu provecho.* (132–33)

> Lázaro de Tormes, you'll never get on in life if you take any notice of what people say about you. . . . So, don't pay any attention to what anybody says; just think about your own affairs, I mean, what's best for you. (78)

Delivered in a tone that is at once prescriptive and conspiratorial, the archpriest's bad advice causes Lázaro to ignore his friends when they tell him that his wife is having an affair.

Ironically, destitution can empower the poor to make of morality an instrument of profit. Monetary and sexual exchanges are intertwined in the culture of the picaresque. Làzaro applies the blind man's prophecy about cuckoldry to the marketplace, and continues to sell wine after he has sold his soul. Since he cannot afford honor, he invests in the economic potential of dishonor. Having learned from the *escudero* and the *buldero* about the gap between words and deeds, Lázaro understands that one must dare opportunity. In his case, *provecho* entails a choice that is ethically blameworthy but economically advantageous. He can neither discuss nor debate, but he can acquiesce, because the archpriest alone controls the production of discourse and the economics of Lázaro's world.[11] Showing a Machiavellian turn of mind, the archpriest, whose spiritual "trade" is supposed to uphold the inherent good of moral choice, teaches Lázaro to ignore criticism.[12]

While testing ingenuity and honesty alike, *provecho* comes with strings attached. From nine to five o'clock, the *pregonero*'s words beget money

and shame others; before and after hours, however, everybody points to Lázaro's own shame.[13] As a material source of empowerment, *provecho* spurs him to profit from his subordinate status—his *situacion de dependencia*. A social parasite, Lázaro profits from the corruption of social institutions and thrives on the pathology, not the good health, of society. Business is transacted in church, whereas public officials are stoned in the streets:

> *Despedido del capellán, asenté por hombre de justicia con un alguacil; mas muy poco viví con él, por parescerme oficio peligroso: mayormente, que una noche nos corrieron a mí y a mi amo a pedradas y a palos unos retraídos; y a mi amo, que esperó, trataron mal, mas a mí no me alcanzaron. Con esto renegué del trato.* (127–28)

> After I left the priest I went to work for a constable as it seemed a good idea to get in with the law. But I didn't stay long with him because my job was dangerous. In particular, one night my master and I were chased by some fugitives who threw stones at us and set about us with sticks. They didn't catch me but they gave my master a proper working-over. That decided me to break the contract. (77)

The question is, how legitimate can the ways of earning be? How valuable is Lázaro's *buena fortuna*? And how profitable is his *provecho*? Given the New Historicist emphasis on money and prestige as the dominant currencies of society, one might surmise that *provecho* presides over uneven exchanges between a handful of privileged individuals—aristocrats, bankers, merchants—and crowds of impoverished *desesperanzados* who rarely transcend the "hand-to-mouth economy."[14]

Lázaro's long-term project is to save for his old age:

> *Ganar algo para la vejez, quiso Dios alumbrarme y ponerme en camino y manera provechosa.* (128)

> To settle down to have an easy life and earn something. (77)

To accomplish this, he expects God and his own wits to discern the direction *(camino)* of his future. *Provecho* stands out as the signpost of a world of sought-after blessings that arise from the seedier realities of the established order. However modest his income, however dubious his respectability, Lázaro achieves his "blessed" goal when he gets the job of *pregonero* in the civil service. To the minds of common folks who have

never escaped the grip of indigence, *provecho* often means unproductive ways of earning. Who, after all, are the real parasites? The very term *manera provechosa* privileges manner over matter, and the qualifying adjective *provechosa* suggests a way of gaining an advantage. In the context of unmitigated poverty, "profit" usually follows from opportunism, with little regard for law or morality. The final irony is that Lázaro changes the markings but not the position of his marginality, even after he has secured a post in the public bureaucracy.

In a gross exaggeration, Lázaro proudly declares that everything in Toledo passes through his hands, and the last chapter of the novel opens to a world where things have become articles of exchange:

> *Y es que tengo cargo de pregonar los vinos que en esta ciudad se venden, y en almonedas, y cosas perdidas, acompañar los que padecen persecuciones por justicia y declarar a voces sus delictos: pregonero, hablando en buen romance.*
> (129)

> Now my job is to make public announcements of the wines that are to be sold in the town, and of the auctions and lost property. I also accompany criminals being punished for their misdeeds and shout out their crimes. In other words, or in simple English, I'm a town crier.
> (77)

Trocar and *negociar* give verbal currency to a world of things of which Lázaro has been long deprived.[15] As an expression of materialist ingenuity, *provecho* ought to be sought where business, banking, and social mobility make it accessible. Such an environment does not exist for Lázaro, whose *buena fortuna* arises from strategies based on deplorable, though effective, opportunism. For him and his kind, it is social structure, not economy, that can provide profitable incentives. Accustomed as he has become to *ciegos* and *bulderos* who sell prayers and pardons, Lázaro profits from men of the cloth. And everyone understands that the authority of churchmen extends to secular institutions as well. Throughout the Renaissance, the worlds of missionary work and political conquest stood shoulder to shoulder. Likewise, religious ritual and commercial trade have become so blurred that Lázaro links the gift of food and clothes to Easter and other holy days.

Because it stems neither from free competition nor from economic productivity, Lázaro's *provecho* includes the archpriest's handouts, but

their not-so-hidden costs are a bargain.[16] Anthropologists such as Marcel Mauss have taught us that gifts entail reciprocity. Because they are prevalent in cultures where personal relationships prevail over impersonal practices,[17] gift economies stand in opposition to currency exchange. By favoring the circulation of ideas over transactions in things, gifts are bearers of a better concept of culture.[18] On the other hand, Jacques Derrida (1992, 12) reminds us that the direction of gifts can be one-way rather than reciprocal. Gifts can testify to the *largesse* of the few and the material inferiority of the many, who acknowledge their lowly status by accepting them. Pagan generosity and Christian charity exist because the majority of people in any culture have been underprivileged throughout human history. From Aristotle and Cicero to Seneca and Boethius, prodigality has been an outstanding feature of the upper classes. The classical tradition of *largitio* describes the rain of golden coins emperors showered on their subjects on special occasions. Likewise, dispensation of economic gratuities was typical of chivalric and carnival rituals.

Lázaro's own marriage turns into a "donation" that entails lifelong obligations. Once the allied powers of Church and State make him an offer he cannot refuse, the town crier has no choice but to defend his wife's reputation by swearing on the Holy Ghost. After all, she is as good a source of economic bliss as can be found in Toledo. Literally and symbolically, she has become a secular deity who can trade principle for convenience; sign and coin coincide.[19] The ambiguity of Lázaro's socioeconomics sheds light on the troubled reality of a society in which gifts uphold unequal relationships. Even legitimate work depends on favors rendered and received. Paradoxically, the job of *pregonero* is at once a form of lawful work and a kind of institutionalized parasitism in a society where the corruption of the authorities is bound to infect the whole body politic.

Whereas business deals tend to be straightforward, the exchange of gifts can be allusive, even conspiratorial. And the indictment launched by Vuestra Merced proves that the marriage investment is about to depreciate the town crier's *buena fortuna*. Having reached what he believes to be the top of the socioeconomic ladder, the *pregonero*'s growth stalls.[20] Picaresque ambition affects what Lázaro de Tormes is, has become, and will never be. Gifts thus shed an ominous light on the growth and decline of the town crier's fortunes; he is at once vulnerable and enviable.

In the pit of mere survival, the gift of food and clothes barely makes a dent on the working classes, whose backs are clothed after the skin has been scratched off by hard labor.[21] The picaresque gift economy thus reflects an unproductive society whose major asset is the symbolic capital of personal loyalties and moral obligations. Throughout the narrative, businessmen and churchmen—*hombres de negocio* and *hombres de iglesia*—often are one and the same;[22] greed and faith, commerce and religion go hand in hand. Men of the cloth turn with ease into *mercaderes*. Given the ironclad nature of these social relationships, Pierre Bourdieu might agree (1997, 217), debts and gifts are symbolic forms of violence. Gift economies are ambiguous; one proverb tells us that "a gift is a misfortune." Rousseau believed that only when gifts were replaced by contracts would society achieve political and economic equality. But contracts between individuals who are liable to affluence and indigence betray a condition that the Toledan *pregonero* never experienced.

III

Cuckold that he has become, Lázaro learns that profit, not love, spurs proliferation. He has no children, but he relishes the accumulation of goods more than the birth of offspring. At the beginning of the narrative, Antona Pérez's "labor" is the result of love and is accompanied by goods that Zaide, her black lover, brings to her:

> *Más de que vi que su venida mejoraba el comer, fuile queriendo bien, porque siempre traía pan, pedazos de carne y en el invierno leños, a que nos calentábamos.* (17)

> As soon as I saw that whenever he came we ate better I began to take quite a liking to him, because he always brought bread, pieces of meat, and firewood to warm ourselves with in the winter. (25–26)

This liaison teaches Lazarillo to equate love with material benefits. Afterward, he finds it easy to make of sex a profitable commodity. Only through hypocrisy has the town crier been able to secure a *manera provechosa*. The *pregonero* does not talk to his neighbors, and he has stopped arguing with his wife. If she is unworthy of him, Lázaro does not deserve better.[23] To a disquieting extent, the text undermines maternity and family alike.

The family that gave Lazarillo life "trapped" him into a heritage of

shame, just as the family that Lázaro creates for himself is a source of indignity. The natural is fertile, and fertility is one theme of the first *tratado*. Grain and water exemplify the "great category of the continuous,"[24] which abhors the kind of isolation that settles in at the end of the last *tratado*. Lázaro has neither family nor friends; he loves his wife in much the same way that a parasite loves its host. In fact, love is never mentioned, and the marriage is childless. The three children who do exist, hers from before the marriage, are ignored. Sexual "labor" has been severed from procreation.[25] Lázaro's stepchildren are as orphaned and vagrant as he himself was, back in Salamanca.

Not only in picaresque fictions were marriage brokers singled out for crooked deals. In Toledo Lázaro learns that clergymen have subtler ways of taking care of such matters. Often the fallout from these investments fed literary panegyrics on cuckoldry—*"encomium cornuum."*[26] From a socioeconomic standpoint, Lázaro's wife is both a gift and a commodity. At least insofar as the town crier is concerned, her use value as mother is nil, but her exchange value as the archpriest's mistress is a considerable asset to the town crier. A chasm exists between Lázaro's role at the center of society, where everything passes through his hands, and his marginality as a puny cuckold. In the broader context of Spanish culture, the text brings to the surface aspects of individual and collective pathology. Lázaro's indignities are a mirror of the given order of things. At the same time, the text makes a rhetorical contrast between the economic "exchanging" of values, which is the town crier's business, and the "exchange" of values, which entails moral devaluation whenever the town crier reflects on marital blessings.

In the competitive world of empirical exchanges, assets and liabilities trade places day in and day out. By the time the *Prólogo* is written Lázaro's luck has run out, and the *caso* forces him to link his own life to the social context of the time. The archpriest speaks about *provecho* in prescriptive terms; for the subordinate Lázaro de Tormes, it is Scripture itself. Since he knows that he will not be allowed to confront authority in court,[27] he answers the inquiry from a position of weakness, and it is quite possible that Vuestra Merced may end up accuser, prosecutor, and judge. Readers of Honoré de Balzac will find picaresque precedents for the deep-seated belief that, since everything has a price, there lies a thief in every man and a whore in every woman.[28] In picaresque literature we are shown a "calculating disposition" that anthropologists and econom-

ic historians—from Marcel Mauss to Max Weber—have based on the predictability of the market economy.

Lázaro does not want to call his hard-gained privileges into question, nor does he want to take on the abusive system that sustains his prosperity. He is motivated by the impulse to conform, and he accepts that he cannot transcend his station or his situation. He seeks to profit from the corruption of a society in which relationships are based on convenience rather than fairness.[29] For Lázaro, the cost of success is a direct measure of personal depreciation. His wife is not a real wife, and his would-be benefactors take advantage of him. He cannot prevent others from abusing his name in a city where corruption seems to go unpunished.

In the ungenerous, self-regarding setting of commercial Toledo, folks never tire of reminding Lázaro that he is an outsider. The *pregonero* boasts about the "cut" he gets from business deals, not caring that his boasts could easily stir resentment. When people operate under restrictions and compete for scarce favors, envy can easily unleash the worst in human nature. From Castiglione to Antonio de Guevara, many have written about the need to suppress envy in court and country.[30] In the picaresque setting in which Lázaro survives, do his neighbors fear for the fate of his soul, or are they more likely to undermine his position? Do they want to defend his reputation or do they covet his privileges? By claiming the high honor of artistic excellence, the picaresque author reaches for a higher form of *provecho,* which can also be defined as profit or progress in the sciences, arts, or moral qualities— *"aprovechamiento o adelantamiento en la ciencias, artes o virtudes."*[31]

However marginal on moral grounds, profit keeps Lázaro at the center of the economic network, where he has secured the bureaucratic post—*oficio real*—of town crier. *Real* qualifies a job, but it also refers to coin and royalty. Semantics thus bears on the final reference to the emperor, who embodies an institution as remote as his ghostlike appearance. We can see why the closing paragraph brings together the town crier and the emperor. They are the two extremes of the bureaucracy, and what links them is neither honor nor blood, but reciprocal forms of exploitation. It is revealing that the king is called emperor at a time when the two terms were ambiguously intertwined. The *monarquía española* crossed national boundaries, extending to Italy, northern Europe, and the American territories. At the same time, *emperador* refers to the typical juxtaposition between the Spanish monarchy and the

Roman Empire. Arguably the two terms became identical during the reign of Charles V (Charles I of Spain), who was destined to play a kind of messianic role in the name of the Catholic faith under the authority of the Spanish crown. This led the Castilians to feel superior and arrogant because they saw themselves as the chosen people.[32] By the time Charles abdicated, in 1556, *Lazarillo de Tormes* was published.

Prejudices and pretenses aside, how solvent was the emperor himself? The politics of imperial bookkeeping was not concerned with the multitudes who had to bear the burden of his ostentatious expenditures.[33] But the aristocracy did not worry about the causes of economic impoverishment as long as its privileges were safe. Under these conditions, *Lazarillo de Tormes* emerged as a text representative of poor people who attributed their misery to the proverbial "ways of the world." In the nobles' world of conspicuous consumption, financial troubles were compounded. In fact, they could be traced back to the fourteenth century, when Pedro of Castille first asked the moneylender Samuel Levi for a loan, then knighted him, and finally devised a tax to pay his debt.

<div align="center">IV</div>

In any age, the way things are raises questions about human greed and inequality. The professional motto of a Florentine merchant, Giovanni Morelli, added security to discretion: "First of all, make less, but make it safe"—*"innanzi fa meno, fa tu sicuro."* The mercantile aggressiveness of earlier times was toned down, and prudence took precedence over opportunism in the fifteenth century. The mercantile world was settling down, and adventurism yielded to caution during the sixteenth century. The picaresque *pregonero* took the Florentine merchant's advice to heart; for better or for worse it guided his conduct from the first to the last *tratado*. Whatever the differences and shortcomings, "writers of things" asked questions more or less close to the *verità effettuale*—the materialist truth—of the way things are.

The poet Cecco Angiolieri set old-fashioned inheritance against the new spirit of enterprising activism:

> He without gold in his purse who falls in love,
> Should make himself a gallows and hang betimes,
> For he does not die once, but dies more times
> Than did the one cast down from heaven above.

Now I, and for my sins, am such a one,
A wretch, if there were ever of this sort.
I even lack two pennies to hale to court
The enemy who wrong to me has done.
Why don't I hang me then, and end my tale?
On reason only, and it's vain, I know.
I have a rich, old father. He may fail.
And so I sit and wait for him to die.[34]

The bitter tone of these lines leaves no doubt that money tested the most fundamental of human loyalties.

A modern proverb reminds us that the devil we know is better than the one we do not know. For Machiavelli (1961, 198), "the true way of going to Paradise would be to learn the road to Hell in order to avoid it." As a metaphor, the road to hell cuts through the way things are.[35] On matters of devils and hellish places, Machiavelli wrote many letters about lay wickedness and clerical corruption. His list of unholy friars— Ponzo, Fra Girolamo, Frate Alberto—holds its own with Boccaccio's prelates and Lázaro's masters. But it is doubtful whether Lázaro and Pablos entertained the idea of devils worse than the ones they knew.

Closer to the socioeconomic mindset of the picaresque, Machiavelli (1965, 3:1160) let the working poor be overtly critical of the powerful rich: "Do not be frightened by their antiquity of blood which they shame us with, for all men, since they had one and the same beginning, are equally ancient; by nature they are all made in one way. Strip us all naked; you will see us all alike; dress us then in their clothes and they in ours; without doubt we shall seem noble and they ignoble, for only poverty and riches make us unequal." Lifelong student that he was of selfish motives, Machiavelli found justifications for deception and crim- inality. Actually, his foxy ways find echoes in the picaresque practice of life, which often relied on cunning and intimidation as ways of promot- ing one's advantage.

The Prince roars in the last chapter of *Il Principe*. Although he calls on the emperor and the Holy Ghost, the *pregonero* ends the last *tratado* with a parasitic whimper. The picaresque *Prólogo*, however, proves that the anonymous narrator possessed the skill to outfox the *pícaro*, the *mozo*, and the *aguador*. Only what damns the *pregonero* can save him, as long as he can prove that everybody else is just as damned. That the outcome is

ambiguous is symptomatic of the boundless range of poverty as well as of the elusiveness of profits gained through moral opportunism.

Any equation between "the good" and "the goods" is as wishful in the business of everyday living as that between morality and opportunism is in Machiavelli's debates about *virtù* and political conduct. When the chips are down, so to speak, *verità effettuale* must have the upper hand over *verità ideale*. Whether at court or in the marketplace, the practice of life puts "the good" in a subordinate position. But then again, most of the individuals Lázaro deals with are not like the humane *buenas gentes* whose generosity helps him to heal at the end of the second chapter. Language is revealing. When used as an adjective, *buenas* is a moral qualifier; but when used as a substantive amid the mercantile quarters of Toledo, *buenos* refers to people whose identity is defined by the goods they own.[36] And many of them are to be counted among the clergy.

Since there is no escape from everyday life, picaresque textuality teaches us that we should keep fighting the devils we have known all along. It has been said that sin is the engine of history, and we can add that greed and the pursuit of gain have fueled it since time immemorial. As one of the inventors of sin, the devil who waves the banner of *provecho* should stand at the top of our list of hellish creatures. A historian as well as a storyteller, Machiavelli (1965, 3:1160) lets an anonymous worker address the "poorest of the people" by exposing the despicable nature of profit, all too often defined as that which rich people have snatched "with trickery or with violence." Profit is a word that the wealthy rely on "to conceal the ugliness of their acquisition." Whenever they confront "hunger and prison," people should not have "any fear of Hell." In fact, the most direct way of obtaining "great riches and great power" is by either "fraud or force."

Amid a culture of rogues, merchants, parasites, and beggars of all sorts, picaresque experiences could not but validate opportunistic deeds midway between the pit of survival and the foothills of selfishness. Picaresque and Machiavellian textuality makes it clear that devils can be fought, avoided, and despised; but they are bound to keep roaming nearby. Yet we do not need the devil to remind us that honor and *provecho* seldom are compatible.

The devils we know are in us, and any attempt to avoid *our* demons requires that we build on the strengths and weaknesses of our own

material deeds rather than on abstract ideas. To protect such an outlook, merchants and usurers, Jacques Le Goff (1984) tells us, invented purgatory, where the cosmic time of God and the earthly time of humankind blended together so that the sins of profit could be purged before the soul could enjoy its heavenly rewards. Once spiritualism and materialism exchanged currencies, it was easy for many unforgiven and unforgettable *pícaros* to agree that paradise is likely to be nothing more than the "better" corner of hell.

THE PRICE OF ONOMASTICS

6 · Lázaro de Tormes

WHAT'S IN A NAME?

All subversion, or all novelistic submission, thus begins with the Proper Name.
—*Roland Barthes*

I

Dante was probably right that hell is the everlasting continuation of life on earth. In Dante's inferno it made little difference whether people had lived by generosity or greed; they kept their passions and their names as well. Legions of souls found the lure of *provecho* irresistible, and they paid with eternal damnation.

A new, ungodly, earthbound pride made itself known midway through the sixteenth century. Unlike Dante, the anonymous *Yo* never thought of itself as sixth among the great ones of antiquity. Going beyond pagan and Christian epics, however, the author of the prototypical picaresque text overtook humanist and religious rebirth alike.

Economic factors were so entrenched in sixteenth-century culture that they molded personality, shaped lifestyle, and gave people their very names. Economic achievements in the new age of mercantile adventurism spawned augural names such as *Bonvicinus, Bonaventura, Moneta, Divitia* and *Alegrancia*—"good neighbor," "good luck," "money," "wealth," and "gaiety."[1] A "good" name, in fact, has always been a chief asset on epic and commercial grounds alike.[2] The humanist Leon Battista Alberti (1969, 122) advised parents to choose their children's names carefully: "It seems to me that a graceless name may well have the power to detract from the dignity and grandeur of a man, even if he is an excellent person." Names such as Alexander are "propitious. They somehow add luster to our virtues and our dignity."

For Erasmus (1965, 1:383–84), a person's character should correspond to his name. Yet the very structure of Erasmus's dialogue hinges on the interplay between being and seeming. By and large, exchanges between ancient and modern, pagan and Christian, commercial and spiritual brought to the fore a culture of unprecedented complexity that shattered the medieval unity between the inner and the outer self. "Man"

had become fox and lion, wore masks, played roles according to circumstances, searched for heavenly rewards while praising earthly goods, and often traded one for the other.

Mindful of provocative studies on the relationship between name and person in Cervantine texts,[3] this chapter anchors the onomastic cluster Lazarillo-Lázaro-*pregonero*-*Yo* to concepts of value, exchange, and appreciation that are at once aesthetic and utilitarian. The anonymous author of *Lazarillo de Tormes* locked character and title into an onomastic nutshell that shed light on the text's narrative, stylistic, and philosophical underpinnings. In the pit of socioeconomic exchanges,[4] the semantic allusiveness of onomastics, the science of names, touches on inheritance and originality.[5] Appropriate to the Spanish narrative is Roland Barthes's belief (1974, 82–83) that to read is "to proceed from name to name, from fold to fold." Whether the narratives be epic or comic, aristocratic or popular, names tell stories, and interest in proper names forms a tradition that has spanned the art of writing from the Greek Odysseus to the Irish Ulysses.

On proper names in sixteenth-century Spain, Luis de Léon (1984, 45) wrote, "There are two different forms and manners of names; those which are in the soul and those which are in our lips." Lázaro de Tormes was the name on everybody's lips among contemporary readers of the novel. At the peak of the genre's popularity, Guzmán de Alfarache asked: *"Quieres conocer quien es? Mirale el nombre"* (290)— "Wouldst thou know who this is? Behold his name" (2:33).

The theme of poverty weighs so heavily on matters of identity in the first three *tratados* that Lazarillo's own name acoustically echoes *laceria*. Lázaro-*laceria*-*lacerado* confirms that a character is equivalent to the sound of his name,[6] which is a form of what Jacques Derrida calls "phonetic writing."[7] While it suggests that the boy's name is a matter of public charity,[8] the homophonic association also resonates in the priest of Maqueda's appellative, *el lacerado*.[9] For Arnold Weinstein (1981, 21), the very word *laceria* reminds us that "the self as hunger is a terrifying lens to place on society."

The antiheroic world of the picaresque made no room for individuals whose names resonated with epic grandeur. Between Homer and Joyce, literary characters often bear names that stand out as "opening signals" for reading literary texts.[10] Onomastics thus traces Lázaro's painful journey from *laceria* to *provecho*. His name foreshadows events to come, and the text sets off a quest that is both name-giving and name-denying.

II

The text opens at the site of Lázaro's birth, which is as much a part of his identity as the name itself:

> Pues sepa Vuestra Merced, ante todas cosas, que a mí llaman Lázaro de Tormes, hijo de Tomé Gonzáles y de Antona Pérez, naturales de Tejares, aldea de Salamanca. Mi nascimineto fue dentro del río Tormes, por la cual causa tomé el sobrenombre; y fue desta manera. (12–13)

Well, first of all Your Grace should know that my name is Lázaro de Tormes, son of Tomé Gonzáles and Antona Pérez, who lived in Tejares, a village near Salamanca. I was actually born on the River Tormes and that's why I took that surname and this is how it all happened. (25)

The river Tormes and the village of Tejares blend into a place of origin that is anchored to the *fact* of being born somewhere. From Tormes and Alfarache to Salamanca and Toledo, the picaresque sense of place bears heavily on the cultural symbolism of the novel.

Once the family breaks down because of Tomé's imprisonment, Antona and Lazarillo move to Salamanca along the river Tormes. This geography points to the biblical account of Moses abandoned to the river, and to Romulus and Remus, the mythic twins whose destiny was to found Rome after being rescued by the river. While archetypal references point to legendary feats, the picaresque brought to the fore people who toiled for their survival day in and day out. Literally, Lázaro was born in the river—*"dentro del río,"* which is a no-place. Tejares and Tormes thus set up the basic opposition between river and land, flux and stability. The "fluvial" current destines Lazarillo to experience "mobility," and the text unravels the journey of a youth that runs against the current. It is not by accident that the *Prólogo* closes the narrative by praising those who

> Con fuerza y maña remando salieron a buen puerto. (11)

Have triumphed by dint of hard work and determination. (24)

As he rows skillfully in dangerous waters,[11] the *mozo* takes advantage of the "liquidity" of fast-moving coins in the first *tratado*. Likewise, the writer invests in a novelistic coinage that may turn out to be as valuable—*bueno*—in invalidating the indictment as "goods" are in empowering "good people"—*"los buenos."*

Lázaro's *adversidades* begin where he is born, a place where puny deeds bespeak his father's shame. Lázaro remembers Tormes only because people remind him of it. When the archpriest warns "Lázaro de Tormes" not to lose sight of his *provecho* at the end of the narrative, location identifies the town crier as an outsider. His material luck remains precarious in Toledo, where his birthplace suggests his inferiority. If one thinks of the proper name as a composite "milieu" of layered meanings,[12] Tormes stands out as the initial place-name against which Lázaro will contend for the rest of his life. Since the status of outsider best qualifies him for the job of town crier, it would seem that places as well as people have standards of "geographical lineage" to uphold. Genealogically speaking, one expects the boy to be named after his father, Tomé Gonzáles. By tradition, many infants were—and still are—given names meant to continue the family lineage.[13] But Lázaro's main task is to sever the time line of independent progress from the family line of conformity and inheritance. In his case, echoes and similes set exemplary models in the past, which is stained. Once the indictment is launched against him, the *pregonero* develops a strategy whereby everyone else's past turns out to be as murky as his own. Moral concepts of social justice are out of currency, and Lázaro sets out to defend himself by proving that honor and dishonor are two sides of the same coin. Thus he rereads the past by merging heroism with criminality.

Because he stole grain, Tomé was tried, convicted, and sent to prison, from which he was freed to serve a knight in the war against the Moors. Interested as he is in redeeming his father's reputation, Lázaro tells us that he died like a loyal servant. Yet "like"—*como leal criado*—suggests a false association, because it is not at all clear that Tomé joined the army voluntarily. In fact, warnings against false heroism were common. "As the sea washes away all the sins of mankind," Erasmus wrote (1965, 1:431), "so war covers over the dregs of every crime." At the level of family chronicle, Tomé's "redemption" foreshadows the rebirth of his own son as a narrator who gets to tell his father's "better," if not "truer," story.

Such a forceful rereading of past events was probably meant to warn Vuestra Merced that the town crier could "reconstruct" facts to his advantage. The "soldier's story" could be a prelude to the *pregonero*'s own. While the town crier endured the indignities of impoverished existence, Lázaro the writer took an assertive stance and made a case on his own behalf. Vuestra Merced wrote to a *pregonero,* but the answer he

received came from a person whose intellectual sophistication had been vastly underestimated.

People keep their names in the first *tratado,* and every character that bears one faces toil (Antona), punishment (Zaide), or doom (Tomé). While Lázaro's stepbrother disappears, Antona trusts her son to a *ciego* who reassures her that he will take care of him *"no por mozo sino por hijo"*—"as his son not just as his boy" (22, 27). The filial appellative— *hijo*—is meant to appease her maternal concerns. Antona's natural child will be the *ciego*'s "adopted" son. Once she leaves, however, the old man abuses the boy cruelly. Having smashed the boy's head against a stone bull, the *ciego* tells Lázaro,

> *Aprende, que el mozo del ciego un punto ha de saber más que el diablo.* (23)

> You'll have to learn that a blind man's boy has got to be sharper than a needle! (27)

The filial *hijo* has been replaced by *mozo,* or lowest kind of dependent servant. Lázaro knocks his head against the harsh reality of his functional name before knocking it against the bull post. From then on, the boy's growth oscillates between amelioration in terms of "what" he is, and degradation with regard to "who" he is. Deceptions are pervasive in the world of the picaresque, to which one can apply the proverb, *"No hay prudencia que resista el engaño"*—"no wisdom can withstand deceit." Yet the boy masters what has been called social cunning—*negativismo social*[14]—and grows up to outwit his master.

III

The title *La vida de Lazarillo de Tormes y sus fortunas y adversidades* confronts readers with a contradiction. *Vida* refers to the entire life, and the blind man instructs his *mozo* in a *carrera de vivir* that unfolds through a series of *fortunas* and *adversidades.* But why the diminutive *Lazarillo?* Why not the adult Lázaro, who is after all the subject of the book?

Only the *ciego* uses the diminutive (in a passage in which he tastes turnips instead of sausages): *"Qué es esto, Lazarillo?"* (39). The boy's name is belittled in the context of picaresque "outwitting." If we keep in mind that the *ciego*'s prophecy about horns came true, we can infer that Lazarillo has grown to manhood, only to become Lazarillo all over again, a helpless boy who cannot control what happens to him.

Cervantes often used diminutives. Don Quixote meets a famous man who has been condemned to ten years in prison. Two conditions of life are pitted against each other: "This fellow is the famous Ginés de Pasamonte, alias Ginesillo de Parapilla." Here too the diminutive is tagged to a form of social "demotion"; Ginés has become Ginesillo. The galley slave reacts angrily, "One day somebody may learn whether my name is Ginesillo de Parapilla or not. . . . I'll stop them calling me that or I'll pluck them" (I, 22). His autobiography will bear the title *La vida de Ginés de Pasamonte.*

Often noblemen took on assumed names. After his first sally, Don Quixote unabashedly proclaims: *"Yo sé quien soy"*—"I know who I am." But this proclamation comes just after he has assumed a new identity, one that he relinquishes later on. The *hidalgo* Quixada (or Quesada) holds Don Quixote responsible for his madness. In the end, he recovers his sanity together with his old name, which, however, wavers between Quexada, Quijano, or Quesada; and so does his Ariostesque model, whom he calls "Roland, or Orlando, or Rotolando" (I, 25). The simple-minded Sancho has no such quandary: *"Sancho nací y Sancho pienso morir"*—"Sancho I was born, and Sancho I expect to die" (II, 4). Actually, names seem to slip by under Cervantes's pen; one can grow in and out of the same name. Onomastic instability is part and parcel of human identity.

"Borges and I" have always been two for the Argentinian writer, and when people in the street asked him whether they ever were one, the answer was, "At times!"[15] But Lázaro de Tormes does not have that choice, because Toledans know what his name has always been. Whether he likes it or not, he will always be Lázaro "from" Tormes. The verbal structure of names parallels the shape of human experience.[16] In a way, to write a name is to narrate a destiny; to acknowledge that Lázaro yields to Lazarillo in the title of the work is to accept belittlement as a verbal sign of self-punishment. From Lazarillo and Pablillos to Guzmanillo, the picaresque novel uses diminutives to affirm the ordinariness of its characters.

Italian *novelle* constitute a direct precedent to the picaresque in the equally secular world of the *Decameron,* where diminutives also point to personal traits. Andreuccio (Little Andrew, II, 5) is a young man who travels from Perugia to Naples in order to buy horses. By evening, his money is stolen, but he succeeds in taking a ring of equivalent value

from a dead bishop. Having survived the Neapolitan ordeal, he returns home next morning. This brief but "educational" experience destroys some of his naïveté. Here the diminutive suggests the immaturity of youth. Presumably Andreuccio will grow up and be called Andrea (Andrew), but the era of the novel had not yet arrived. We do not know whether Andreuccio ever became Andrea, but we know that Lazarillo outgrows his diminutive name by the end of the last *tratado*.[17] Its reappearance in the title is as relevant as every other detail of the novel. By giving life to a materialist *pregonero,* the novelistic *vida-Bildung* "deconstructs" onomastics and makes the proper name less valuable.

Centuries later, life at the lowest level of existence found literary expression in Realism and Naturalism, in the work of Dickens, Zola, and other nineteenth-century writers. Writing about Balzac's *Old Goriot,* Victor Brombert (1988, 19) says that the name Goriot is "distinctly plebeian and even vulgar (*goret* means young pig)," for it points to "a mimesis of very ordinary life, associated with realistic intentions." The Sicilian Giovanni Verga likewise highlighted the reality-based poetics of *Verismo* through novels and short stories whose titles are emblematic of their contents.

In terms of picaresque lives at the edge of survival, the *novella* "Rosso Malpelo" (from Verga's collection *Vita dei campi,* 1880) introduces a mean boy who faces long odds. The title refers to the youth's nickname, which describes a physical feature with moral implications. *Rosso* means red, and *Malpelo* means "bad hair": "He was called Malpelo because he had red hair; and he had red hair because he was a mean and bad boy, who promised to turn into a first-rate scoundrel. So everybody at the red-sand quarry called him Malpelo; and even his mother, having always heard him called by that name, had almost forgotten his real one."[18] The name is the character's fate inasmuch as red hair was believed to be a sign of evil in parts of Sicily. Like the picaresque text, the *verista* narrative begins with the protagonist's father's demise, and the middle section dwells on Malpelo's contemptuous behavior toward people and animals. The picaresque imagery of mouse, snake, and wolf is expanded in the Sicilian narrative. Malpelo's father dies like a rat *(sorcio)* buried under an avalanche of red sand, and a crippled companion is called *Ranocchio—* frog. At the end of the story, Malpelo disappears into a mine, never to be seen again.

Having been abused, the underdog in turn has become abusive. Even

the poor can be despicable, and Malpelo is so bad that the place where he lives takes his name: *la cava di Malpelo*—the quarry of Malpelo. Darwinian at heart, Verga's environment leaves no room for development or complexity. Malpelo is bad through and through; like Lazarillo, he is a product of his environment. In picaresque terms, he is one of the many *pícaros* who does not get away. In fact, Verga conceived of his major narratives as a cycle about vanquished people—*ciclo dei vinti*—who had been forever trapped by an inscrutable fate.

Among the working classes, growth has a way of merging identity with function; "picaresque" as well as "naturalist" workers tend to be what they do. Lázaro takes the name of his deeds when he becomes *pregonero*. This appointment is his social "rebirth" as *hijo de sus obras,* which entails a life of service.[19] The roles of servant, water carrier, and town crier involve menial everyday tasks that stand in opposition to heroic exploits. While proper names are inherited, common names grow out of life's experiences.

Given such a cultural framework, *pícaro* and *picaresque* "named" the lifestyle of a social enclave, the onomastics of a popular type, and a new literary genre. Because the diminutive builds and undercuts the narrative from beginning to end, it is inevitable that proper and common names, that is to say, *mozo, pregonero,* and Lázaro de Tormes, are bound to be, by turns, assets and liabilities. Antonio Nebrija sorted out common from proper names by means of *calidad.*[20] The meaning of Lázaro's name is very much in the balance. He is a man without innate qualities, a kind of sponge that absorbs its environment. If the narrator can convince Vuestra Merced that he is *a* Lazarillo, that is to say, a social type, his case will be strengthened.

The title tells us that Lázaro cannot be severed from fortunes, adversities, and Tormes itself. They weigh him down and erode his *buena fortuna.* The narrator calls his book a *nonada.* As a "nobody," he anticipates a fundamental strategy of realistic fiction meant to transform individual guilt into collective responsibility, which can be traded just like a commodity.[21] Lázaro can take pride neither in his own ancestry nor in his nation's heritage. Given the fact that so many *conversos* felt themselves outsiders in their own country, the *pícaro*-turned-writer sketches a picture of a society in which pride in names has been lost. His critical posture calls to mind the second *tratado,* in which the priest's beating is so severe that Lázaro, like Jonah, spends three days in the belly of the

whale. The biblical reference is physical as well as moral. Jonah prophe-
sies divine wrath against the sinful city of Nineveh (Matthew 12:38;
Luke 11:29). Because he is convinced of God's mercy, Jonah does not
actually believe that punishment will be delivered, but he hints vaguely
of doom.[22] Lázaro does even less than this in lawless Toledo. And in fact
neither Jonah nor Lázaro has the means or capacity to effect social
reform. Like the valorous soldier in the *Prólogo,* the "better" Lázaro
scales the ladder of fame, but he probably does not live long enough to
hear about it.

IV

The rise of individualism in the early modern era saw the denial of
names as an indication of social inferiority, and we can understand why
Lázaro refuses to give names to his masters and employers. Giambattista
Vico tells us that *nomen* in Latin and *nomos* in Greek signify law. "In
French, *loi* means law, and *aloi* means money" (*The New Science* par.
433). Onomastics thus implies some form of legitimate recognition that
includes an economic dimension. The picaresque ethnic acknowledges
that law and money have been intertwined since time out of mind—in
ways lawless as well as lawful. In terms of the picaresque, the author's
use of names is mirrored by the indignities that plague his protagonist.
In sixteenth-century Toledo, the "stoning" of the constable makes it
clear that lawful authority is at risk.

Although his economic lot and social standing change, Lázaro de
Tormes is stuck with a name that is somehow disjointed from what he
has become. But his anonymity makes it possible to gain freedom from
himself as well as from everybody else. By and large, anonymity points
neither to accidents nor to omissions, but to an essential aspect of liter-
ary reality. Toledans put Lázaro de Tormes on trial by resorting to
mousetraps, whispers, and rumors that bridge the gap between the *trata-
dos* and the *Prólogo.* The city of commercial transactions is a milieu to
which Lázaro belongs yet does not; he is at once inhabitant and exile.
Classically speaking, the integrity of naming finds validity in the city,
where people live, do business, trade knowledge, and sell commodities.
In the city the humanist myth of man as a socially integrated citizen is
enacted.[23] Lázaro's relationship to Toledo is quite different. As a *converso,*
his civic identity is peripheral; as a cuckold, he is socially laughable; as

the object of an indictment, he is vulnerable; as a narrator, he is about to tell a controversial story.

Narrative precedents suggest that empowerment affects the acquisition of names, much as their denial entails dispossession. When characters lose their names or do not know what to call themselves, a potentially tragic situation is created.[24] Loss of name implies loss of personality; anonymity is an extreme case of onomastic denial. Because the impending *caso* may entail punishment, Lázaro denies his origins and claims an artistic rebirth in the hope of avoiding humiliation and social disgrace. He declares himself worthy of his neighbors, although, according to Don Quixote, "no man is worthier than another unless he does more than another" (I, 18). Having done more than his neighbors, the town crier is about to become a better "other." Anonymity proves to be a viable alternative in a social milieu where nothing—and nobody—can slip by.[25] Given the miserable existence he has to endure, will the "resurrected" Lázaro-Lazarus keep his name? Whether Lazarus or Adam, can anyone fall or be reborn without changing his name? Can anyone change his character without also changing his name?[26]

By his own choice, the picaresque narrator puts himself on trial in the world of art, and thus becomes a witness for the prosecution. The outcome of the *caso* will not be printed; the narrative does not reach closure, and readers are left to guess. A self-proclaimed *nonada,* the text stands out as an outcast that asserts its currency while tampering with convention. Yet picaresque sequels have proved that Lázaro's unfinished project was a valuable investment. The intricate and sometimes antithetical relationships that bind character and narrator as they are, as we perceive them, or as they let themselves be approached, cover the range between heteronymity and anonymity. We confront the paradox of a notorious namelessness that exists in the hiatus between Lázaro and *Yo, Tormes* and the book.[27] In that gap, as Jacques Derrida (1986, 10) put it, "the one who names, de-names—the great denominator officiates very close to the scaffold."

Because of the indictment, Lázaro de Tormes may be about to suffer punishment, which turns onomastics into a form of thanatography. The text can be read as explanatory as well as subversive. It introduces Tormes and leaves it behind, just as it praises Toledo only to shame it. To that effect, writing plays a crucial role in Lázaro's story. Having made a crucial shift in the matter of artistic creation, modern literary

works have claimed the right to kill their authors. To an extent, the indictment at the heart of *Lazarillo de Tormes* can execute that task literally and symbolically.

Paradoxically, onomastic suicide engenders a rebirth of sorts; somehow Lázaro the *pregonero* has to die before Lázaro the narrator can see the light of day. If we take artistic creation to be an act of rebirth, could the picaresque author sign his name without falling prey to the burden of onomastics all over again? The pronoun *Yo* thus enacts a rhetorical strategy of concealment and exposure.[28] Since people harp on Lázaro's bankrupt morality until the *caso* threatens to discredit him,[29] the narrator finds it more convenient to exchange his name for namelessness. Only through anonymity can the *Prólogo* assert familiarity with Pliny and illustrate the Ciceronian dictum that "honor encourages the arts."

Lázaro's rebirth into literature does not proclaim the glory of a new name, but it does make a case against the retention of old ones. Because the picaresque *tratados* exploit the chasm between expectation and result, onomastics points to the facts of poverty as well as to the pretensions of wealth. Social and artistic priorities are drawn together:

> *Suplico a Vuestra Merced reciba el pobre servicio de mano de quien lo hiciera más rico si su poder y deseo se conformaran.* (9–10)

> I beg Your Honour to receive this little gift from the author who would have written it better if his desire and skill had coincided. (24)

Suplico describes an act of begging that takes author and reader back to the adolescent *mozo,* who so toys with the assets and liabilities of religion that neighbors call him *pecadorcico,* a term that alludes to sinners and rascals alike. The benevolent appellative *"niño inocente"* is bound to become obsolete, because the adolescent Lazarillo of the first *tratado* is no longer "innocent" by the time he mixes name with title. What finally emerges is the prosaic story of an average man's fortunes and adversities.[30]

Anonymity also wedges a hyphen between "auto" and "biography." Literary and biographical spaces, as well as aesthetic and historical realms, converge, overlap, and drift apart.[31] To quote Paul de Man (1984, 68–69), "we assume that life *produces* the autobiography as an act produces its consequences"; but we could as well assume that autobiography may produce and determine the life. Whatever the writer does is governed by "the technical demands of self-portraiture," which empha-

size self-determination at the same time that Vuestra Merced's indictment curbs self-confidence. Readers of the picaresque confront an autobiographical act meant to withstand social pressure and moral deviance. The autobiography of a single individual is set against, and tied to, a trenchant biography of society; and Lazaro's task is to blend one into the other. After all, the *pregonero* wants to become a *hombre de bien* more or less "like" the city folks he admires. As a writer, however, his models fall outside the culture of the time.

To what extent, one might ask, is the anonymous writer "like" Lázaro de Tormes? Finally, anonymity exemplifies an attempt to erase the blemishes of the past. Yet Lázaro cannot legitimize himself any more than he can legitimize the literary form he brings to life. The narrative thus raises self-defeating expectations:

> *Yo por bien tengo que cosas tan señaladas, y por ventura nunca oídas ni vistas, vengan a noticia de muchos y no se entierren en la sepultura del olvido, pues podría ser que alguno que las lea halle algo que le agrade, y a los que no ahondaren tanto los deleite. Y a este propósito dice Plinio que "no hay libro, por malo que sea, que no tenga alguna cosa buena;" mayormente que los gustos no son todos unos, mas lo que uno no come, otro se pierde por ello, y así vemos cosas tenidas en poco de algunos que de otros no lo son.* (3–4)

> I think it's a good thing that important events which quite accidentally have never seen the light of day, should be made public and not buried in the grave of oblivion. It's possible that somebody may read them and find something he likes and others may find pleasure in just a casual glance; and as a matter of fact, Pliny says there is no book, however bad it may be, that doesn't have something good about it, especially as tastes vary and one man's meat is another man's poison. (23)

At this stage of personal and artistic maturity, the authorial *Yo* heightens and debases himself. The *Prólogo* thus upholds the Spanish mode of *hacerse* and *deshacerse* by keeping the pronoun at once assertive and reticent.[32] Anonymity in literature can be filled neither with names nor with signatures; only the nameless *Yo* can authorize the book.[33] In the words of the modern poet, he can rejoice:

> Que alegra más alta:
> vivir en los prenombres!

What higher joy
To live in pronouns!
(Pedro Salinas, *La voz a ti debida,* 1933)

v

Once he asks the Toledan *pregonero* to clarify his situation, Vuestra Merced assumes that he will receive a written note whose form and content ought to reflect Lázaro's presumed lack of formal education. Vuestra Merced thus intends to show Lázaro in a bad light. But the document he receives astonishes him; it is unlike any literary form he has seen before. The anonymous *Yo* thus highlights an economics of the mind that was bound to yield unforeseeable dividends. In a way, econopoetics spells out the development of Lázaro's *buena fortuna* along the etymological variations of the word *pretium,* which is at the root of both "price" and "praise." To gain praise, the writer renounces his own name and starts his own defense by giving back to neighbors, employers, and superiors what they have given him; his *laceria* is everybody's misery.

By denying names, the authorial *Yo* denies much of life, as much of it as people deny him by calling him Lázaro de Tormes. Since any "achieved" identity harbors the seed of its own subversion,[34] Lázaro-Lazarus has to die before he can be reborn to *pretium* as a measure of fame rather than infamy.[35] Ironically, individualism reaches its greatest intensity when the author declares anonymity, which salvages literary value from an array of dehumanizing hostilities.[36]

If proper names are erased and authorial signatures become impossible, the authorial *Yo* is rewarded with the knowledge that his work can be bought, read, and praised. To that extent, literary creation is imbued with negative idealism, of a kind that takes readers back to the biblical symbolism of ultimate indigence.

7 · Will Lazarus Ever Be a Wage Earner?

Most human labor is a labor of Sisyphus, and the people are not aware that it is merely
a pretext for giving them their daily bread, not as their own, but as something belong-
ing to the giver, who mercifully allows them to earn it.
—*Miguel de Unamuno*

I

Once the themes of indigence and onomastics are drawn together,
Lázaro immediately calls to mind the biblical story of Lazarus, who
is deprived of health as a leper and of wealth as a beggar.[1] As a prototype
of human affliction, Lazarus is the negative counterpart of the healthy
man who performs deeds worthy of moral praise and materialist
rewards.

The idea of improvement is anathema to Lazarus, so much so that
Jesus, who was born the poorest of the poor, chose him as the recipient
of a miraculous resurrection which did not change his lot. What, then,
did happen to the quality of his life? Did he rise to a more human level
of existence or did he fold back into the same life of utter privation? As
far as we know, the gift of a second life did not change his utter destitu-
tion. Lazarus-types warn poor people that, by comparison, they have
something to be thankful for. His destitution was typical in a society
where the majority of people were culturally and economically
deprived.

The story of Lazarus echoes that of *laceria,* which brings us to Lázaro's
own name. Antona uses the word *hijo* when she gives her son away, but
it is strangers who give the boy—*"a mí llaman"*[2]—a name that draws on
communal experiences of indigence.[3] For it is among the poorest social
enclaves that people are familiar with the ranking name in the index of
destitution. In Romance languages, to be a *Lázaro* is to be poor. The
popular phrase *"Lázaro existia antes que Lázaro"*—"Lázaro existed before
Lázaro" speaks to the timelessness and ubiquity of poverty. Emphasis on
the priority given to names over family suggests the kind of "collective"
liabilities on which the *pregonero* will base his defense.

The medieval synonym for leprosy was *lazar.* The kindred noun *laz-
zari* was coined in Naples around the middle of the seventeenth century.

Lazzaretti were leper-houses where beggars found shelter. In the leper two aspects of social pathology merged into a single figure.[4] Leprosy is a manifestation of poor physical health in much the same way that begging is a sign of financial hardship; both point to the marginal economy of alms.[5]

<center>II</center>

Lazarus the beggar neither rejects nor improves his lot, and nobody helps him to do otherwise. In his case, the miracle of rebirth is strictly biological. Of course, there are miracles and then there are miracles. In their secular guise, some take the form of gifts, dispensations, and *largitio*. But they all uphold inequality, so much so that the Greek word *dosis* defines the act of donation as well as a lethal potion. When it comes to people who are out to improve themselves, their families, and their society, the materialist value of Lazarus-like resurrections may be irrelevant, since the gift of a second life on earth "resurrects" Lazarus neither to wealth nor to learning.[6] Picaresque narratives exposed the cultural forces that have always been responsible for enforcing socioeconomic forms of leprosy and *laceria*.

Miracles are gratuities whereby things are obtained without effort. Exceptions to the given order of things, miracles engender neither revolution nor reform. Instead, they call for prayer, which stakes out an investment in chance whose odds are quite exceptional. In that sense, the distinction between the miraculous and the parasitic is either an act of faith or an act of convenience. A medieval legend has it that Lazarus spent the rest of his days fearing death all over again.[7] The implication is that birth bestows the gift of life, but name-giving warns not to expect much from it.[8] If there is truth in the assumption that every "nomen" conceals an "omen," the Lázaro-Lazarus symbolism upholds themes of pain and privation that grew to prominence in picaresque onomastics.[9] Unlike his Christian homonym, the *pregonero* gives up begging at the rich man's door, where the archpriest offers him a job and a wife. Perhaps Lázaro has grown to believe that he can conquer his own name, even though his pursuit of a better future is more fraught with danger than he can foresee.

To the starving, the gift of food is miraculous, even though it does not solve the problem of hunger. In the last *tratado* of the picaresque novel, however, the archpriest's "gifts" help a lot because they are not spurious, and the *pregonero* lists the gratuities he receives:

Y siempre en el año le da, en veces, al pie de una carga de trigo; por las Pascuas, su carne; y cuando el par de los bodigos, las calzas viejas que deja. (131)

Every year I get a whole load of corn; I get my meat at Christmas and Easter and now and again a couple of votive loaves or a pair of old stockings. (78)

Ironically, the regularity of these gratuities makes his subordination ever more burdensome. Charity is not the same thing as justice. Then as now, many preached but did not enforce Christian doctrines of social justice. In the marketplace of selfish interests, the *ciego* makes of faith a source of income, while the *buldero* counterfeits religion altogether. Some Christian accounts can be read as juxtapositions—valid in the Renaissance and thereafter—between the Christianity of the poor and the Catholicism of the rich—*cristianismo de los pobres* and *el catolicismo de los ricos.*[10]

Scholars have pointed out that *población ociosa* singled out people who were physically incapable of earning income—*mutilados, enfermos, desplazados.*[11] At the same time, a body of moralistic writings insisted that whoever was healthy enough to work could not be called poor and distinguished between the native poor, the deserving poor, and the rural poor, among other categories.[12] Impoverishment forces people to offer their services for the lowest wages, and it has always been the rich man's choice to exploit the cheapest source of labor. Inevitably, economic stagnation fosters cultural immobility in a society where poverty and wealth are the result of meager harvests, despicable friars, a parasitic bureaucracy, and deals at once profitable and dreadful. In Toledo as everywhere else, the fact of poverty failed to inspire the powerful to make amends.[13] At the edge of survival, underpaid work was still better than no work at all, and the picaresque narrative sketched landscapes of utter destitution where any job that made survival possible was a blessing.

Beggars and *pícaros* aside, it was imperative that the lower classes not be exposed to the idea that there could be life without hunger. Above all, the poor were to believe that life was worth living even if one could never escape indigence. As Cervantes wrote, "Holiness consists in charity, humility, faith, obedience, and poverty." Indeed, the heart of the Christian message was that acceptance of one's lot in life, however miserable, could be redemptive. As Cervantes put it, "He must indeed be

possessed of much godliness who can be content with being poor" (*Don Quixote* II, 44). Christian dogma told the poor that their deprivation on earth, provided they accepted it faithfully, would be rewarded in heaven. Earthly trials were in fact blessings. Priests and economic masters both called on the poor to obey the "given" order of things. In his Counter-Reformation *Treatise on Tribulation* (1589), Pedro de Rivadeneira described human miseries as "treasures of inestimable value" and "the gentlest of fruits." This message was as blatantly manipulative as it was typical of an aristocracy that did not collapse under the weight of its own foolishness only because it had the power to enforce its political rhetoric. The politics of privilege were paternalistic, and a long tradition of Christian belief and rhetoric upheld the idea that poverty was virtuous and wealth evil. Economic equity was rarely pursued, however; and when the question was raised, the answer remained inconsequential. Erasmus (1963, chapter 35) warned: "Are you, as a follower of a penniless Christ and one called to a far more valuable possession, going to gape with awe over the importance of stuff every pagan philosopher scorned? Not to have wealth but to rise above it—this is greatness. But the vulgar—Christian only in name—contradict me and rejoice in adroitly deceiving themselves." The clergy exerted little effort against the direct and indirect benefits that ensued from new forms of productivity. Moralistic sermonizing against greed was often a front; what was condemned in principle was accepted in practice.

Begging and the giving of alms produce neither wealth nor surplus value but merely perform a ritual function at the margins of society. The meek may inherit the heavenly kingdom, but on earth they can barely survive. As popular wisdom had it, *"llamarse Lázaro ya era una predestinación"*—"to be called Lázaro already was a matter of predestination." In terms of onomastics, this popular phrase inspired much picaresque narrativity. Like Guzmán, who called himself a *pícaro* and was entirely his own master during his days as errand boy, Lázaro de Tormes proved that poverty could not be overcome without loss of freedom. The achievement of affluence calls for compromises, and Lázaro's freedom is most restricted during his stint as a prosperous town crier. In that position he learns that bureaucracy imposes codes of conduct that limit one's freedom.

Quevedo compared Lazarus to Pablos Buscón inasmuch as both smelled. The physical analogy is degrading. Once he is smeared in

human waste, Pablos becomes the butt of a joke. The humiliating ordeal leads him to draw a lesson:

> *"Haz como vieres," dice el refrán, y dice bien. De puro considerar en el, vine a resolverme de ser bellaco con los bellacos, y más, si pudiese, que todos.* (49)

> "When in Rome, do as the Romans do," says the proverb, and how right it is. After thinking about it I decided to be as much a tearaway as the others and worse than them if I could. (112)

Perhaps the time had come for Lázaro, Pablos, and their heirs to bury the Lazarus legacy once and for all.[14] The resurrection of one wretched soul did not correct the painful marginality of the poor. And the last thing one could ask of them was to wait for a miracle to change their luck. Miracles aside, would Lázaro ever sign a contract? Would he ever be the subject of financial exchanges?

The genealogy of human archetypes has given us Sisyphus, the mythic pagan who is punished with eternal labor. By pushing the rock beyond the bounds of life itself, Sisyphus resists the ruthless powers of *Fatum,* and Alemán links his doomed efforts to the troublesome ascent of his picaresque character:

> *Y ya en la cumbre de mis trabajos, cuando había de recebir el premio descansando dellos, volví de nuevo como Sisifo a subir la piedra.* (822)

> And being come now to the height of all my labours and painestaking, and when I was to have received the reward of them, and to take mine ease after all this toyle, the stone rolled downe, and to fall afresh to my worke. (4, 220)

Since it points to efforts without results and immobility within mobility,[15] much picaresque narrative falls under the aegis of the mythic character. Sisyphus's rock represents the heavy burden of materiality. In its picaresque mode, poverty is just as burdensome for Guzmán:

> *A nadie debe y a todos pecha. Desventurado y pobre del pobre.* (437)

> He is Debtour to none, and yet must make payment to all. (2, 262)

No reasonable justification is offered for such a state of things.

Albert Camus (1955, 88–90) wrote that Sisyphus "became the futile laborer of the underworld," and his whole being was "exerted toward

accomplishing nothing." In a way, the *pregonero* is a kind of futile laborer in Toledo, where his modest achievements are always vulnerable to loss. Like Sisyphus, he reaches the point where "the lucidity that was to constitute his torture" crowns "his victory" as well. Willful self-exposure dignifies one's shortcomings, for no fate can be "surmounted by scorn." Although his struggle is bound to remain fruitless, Sisyphus finds freedom in being fully aware of the futility of his effort. He knows that he can never become a deity, and Camus calls him the "proletarian of the gods."

<p style="text-align:center">III</p>

In ancient times and modern, in East and West alike, the well-being of the toiling masses has always been subordinated to the privileges of the few. Instead of securing peaceful coexistence, the distribution of work among humans has stirred deadly conflicts. In a way, Cain had to kill Abel before he could move out of myth and walk away with the other stealers of fire. Theirs was yet another chapter in the story of humankind's fall from the work-free bliss of Eden. Cain is the founder of the city and the state, which are the children of wealth and war. Civilization began "on the day on which one man, by subjecting another to his will and compelling him to do the work of two, was enabled to devote himself to the contemplation of the world and to set his captive upon works of luxury" (Unamuno 1954, 280). Civilization itself is a Cainite enterprise, and one might argue that warrior-heroes and merchant-patrons have always lived at someone else's expense. For Unamuno (1976, 287), "envy is a thousand times more terrible than hunger, because it is spiritual hunger. If what we call the problem of life, which is bread, were resolved, the Earth would turn into hell, because the struggle for survival would break out with greater force." As a form of hunger, aggressiveness could turn, as indeed it has, parasites into assassins.

Popular legend tells us that Abel enjoyed privileges that were then extended to kings and aristocrats. Adamic and Abelite bliss still prevails where humankind lives at peace with nature. Christian and other religious myths also hold that such a "privileged" condition will be restored in the Promised Land, where goods will be for the taking. Like Abel, most *pícaros* and *pícaro*-like wretches were sacrificed to the "better" society that ploughed those "better" grounds of urban living that have been celebrated in "great men" historical narratives.

But the *caso* launched against the *pregonero* proves that disguised forms of utter subordination can stir some people to reflect on human excellence, social appearances, and literary standards. While remaining in the eye of God, Lázaro trades spiritual for secular deities. And he survives because the "curse" of work is a punishment as well as an opportunity. Once he secures the job of *pregonero* in the last *tratado,* Lázaro becomes one of those who leave marks on "popular culture" but cannot share in the privileges of "high culture."

To improve the lot of humankind throughout the Golden Age, it would not have been enough to multiply the loaves and fishes. Wages, not handouts, were what was needed, contracts of exchange, not alms. Patience and resignation only propped up the status quo, only strengthened the social and economic divisions that kept one class under the yoke of another. Charity and "miracles" are escape valves that substitute one form of subservience for another.

The real miracle will occur when ordinary people rise up against the system that holds them down, but this will not happen until the Lazarus mythology is turned around. Instead of waiting in poverty for the false promise of another life, people must improve this life by creating systems of production and distribution that will allow them to become wage earners. History teaches that neither religious miracles nor political charisma are a panacea, especially when our collective welfare hangs in the balance. If fairly rewarded, steady work and honest *provecho* remain the best vehicles for redemption. The *caso* forces Lázaro to bring up the underside of his success, but it also gives him a critical perspective on his own endeavors. By definition, heavenly epiphanies are the exception that prove the rule. But Lázaro's ability to raise his standard of living and educate himself is a sort of self-made miracle. The street smarts that he acquires in the academic city of Salamanca yield to the literary sophistication that he is forced to reveal in Toledo, the city of business, when the *caso* against him puts his *buena fortuna* in jeopardy. As a writer, Lázaro is reborn to a better life, a life of values at once humane and humanistic.

DIVIDENDS OF THE MIND

8 · The Cost of Education

A TALE OF TWO CITIES

Who taught Lázaro to write?
—*Peter Dunn*

I

Anumber of years intervene between the end of the last *tratado* and the *Prólogo* of *Lazarillo de Tormes*. During that interval, we must infer, much literary education took place in the house next door to the archpriest's, for the text is not explicit in the matter of Lázaro's schooling.

When did Lázaro learn to write? We surmise that the linear progression of the narrative stands in counterpoint to a subplot that includes a clandestine education. The town crier's growth is more extensive than the text itself suggests. The narration unfolds on the written page as well as in the unwritten gaps between episodes. It is in those gaps that the *pregonero* leaves behind the chivalric deeds of Amadís and the Boccaccesque ordeals of Andreuccio da Perugia. Indeed, the Salmantino *mozo* became a writer in Toledo.

Having left Salamanca, the most prestigious seat of Spanish learning, behind,[1] Lázaro proves that the education available in Toledo, the city of business, is more substantial than Vuestra Merced or anyone else suspects. From nine to five, the town crier performs commercial transactions, suffers moral indignities, and endures social ostracism. But his long and lonely evening hours must have been put to a different use. And his "hidden" investment pays off when Vuestra Merced asks him to explain his marital situation. The written request is vague, and the *pregonero* chooses to answer it more fully than he is asked to.

> *Y pues Vuestra Mercéd escribe se le escriba y relate el caso muy por extenso, parescióme no tomalle por el medio, sino del principio, porque se tenga entera noticia de mi persona.* (10–11).

Your honor has written to me to ask me to tell him my story in some detail so I think I'd better start at the beginning, not in the middle, so that you may know all about me. (24)

His strategy is to find collective causes for his transgression.

Vuestra Merced does not expect to receive a written autobiography that justifies the writer and blames his social context. His argument amounts to a defense of the poor, whose sins pale in comparison to the sins of the rich, especially given the latter's advantages.

> *También porque consideren los que heredaron nobles estados cuán poco se les debe, pues Fortuna fue con ellos parcial, y cuánto más hicieron los que, siéndoles contraria, con fuerza y maña remando salieron a buen puerto.* (11)

I'd also like people who are proud of being high born to realize how little this really means, as Fortune has smiled on them, and how much more worthy are those who have endured misfortune but have triumphed by dint of hard work and determination. (24)

Through his writing project, Lázaro reverses that which Fortune has allotted him, so much so that the instrument of fear *(caso)* spurs the writing of the autobiographical novel.[2]

Like his father, who did not deny being a thief, Lázaro the *pregonero* does not deny the charges that are leveled against him. Unlike his father, however, Lázaro unleashes a counterindictment that charges everyone. Having struggled to survive in the harsh world of commerce, the town crier exercises a new kind of judgment and control in the literary sphere. These two levels of reality merge in the *Prólogo*.

Once he is called upon to defend his *buena fortuna,* the town crier-turned-writer sets up his defense by falling back on the "cultural" savings he has accumulated over the years. Lázaro's ascent toward intellectual maturity and critical reflection proves to be literate as well as literary.

Giambattista Vico reminds us that the etymology of *auctor* derives from the Greek *autos.* Its Latin equivalent is *proprius,* which also means property. In short, the concept of authority stands at the borderline between literary and economic production. This chapter outlines the extent to which dividends of the purse sponsor Lázaro's success with dividends of the mind. Toledo, the city of fact, sets him free to create his own—Salmantina—city of letters.

II

The *Prólogo* returns us to the point at which Lázaro and Antona first

came in contact with the learned world of Salamanca,³ the site of Spain's most prestigious university:

> *Mi viuda madre, como sin marido y sin abrigo se viese, determinó arrimarse a los buenos, por ser uno dellos, y vínose a vivir a la ciudad y alquiló una casilla, y metióse a guisar de comer a ciertos estudiantes, y lavaba la ropa a ciertos mozos de caballos del Comendador de la Magdalena.* (15)

As my widowed mother saw that she had no husband and no protector she decided she would mix with respectable people so that she could become one of them. She came to live in the city, rented a house, and started to cook meals for students and to wash clothes for the stable boys. (25)

As an adult, the narrator considers his mother "widowed," though technically she is still married. Economically, however, her husband is neither provider nor protector; in prison, he is as good as dead.

In Salamanca Antona failed to "join respectable people"; the best she could do was to wait on young students. Lazarillo was just a little boy, but he probably took notice of the world around him.

On one occasion, his half-Negro stepbrother did not recognize himself in his own Negro father:

> *Y acuérdome que estando el negro de mi padrastro trebajando, con el mozuelo, como el niño vía a mi madre y a mí blancos y a él no, huía dél, con miedo, para mi madre, y, señalando con el dedo, decía:*
> *"¡Madre, coco!"*
> *Respondió él riendo:*
> *"¡Hideputa!"*
> *Yo, aunque bien mochacho, noté aquella palabra de mi hermanico y dije entre mí: "Cuántos debe de haber en el mundo que huyen de otros porque no se veen a sí mesmos!"* (17–18)

I remember my black stepfather was playing with the boy one day and the child saw that my mother and I were white and he wasn't. He was scared and ran to my mother and pointed to the black man and said:

> "Mummy, bogeyman!"
> He laughed and answered:
> "Your mother's a whore!"

Although I was only a boy, I thought a lot about what my little brother had said and asked myself:

"How many people must there be in the world who run away from others in fright because they can't see themselves?" (26)

Lázaro's reflection applies to his own search for identity. Throughout the narrative, people teach Lázaro what to do and what to avoid. But he finds the will and talent to pursue his secret life of learning on his own, without the help of others. The narrative thrives on exchanges between innate and acquired values.

As the blind beggar's servant, the boy begins his schooling in the fundamentals of survival by learning the oral language of everyday practice:

Comenzamos nuestro camino, y en muy pocos días me mostró jerigonza; y como me viese de buen ingenio, holgábase mucho y decía: "Yo oro ni plata no te lo puedo dar; mas avisos para vivir muchos te mostraré." (23)

In just a few days he taught me thieves' slang, and when he saw I was quite sharp, he looked very pleased. He kept on saying: "I won't make you a rich man, but I can show you how to make a living." (28)

Although he teaches Lázaro to be sharper than the devil himself when he tricks the boy by crashing his head against a stone bull, the *ciego* can teach him neither how to plan a career nor how to secure a steady income through gainful employment.

Once Lázaro begins to switch half *blancas* for whole ones from his master's hand, the *ciego,* seeing his income dwindle, decides that the more affluent Toledo is the place to go:

Cuando salimos de Salamanca, su motivo fue venir a tierra de Toledo, porque decía ser la gentes más rica, aunque no muy limosnera. Arrimábase a este refrán: "Más da el duro que el desnudo." (35)

When we left Salamanca, his plan was to go to Toledo, as he said that the people there were better-off, though not very generous. He relied on the proverb which says that a hard man will give more than a man who hasn't anything at all. (32)

Moral character and spiritual belief have no role to play when it comes to the appropriation of goods; material value must be secured before

spiritual concerns can be entertained. While money as investment pro-motes mercantile expansion in the world of Boccaccesque narratives, mobility is reduced to hoped-for gratuities in the world of the pica-resque. Lázaro thus enters a milieu in which income—whether from the distribution of water, the sale of indulgences, or the exchange of goods—flows from labor.

On the strength of those experiences, Lázaro sets out to befriend powerful people who might help him in Toledo:

> *Y con favor que tuve de amigos y señores, todos mis trabajos y fatigas hasta entonces pasados fueron pagados con alcanzar lo que procuré.* (128)

> I received a lot of favours from friends and gentlemen and found all the hardships and struggles till then well compensated for by getting the post I did. (77)

"Amigos y señores" make it possible for the town crier to pursue a *"man-era provechosa"* (55). *Deseo* and *poder* are channeled first toward *provecho* and then toward *arte*.[4] Once the indictment is launched against him, the *pregonero* makes a case in his own defense. Thus he creates a literary form that Salmantino students might find intriguing, though they would never suspect that it has been written by the son of a woman who used to be their cook.

However slight Lázaro's economic ascent in the first three *tratados*, his growth in critical judgment changes the narrative strategy in the one-paragraph fourth *tratado*. Its very brevity shows that the narration of deeds has given way to a critical assessment of their effects:

> *Ni yo pude con su trote durar más. Y por esto y por otras cosillas que no digo, salí dél.* (111)

> I left him because of that [too much running around] and also because of one or two other things that I'd rather not mention. (66)

In the textual gap between the third and the fourth *tratado*, Lázaro has learned to evaluate circumstances and to leave things unspoken. The processes that shape mental growth are not spelled out, even though the plot bears out their impact. The inference is that silence and inaction do not equal stagnation. At the end of the final *tratado*, one can visualize the town crier acting out a predictable routine. After a full day of business deals, Lázaro has plenty of time in the evening to ruminate on *honor*,

provecho, and favors of sorts while his wife is busy next door, where she gratefully waits on the munificent archpriest. However dishonorable his standard of living as *pregonero,* Lázaro invests in learning.

III

As one might expect, picaresque and Cervantine texts alike placed great trust in the proverbial wisdom of "minimal necessities." For Sancho Panza,

> *Dos lineajes solos hay en el mundo, como decía una abuela mía, que son el tener y el no tener; aunque ella al de tener se atenía; y el día de hoy, mi señor Don Quijote, antes se toma el pulso al haber que al saber.*

> There are only two families in the world, my old grandmother used to say, the *Haves* and the *Have-Nots.* She was always for the *Haves,* and to this very day, my lord Don Quixote, the doctor would rather feel the pulse of a *Have* than a *Know.* (*Don Quixote* II, 20)

Lázaro's life project is to steer the profits of the world of "to have" toward the world of "to know." Two mindsets lock horns in Toledo, where the writer-to-be leaps beyond materialist gains. As soon as his mental assets begin to grow independently of monetary increase, the "learned" town crier tests the Marxist belief that the less one is the more one has: "The less you eat, drink, buy books, go to the theater or to balls, or to the public house, and the less you think, love, theorize, sing, paint, fence, etc., the more you will be able to save and the *greater* will become your treasure which neither moth nor dust will corrupt—your *capital.* The less you *are* . . . the more you *have.* Accumulation weighs one's being down."[5] It would seem that one must own something before one can even begin to think of being somebody. Under picaresque conditions, the two terms—having and being—appear to be just as interdependent. For better or worse, Lázaro's vagrant "homelessness" comes to an end in Toledo, where a steady income allows him to seek a better place in society. Neither scholar nor hero, he slowly shifts from the world of "to have" to the world of "to know," from materialist need to intellectual self-fashioning.

Actually, threats to Lázaro's gains spur the growth of mental capital in the *Prólogo,* which celebrates those who "have endured misfortune but have triumphed by dint of hard work and determination" (24). Lázaro's

search for a place in society entails compromises. While Vuestra Merced threatens Lázaro's career and prosperity, the *Prólogo* flaunts intellectual growth by adding praise to profit. A divide separates the two, and it is the task of novelistic rhetoric to convince readers that a causal relationship exists between them.

The function of rhetoric is to persuade, and Lázaro uses his own circumstances to make a rhetorical point. In the *Prólogo,* his economic subservience gives way to literary assertiveness:

> *Quién piensa que el soldado que es primero del escala tiene más aborrescido el vivir? No, por cierto; mas el deseo de alabanza le hace ponerse al peligro; y, así, en las artes y letras es lo mesmo.* (6)

> Who thinks that the soldier who reaches the top of the scaling-ladder first hates life the most? No, of course he doesn't; it's desire for praise that makes him expose himself to danger and it's the same in the case of the arts and in literature. (23)

The anonymous *Yo* trusts rhetorical analogies—military, artistic, political.[6] The image of the valorous soldier in the *Prólogo* calls to mind Tomé Gonzáles's alleged heroism at the disastrous battle of Las Gelves, where he gave his life for the cause of Spanish Christianity (at least according to Lázaro's report). The *Prólogo* transforms mediocrity into excellence, conformity into originality, and compromise into provocation. The military image thus becomes a metaphor for a new literary form that its author pits against tales of chivalry. The water carrier's sword was the sign of empty gesturing and anachronistic valor; but the town crier's pen becomes a weapon at once offensive and defensive. Some believed that the "discovery" of the New World had rid mainland Spain of rogues and villains who otherwise would have stirred up trouble at home. But Lázaro was one of those rogues who stayed, and his novel stirred up trouble.

As soon as he begins to feel at ease with the cultural signifiers of relative prosperity, Lázaro gains familiarity with the language of the literary tradition, and he does it better than many a student in Salamanca. The *caso* thus calls forth a critical acumen that cannot have been born overnight. Given his lack of formal education, Lázaro's rebirth as an author defies expectations.[7] References to pagan writers—Pliny, Cicero—heighten the more "secular" aspect of Spanish humanism. At

the same time, the pending *caso* brings a sense of urgency to the narrative. The narrator lacks the leisure to meditate at his desk on Cervantine questions of style and learning. His circumstances aside, he is convinced that authors

> *quieren, ya que lo pasan, ser recompensados, no con dineros, mas con que vean y lean sus obras y, si hay de qué, se las alaben.* (6)

> want to be rewarded, not financially but with the knowledge that their work is bought and read and praised if it deserves praise. (23)

Money and favors make it possible for Lázaro to invest in culture. All in all, the city of fact is an appropriate birthplace for a genre rooted in materialism. In Toledo the anonymous author trades vicarious prosperity via *"los buenos"* for the better humanity of letters.[8] Antona's proverbial statement of intention—*arrimarse a los buenos*—comes back. Lázaro befriends mighty *buenos* who finance his daytime activities. At night he befriends a group of *buenos* who are good because of their literary excellence. In the realm of creative endeavor,[9] authorship finds ways of rising above the world of circumstance. Among priests and blind men,[10] the pen achieves what *provecho* could not afford.

At the archpriest's, Lázaro gets up with a full belly and a somewhat worried mind. At his own dinner table, he is burdened by heavy thoughts about gifts, profits, and blackmail. Thus it is less than accidental that the *Prólogo* opens with a proverb about the contradictory effects of food:

> *Mas lo que uno no come, otro se pierde por ello . . . ninguna cosa se debría romper ni echar a mal, si muy detestable no fuese.* (4–5)

> One man's meat is another man's poison . . . nothing should be thrown away or given up completely so long as it's not really disgusting. (23)

The old metaphor of intellectual nourishment has been turned upside down. Since antiquity, literary fellowship has taken place over food and drink. In fact, the etymology of the word *companionship* joins fellowship *(cum)* with the sharing of bread *(panis)*. Through a ritual of communal abundance,[11] the "banquet" topos is meant to overcome hunger, solitude, and ignorance. Earlier in the Renaissance, the Neapolitan humanist Giovanni Pontano wrote that the splendid man should enjoy elegant

meals even when he did not entertain friends. Lucullus even held a solitary dinner that was an especially elegant occasion. But one wonders whether Lázaro shares their sentiments. He dines alone not, presumably, by choice but because his likely dinner companions are unavailable. The archpriest is absent because he is busy in his own house, where Lázaro's wife dines on more occasions than her husband cares to count. Others are not invited because they remind Lázaro of his dishonorable *menage-à-trois*. Lázaro keeps people at a distance for his own peace of mind, though he knows that, metaphorically speaking, he is eating food laced with unhealthy ingredients. The details tell a story that sets forth an indignity that no clergyman can ever redeem. In a way, picaresque banquets are parodic variants on the degeneration of humane standards in the underprivileged milieu of "low-life" culture.

We have reached a point where the picaresque addresses the opposition between the active and the contemplative life, which chivalric literature translated into the dualism of *armas y letras:*

> *Come, Sancho amigo, dijo Don Quijote; sustenía la vida, que más que a mi te importa, y déjame morir a mi manos de mis pensamientos y a fuerza de mis desgracias. Yo, Sancho, naci para vivir muriendo, y tu para morir comiendo.*

> "Eat, Sancho, my friend," said Don Quixote. "Sustain life, for you have more need than I; and let me die a victim of my thoughts and of the force of my misfortunes. I was born, Sancho, to live dying, and you to die eating. (*Don Quixote,* II, 59)

Like Sancho, Lázaro de Tormes never gives up on food, and he knows that his eating of the "societal pie" is no more undignified than anybody else's. Unlike Don Quixote, his deeds are neither valorous nor memorable. But once he is challenged, Lázaro rises to the occasion by displaying an arsenal of literary weapons. Whether the enemy is windmills or breadboxes, unholy priests or Biscayan infidels, *letras* remain a fixed point of reference for prose writers at large.[12] In a way, the picaresque text tells a tale of two cities. One of them is the Salmantina academy of humanist studies and the other is the materialist world of Toledo. One is the negative of the other, but the town crier-turned-writer has profited from both.

Above any materialist *buena fortuna,* Lázaro conquered Salamanca by re-creating it in a new location.[13] And the symbolism of *castellanidad* is

used to encourage the creation of one's fatherland outside one's native territory,[14] an experience of many Spaniards. Biographical details tell us that Fernando de Rojas and the anonymous author of *Lazarillo de Tormes* were *conversos* who, because of their "inferior" birth and faith,[15] often resorted to simulation in order to cope with an adversarial culture.[16]

Salamanca was the *axis mundi* of education, and Fernando de Rojas earned the degree of *bachiller* there.[17] In addition to regular students, the world of the university also included student shepherds, student *pícaros,* and student cavaliers. They were citizens of the "republic called Salamanca," which thrived on two legends: students told one of freedom while teachers cherished another about perfectibility. As it accumulated wealth from the ripple effects of goods from the New World, Castile changed from a country of soldiers into one of *estudiantes, juristas, clérigos, teologos, escritores,* and *artistas.*[18] Only disguised as a tuna fish in a spurious sequel to the original text does Lazarillo report on scholarly disputations with doctors in Salamanca.[19] Northrop Frye has suggested that only those who are economically liberated can enjoy a "liberal" education.[20] In Lázaro's case, economic liberation never takes place, and the *caso* exposes the precariousness of his situation. The anonymous author thus steers his future toward a harbor of the mind where the nobility of fame can mute the powers of profit.[21]

The *Prólogo* gives the narrator a chance to reconstruct the life of a *mozo-bellaco-gallofero-pregonero* into a fiction that even Ginés de Pasamonte, one of Cervantes's "learned" characters, accepts as exemplary of the new picaresque genre. If the literary *pícaro* is a "figure transcending the *pícaro* of reality," then it is equally true that the anonymous *Yo* transcends the moral and social conditions of his creation. While asserting a grounds-eye view symbolic of Lázaro's own existence, the act of "rowing" at the very end of the *Prólogo* leaves the reader with an energizing sense of purpose that contrasts material prosperity with artistic merits.[22] Lázaro thus makes a case for himself by probing the institutional causes of poverty. While the town crier reminds us that to err is human, the narrator speaks in a voice that echoes the longings of a majority at once silent and silenced.

IV

At least theoretically, the debate between feudal nobility of blood and Renaissance nobility of heart was solved in favor of the latter. Yet even

as exemplary a writer on self-fashioning as Castiglione acknowledged that, in practical terms, an aristocratic upbringing would have been easier for the courtier. Ordinary folks faced up to practical difficulties that humanist treatises either minimized or ignored altogether.

In the world of picaresque literature, Guzmán ends up in prison, where he writes his *memorias:*

> *Que antes parece muy llegado a razón darla un hombre de claro entendimiento ayudado de letras y castigado del tiempo, approvechandose del ocioso de la galera.* (96)

> It seemeth agreeable unto reason to present unto you a man of a cleere understanding, holpen by Learning, and punished by Time, making benefit of that idle time, which he had in the Gallies. (1, 19)

Somehow the harsher circumstances of *vivir* get the best of any educational potential. In Salamanca, a Cervantine creation (Cervantes 1982, 121), Tomas Rodaja, looks "for a master who, in exchange for his services, would give him the opportunity to study." Having found one, the young lad completes his course of studies with distinction. But people relate to him only as long as he believes that he is made of glass. Guzmán and Buscón, by contrast, can never afford the leisure of scholarship in places of their choice.[23] Picaresque and Cervantine characters frequently seek education, but no one gains academic distinction.

In the world of Toledan commercial transactions, the indictment gives Lázaro the opportunity to link life to art, and his life story upholds Mikhail Bakhtin's (1981, 37) belief that there always remains a surplus of "un-fleshed-out humanness." Against exemplary types such as the scholar, the aristocrat, the courtier, and the soldier, the *pregonero* makes room for the man of modest qualities. In the end, he proves that his humanness is not so ordinary after all. "Low" picaresque and "high" heroic images intersect in a parodic mode that becomes momentous once it is transcribed into a literary framework. Lázaro is more resilient than most *pícaros* and his ambitions exceed his social station. The ordinary becomes extraordinary in much the same way that circumstances lead the nameless foot soldier to perform deeds of exceptional valor. The *Prólogo* upholds the higher ideals of aristocratic emblems: "Better to fly high"; "Death to life and long life to glory." By so doing the author-soldier hopes to acquire a new title, but he does it anonymously.[24]

Let us not forget that the picaresque text opens with an invitation to disinter Lázaro's story from the tomb of oblivion:

Yo por bien tengo que cosas tan señaladas, y por ventura nunca oídas ni vistas, vengan a noticia de muchos y no se entierren en la sepultura del olvido. (3)

I think it's a good thing that important events which quite accidentally have never seen the light of day, should be made public and not buried in the grave of oblivion. (23)

The indictment calls on the *pregonero* to aspire to the humanist project of *rinascita* even while remaining rooted in the material world. The picaresque narrative rescues worthy deeds from oblivion and teaches people to live in conversation with the past. Emulation and revival are central to the poetics of humanism, and the project of recovery and renewal takes place in the novelistic *Prólogo,* where the act of writing itself is a form of rebirth. To Vuestra Merced's great surprise, the indictment allows Lázaro to demonstrate his intellectual maturity and literary talent and to create a literary Salamanca of the mind.[25] The childless *pregonero* at last is transformed into a *homo litteratus.*[26]

The town crier's *buena fortuna* turns out to be based on a counterfeit economy. Lázaro's assets—house, food, clothes, marriage, and employment itself—entail obligations that cannot be repaid. The written *nonada* turns out to be the blueprint of a countercurrency. Lázaro's critical awareness does not lead to revolutionary deeds, but it brings into the light of day a poisonous value system that was validated by the imprimatur of Church and State.

The nameless *Yo* gives textual presence to a "second self."[27] We know that Lázaro is the same person as the narrator, but the narrator is not the same thing as the author. The literary project allows Lázaro to transcend his marginal existence as town crier. Indeed, the anonymous *Yo* has become "a better man," perhaps the very best that he can be, in the circumstances. In response to Vuestra Merced's challenge, Lázaro gives birth to a new literary genre.

9 · The Economy of Genre

The rise of the novel in sixteenth-century Spain seems to have been rooted not in the
triumph but in the frustration of the bourgeoisie.
—*Claudio Guillén*

I

Whether we turn to *laceria, provecho,* or the *escudero*'s toothpick, we
see the unity of the linguistic with the monetary, which, to
quote Marc Shell, "cannot be eradicated from discourse without chang-
ing thought itself, within whose tropes and processes the language of
wares (*Warensprache*) is an ineradicable participant."[1] This chapter out-
lines the extent to which the tale of two cities affected the "economy of
genre." I use this phrase to describe economic activity not addressed in
the grand narratives of the imperial Golden Age, the kind of develop-
ment that led to modest profits, opportunistic adjustments, and a greater
awareness of moral duplicity.

The picaresque genre rejected the "most-favored" status of treatises
and panegyrics, thriving as it did on a stylistic, social, and linguistic
diversity that changed literary conventions forever. Material riches are
sought, but economic motives are often suspect. Success is hard to come
by, and hopes are easily crushed.[2] In fact, the culture of the picaresque
asserted an altogether new approach, based on what Mikhail Bakhtin
(1981, 366) has called "a Galilean perception of language, one that
denies the absolutism of a single and unitary language."

No longer confined to their place of birth, picaresque characters
roam as far as the new American continent. Sixteenth-century literature
had to make adjustments once the old, finite, earth-centered view of the
world gave way to a heliocentric universe. While the prose of Giordano
Bruno and Thomas Traherne embraced the new world opened up by
science, John Donne had doubts, and Blaise Pascal feared the displace-
ment of the earth from the center of the planetary system. Old-fash-
ioned Latinists must have felt just as displaced by the challenge of the
vernacular to language in the "high" style.[3] Worshippers of epic
grandeur were unsettled by the emergence of new genres.[4]

Against the background of "high style" genres, picaresque texts introduced a world of urban low life, in which economic gains such as Lázaro's promised rebirth in the heaven of art. Georg Lukács has argued that the emergence of the picaresque was a "social phenomenon" in that it focused attention on a population and a way of life heretofore ignored in literature. As a genre, the picaresque was rooted in the materialist belief that goods-as-money are most valuable, and that value itself depends on their availability.

It has been noted that the culture of classical antiquity, once it peaked, stopped asking path-breaking questions; complacency settled in. It was no accident that the Renaissance began to flower when Petrarch and his humanist cohorts began asserting the value of the non-Christian past. Antiquity provided new sources of emulation for the humanists, who found original answers to age-old questions.

The Renaissance itself waned once learning, heritage, and nostalgia were folded in; imitation got the best of invention. Was the humanist's praise of Roman heroism still relevant in the context of modern politics and modern economics? Had the time come to reach out to a new constituency? Was there a link between high and popular culture? The rebirth of antiquity was over, and the time was ripe to take up the issue of modernity's own physiology.

This study has centered on the materialist belly of the Renaissance, where the economics of the poor led Lázaro to "live down" traditional ideals. Economic and cultural conditions restricted his growth, but they did not stop his literary *Bildung*. Analogies can be drawn between lost illusions and great expectations, which moved young men to challenge their lot, even though they often exchanged one form of dependence for another.

II

In 1527, the sack of Rome intensified the "crisis" of the Renaissance. The center of humanist culture lost its hegemonic grip, and an aggressive criticism of the *status quo* began. A healthy sense of skepticism tested boundaries everywhere. Humanists throughout Europe promoted the use of the vernacular in palaces and academies alike. But how much did they care about the education and welfare of those who spoke the vernacular on the streets and in the marketplace? After the turn of the sixteenth century, humanist idealism could neither conceal nor bridge

the gap between theory and practice. Ludovico Ariosto let madness infect chivalric heroes, and Giovanni della Casa wrote rules of conduct for middle-class people who met standards of mediocrity rather than excellence in *Il Galateo*. In the marketplace, individualism meant greed, cunning, and selfishness.

Machiavelli placed a wedge between *verità ideale* and *verità effettuale* (ideal and empirical truth), for *homo oeconomicus* often proved to be *homo duplex*. But he still believed that effects could explain their causes. Fellow Florentine Francesco Guicciardini countered that if that were so, people would not keep on making the same mistakes. Guicciardini focused on the details—*particolari*—of everyday life rather than historical theories of progress. Although his work does not belong to the picaresque genre, his approach showed the extent to which, after the first quarter of the sixteenth century, the fabric of humanist idealism was being rent from within.

Up until this point, humanist literature tended to portray exemplary merchants. In his treatise on the economics of the successful merchant *(I libri della famiglia)*, Alberti does not mention the ruthlessness that is part and parcel of making money. Successful businessmen wrote private *diari* and *zibaldoni,* but they did not record all of the underhanded deals that went into the making of financial dynasties. None of those texts addressed itself to the education of mediocre youths who grew into mediocre adults.

Although Baldassar Castiglione (1959, 11) described "the perfect Courtier, without defect of any kind," *Il libro del Cortegiano* was written in a defensive mode that mixed praise with apology. Still determined to defend the center of humanist idealism, Castiglione endowed the perfect Courtier with grace, a gift of nature: "But as for those who are less endowed by nature and are capable of acquiring grace only if they put forth labor, industry, and care, I would wish to know by what art, by what discipline, by what method, they can gain this grace" (41). The answer exposed the limits of humanist idealism: "'I am not bound,' said the Count, 'to teach you how to acquire grace or anything else, but only to show you what a perfect Courtier ought to be.'" Any more direct answer would have tested the theoretical model. But it was inevitable that this type of idealization would eventually be challenged.

Well into the sixteenth century, Italian humanism was hampered by its own adherence to the canon of antiquity. Invention was stifled in the

name of rigid, unquestioning loyalty to standards that Aristotle and Horace themselves would have found extreme.[5] Torquato Tasso's best "epic effort" produced the Christian *Gerusalemme liberata*, which he revised because it did not conform to the critical demands of epic conventions. The more "orthodox" outcome was called *Gerusalemme riconquistata*, which has deservedly fallen into oblivion.

Boccaccio was the first great short story writer. But the novel developed in Spain, where literature and the arts were less burdened by the humanist heritage than anywhere south of the Alps. Petrarch's letters often verged on essays, but it was Michel de Montaigne who "created" the essay in France. The novelist asked: "How does one shape a life?"[6] And the essayist echoed: How does one shape a thought?[7] However tentative they remained about the value and legitimacy of their own novelty, essayists and novelists created new forms.[8]

Erasmus understood that models of human growth no longer could ignore the everyday practice of life.[9] He thus set out to outline "a way of life" rather than "a course of study." To accomplish that, necessity "encourages us to get property; if we had none we could not even live. If we do not have enough, we live too poorly" (*Enchiridion*, chapter 35). In the novelistic mode, need rarely allowed an inquiry into ideological values, for mere survival often constituted a lifelong project. The novel thus unraveled a "genre-in-the making" that crowded literature with less than perfect characters. Their conspicuous presence vis-à-vis traditional figures of authority betrayed the "marginal" status of the new genre, which was ill at ease within the canonical hierarchy of writing. Once the novelistic mode gained strength, topographies of perfection made way for the itinerant chronotope of the road.[10] From Tormes and Salamanca to Toledo, the exchange of ideas often took a back seat to the transaction of business deals.

By and large, artistic representations of society were rooted in the privileges of blood, wealth, and nobility. "High culture" controlled the form and content of literary expression, and the same year that Christopher Columbus sailed westward, Antonio de Nebrija addressed Queen Isabella of Castille in the prologue of his *Gramática de la lengua española* (1492): *"Siempre la lengua fue compañera del imperio"*—"language always has been an instrument of empire."[11] With the blessings of political authority, language and the canon joined forces. Nebrija described the advantages of the vernacular over Latin as a form of *provecho* that

shed light on imperial policies of territorial expansion. The language of the Holy Roman Empire had found a modern counterpart.

The other instrument of empire was education, both humanistic and technological. The result was the creation of a massive bureaucracy, which introduced what J. H. Elliott (1989, 15) calls "government by paper." Educational institutions multiplied. At the beginning of the sixteenth century, there were eleven universities in Spain; a century later, this number had grown to thirty-three. Many lawyers spent most of their lives abroad, from the Philippines to South America.

Diego de San Pedro had humanist models in mind when he constructed his *Carcel de amor,* and its publication coincided with the acceptance of Castilian as the language of the empire. Juan de Mena wrote the epic poem *Laberinto de Fortuna* (1444), a Spanish counterpart to the *Aeneid.* By contrast, Alfonso Martinez de Toledo's *Arcipreste de Talavera* (1498) was a satire on love that imitated the rhythms of vernacular speech. Both styles merged in Fernando de Rojas's *La Celestina* (1499). Almost forty years later, in 1535, Juan de Valdes produced *Diálogo de la lengua,* a model of refined conversation in which writing was subordinated to speaking. The hope was that no gap existed between the two. At the margins, questions of affluence and indigence bore on the relationship between economic and linguistic currencies.

Once they entered the literary arena, uneducated folks of all sorts confronted the writer with a challenge: what kind of language would they speak? Picaresque language was neither courtly nor chivalric; indeed, it was a parody of Castilian. Fernando de Rojas used antirhetorical forms of expression in *La Celestina:* "Avoid, sir, such circumlocutions—such poetic expressions—for reference to that which is not commonly known or understood or to information not shared by all is not a proper subject of discourse" (act 8). Such literary "sources" notwithstanding, the picaresque drew on an array of folkloric materials such as tales, proverbs, anecdotes, and *refranes,* which had their roots in ballads, romances, proverbs, and *cuentecillos.*[12] Suffice it to say that Italian models did not overburden Spanish artists, who remained more responsive to local traditions. *Elementos folklóricos* such as *burlas, frases ingeniosas, cancioncillas,* and *historietas* affected poetry, prose, and theater.[13] Peter Burke (1978, 28–29, 46–47) suggests that this was the type of linguistic brew typical of the culture of minorities. We edge on the borderline between written and unwritten poetics,[14] which thrived where artists responded

to the latent energies of an unofficial culture that included the genres of everyday life, such as letters, confessions, sermons, diaries, and hybrids thereof.[15]

Because it was so close to both life in the raw and society in the making, the novel never tired of breaking down the boundaries between literary poetics and nonliterary prosaics.[16] The Russian Formalists argue that, in its novelistic mode, literature at the margins constituted a point of entrance for the nonliterary forms of language and life.[17] The inference is that the novel tends to "debase" whatever is considered "higher" by the standards of the age. By now we have learned that Renaissance texts are important for what they present as much as for what they leave out.

At the boundary between begging and earning, or between work and theft, the *pícaro* has been called a "half-outsider" and, needless to say, "outsiderism" is central to the picaresque.[18] In an essay on Quixotism, Unamuno (1976, 342) bluntly states, "In each epoch, it is said, the hero who is needed appears. . . . And every hero other than the one needed must end in wretchedness or oblivion, in the galleys or the lunatic-asylum, even perhaps on the scaffold." Lázaro de Tormes is just such a hero. Half a century later, Cervantes created Don Quixote, whose literary reminiscences emerged after the revolutionary expansion of book printing. And time has shown that Western culture at large has turned the picaresque and the quixotic into central models of novelistic representation well into our own day.[19]

At the conclusion of *Writing in the Margin,* Paul Julian Smith (1988, 204) sets the issue of marginality against the grand scale of European geography: "The particular significance of Spain and its Renaissance writers might be an example of persistent and irreducible marginality. For Spain is the 'woman' of European culture. She is excluded from the main currents of political and cultural power, scorned for her supposed emotionalism and sensualism, and pitied for her lack of that serene classicism or rationalism which once presented itself as the ideal." At the center of Renaissance culture, one finds the heroic past in its mythic, classical, and modern variants. The center is a world of privileged origin and intellectual excellence, a world where matters of money are taken for granted because money belongs to the center by historical appropriation, if not by natural right. Alberti's successful merchant in *I libri della famiglia* is concerned with the dispersion, not the acquisition, of money.

In fact, the treatise trades mercantile ingenuity for civic humanitarianism amid a culture of encomiastic genres (treatise, panegyric, epic) that enacted a rhetoric of praise. The center was the place of ideological certainty where the "high" genres shaped ideal figures and hypothetical structures, and humanists ancient and modern understandably had no interest in posing questions that might unseat them.[20]

Whether at the margins or at the center, the Renaissance revival of ancient forms spurred productivity. In the wake of Sannazaro's *Arcadia* and the eclogues of Garcilaso de la Vega, Jorge de Montemayor wrote *Diana,* a pastoral romance inhabited by shepherds dedicated to a life of artistic leisure. The labor-free, moneyless pastoral setting shows the pursuit of wealth to be an error that stands in the way of happiness. In any acquisitive society, Renato Poggioli (1975, 4) tells us, these pursuits come together, to the point that one can view the dictum *"enrichissez-vous* as a moral as well as an economiastic command." In Lázaro's acquisitive but unproductive society, the attainment of limited goods requires compromises that put him at risk. In order to have literary currency, the picaresque author could not fall back on either epic or utopia. From Petrarch to Ronsard, epic revivals were not successful. Unlike commodities we discard once they have outlived their usefulness, literary texts often are long-term investments to which readers turn because of other texts that are indebted to them. Once Guzmán de Alfarache entered the world of art, his Toledan ancestor was rediscovered and his work brought out in new editions.

Anthropologists remind us that liminality signals permanence rather than transience, so much so that it has been defined as a state in itself. When Mateo Aleman's *Guzmán de Alfarache* came to be known popularly by the shortened *El Pícaro,* even titles proved the point; the picaresque had undergone both evolution and settlement, a process that took place both within the Hispanic tradition and across the European continent. By the end of Carlo Ginzburg's study of an Italian miller, we have learned many things about Domenico Scandella, known as Menocchio. But we know nothing of legions of other workers who lived and died like him, for we are dealing with a population that did not write about itself because it lacked both the skill and the means. After reading Natalie Zemon Davis and Gene Brucker, much the same could be said of Martin Guerre or of Giovanni and Lusanna in relation to a whole population of forgotten peasants, *popolani, pícaros,* and *conver-*

sos.[21] For its part, the dominant class was determined to let that state of things endure, and endure it did.

Most *pícaros* never rose above subsistence. But a few did; and they made a difference. Lázaro de Tormes was one of them. He was not a "hero" in the grand and glorious sense, but he was a worthy protagonist; however ordinary, his story made a case for those microhistories that took on the establishment. Often, "micro" was not as small or inconsequential as one might believe. In fact, the very term "microhistory" is ambiguous. Applied to human subjects, it seems to suggest "stories" of ordinary people who are engaged in daily routines. Above such stories, however, there stands the broader range and deeper contents of macrohistory, which takes as its subject the grand narratives of exemplary public individuals. Let us remember that *historia* is a portmanteau word which means both *story* and *history* in Romance languages *(storia, histoire).*

However specific the motive *(caso)* and the individual representation *(vida),* even as "micro" and "diminutive" a story as that of Lazarillo's *fortunas y adversidades* refers to historical events (Las Gelves, the emperor's entrance in Toledo) and raises issues about famine, nobility of blood, ecclesiastic corruption, labor exploitation, bureaucratic inefficiency, and outright criminality. At the beginning, the law is transgressed in Tejares, where the archetypal "incrimination" of the father in the picaresque text returns in Garcilaso de la Vega's *Comentarios reales de los incas* (1609), which *El Inca* wrote to exonerate his own father. The law again is abused in the streets of Toledo in the last *tratado,* and Vuestra Merced's indictment in the *Prólogo* tests the narrator's cunning and competence.

The themes of "persecution, prosecution, and punishment" come to the fore under the imprimatur of the emperor himself. He is mentioned at the very end of *Lazarillo de Tormes,* as if to implicate the supreme authority in the systemic disregard for and the inefficiency of the law in this corrupt society. Deposition and confession are models of picaresque textuality, and the legalistic strategy is a prelude to the main features of the literary text.[22] The "trapping" plot and the impending punishment intensify both narration and reception in *Lazarillo de Tormes.* As a cultural concept, *provecho* itself can be associated with a feature of discourse known as "sententiousness," which tends to "lay down the law."[23] In the predominantly illiterate culture of the picaresque, law also falls back on proverbs that utter moral warnings and sanction common practices.[24]

Like many "peripheral" writers, Fernando de Rojas and the author of *Lazarillo de Tormes* rely on judicial models. Their argumentative structure and rhetorical persuasiveness present cases without much concern for the truth. Facts are interpreted to one's advantage, so that the imitation of judicial models tends to take neither appearance nor reality at face value. The goal of the picaresque story is to "normalize" the practice of social mores by "normalizing" the practice of literary subversion. This undertaking is at once self-fulfilling and self-defeating. Because his defense strategy is based on collective guilt, Lázaro puts on trial some of the very people who will pass judgment on him. In a way, the *ratonera* and the *caso* become central features of what has been called the novel of trial.[25] Lázaro's entire life is a series of physical, economic, social, and intellectual ordeals.

It is thus inevitable that he is finally forced to prepare a case in his own defense. It is not by accident, therefore, that the symbolism of the "trap" gains general significance, for the *pícaro* "is not a self caught in a cage, he is the bars of the cage." Roberto Gonzáles Echevarría has highlighted (1998, xi, xv, 10) the abusive role that the law played in the emergence of prose narratives. As to the literary form, the *caso* forces the *pregonero* to present a *relación,* which, as a letter that bears witness to something, "belonged to the huge imperial bureaucracy through which power was administered in Spain and its possessions." Links thus exist between "the development of a modern state run by a patrimonial bureaucracy and the appearance of picaresque fiction."

Once art began to portray ordinary, flawed human beings, some readers found the result too life-like. To counter that effect, authors used superlatives to intensify everyday values so as to make their characters more attractive. By and large, the personalities of most people are not intense enough to be literary. However ordinary, a story worthy of literary depiction must rise above mere chronicle of fragmentary existence.[26] To be fictional, "ordinariness" must be heightened, and *Lazarillo de Tormes* achieves this in the third *tratado,* when the *escudero* introduces Lázaro to a world of ideas that allows the youth to develop a critical perspective on his master as well as on himself. The moment this takes place, Lázaro moves beyond subsistence and folkloric modes of conduct. However earthbound his ambitions and pedestrian his problems, Lázaro no longer is ordinary. By the end of the final *tratado,* the *pregonero* has settled among men who pit happiness and misery against

the facts of existence. But the nameless *Yo* stands above them all; unbeknownst to them, he has overcome triviality, and the way he writes about it is quite extraordinary.

Once he has achieved this, is the insightful *Yo* content with a second-hand wife and worn-out stockings? Is he content to remain a cog in the exploitive machinery that he understands so well? This question presumes freedom of action and social mobility; but these things are not available to Lázaro, who remains trapped in Toledo. His only escape is to use the indictment to his advantage—to show that everybody is trapped in Toledo.

The picaresque text is not another *libro galeotto* relying on forms of chivalric escapism. It is a book that anyone as underprivileged and as ambitious as Lázaro de Tormes would be wise to purchase. For the picaresque text is as exemplary in the world of indigence as the humanist treatise was in popularizing mercantile affluence in precapitalist Florence. The difference is that Alberti had to create a character whose conduct he described only hypothetically. The content and form of the picaresque text, by contrast, takes its start from existence itself.

The *Prólogo* of *Lazarillo de Tormes* draws on both encomium and invective. In the Erasmian tradition of praising folly, the anonymous *Yo* exploits the rhetorical paradox of praising what cannot be praised.[27] This posture is typical of writers who know that they are shaking literary and ideological conventions. Earlier, Fernando de Rojas introduced his work as an error in the verse *Prólogo* of the 1501 edition of *La Celestina*. Actually, his literary creation is a daring act as unwise and foredoomed as the flight of the winged ant, which is transformed into a lonely flyer at mortal risk outside its natural environment. The simile plays on a transgression of the natural order, which finds human equivalents in hierarchy and worship of the canon. "Just as this creature dreamed of the exultation of flight, and I of obtaining honor with my pen, so the two of us came to grief."[28] Yet Rojas knew that his artwork was not an error, much as the picaresque author knew that his autobiographical narrative was not a *nonada*. And both believed that they would survive their acts of daring in spite of the controversies that their unorthodox creations were bound to stir. We have been reminded that contemporaneity is a subject of representation only for the low genres, which include the popular culture of laughter. And indeed, at first, *Lazarillo de Tormes* was read as a comical text. But the

comic veneer was a rhetorical strategy meant to disguise the work's radical implications.

Since the emergence of "realism" is linked to literature about common people, we might reflect on Antonio Gramsci's comments (1975, 2:1013) on a readership that "does not care about the personality of the author, but about the character of the protagonist. The heroes of popular literature, when they have entered the sphere of the intellectual life of ordinary folks, detach themselves from any 'literary' origin and claim the validity of historical characters. Their whole life is interesting, which also explains the popularity of 'continuations.'" The *Vida* in the title of *Lazarillo de Tormes* validates modern speculations about the novel, which constructs the world around a single character that wavers between the ordinary and the exemplary.[29] From Benedetto Croce to Mikhail Bakhtin, scholars have described the novel's range as epic. In fact, the new genre bridged the gap between story and history in the anticanonical mode of parody. Lázaro's whole life is so intertwined with popular culture that "continuations" proliferated side by side with those about Cervantine *hidalgos*. By the end of the final *tratado,* Lázaro's *buena fortuna* has made desire manageable by trading things, values, and honor into a profitable arrangement that bears out the fruits of his "good luck."

It is indeed true that individual desire and external circumstances threaten the novel at its very inception.[30] Lázaro outmatches Vuestra Merced's request by producing a written document that reveals his literacy and tests the boundaries of literature. The writing of the picaresque text created a "case" of its own in the Renaissance nomenclature of literary forms. In the first *tratado,* physical shocks bring about emotional growth beneath the wine jug and by the stone post. On both occasions, the *ciego* reminds his *mozo* that a blind man's boy must be sharper than the devil. Once the *caso* tests Lázaro's ingenuity, what emerges is a writer who surprises Vuestra Merced by producing an unprecedented literary document. Postmodern readers familiar with popular culture might raise questions. Did it take a pseudo-legal indictment to give artistic form to the everyday practice of life? Is it possible that the value of a picaresque life can become meaningful only under the threat of punishment?[31] Should we not reflect on the dominant role that the economics of affluence has played with regard to matters of artistic representation? In other words, on whose backs was the New World "dis-

covered"? And on whose skin did gold and silver enrich commercial dynasties and Catholic kings alike?

III

Once they became the focus of literary representation in Renaissance art, ordinary people tended to be depicted as subnormal. In an effort to reveal the ugly face of poverty, literary and pictorial images of poor folks often showed them as physically abnormal. Between the epic and the comic, one could hardly find a middle ground where the ordinary and the normal coincided. We have been told that the poor are the opposite of the rich, the powerful, the soldier, and the citizen.[32] To be the opposite of the rich during the Renaissance meant just that. It did not point to a neutral condition of sufficiency between wealth and indigence, because normality was yet to be defined as such. And what was ordinary in the first place? If the rich set standards, which they did, the poor upheld their own antistandards.

The picaresque was born of poverty, which drained individual and social energies in the pursuit of economic survival. As Fredric Jameson (1981, 106) puts it, "genres are institutions, or social contracts between a writer and a specific public." In the practice of sixteenth-century prose fiction, the picaresque yielded parodic representations of people who were marginalized by external abuses and personal shortcomings.

Sheer descriptions of life-as-is tend to be negative because the social mimesis at stake consists of ethical and material poverty. Tomé, the escudero, the fraile de la Merced, and the buldero suggest that the praxis of life cannot support itself without degenerating in one way or another. Perhaps the very idea of common men leading common lives under the guidance of ordinary values is itself a fiction. To be sure, the socioeconomic structure of the picaresque is based on a tight system of reciprocal exploitations either below or above the ordinary. In the practice of everyday life, much piety, charity, and compassion are no more than rhetorical tools meant to enforce strategies of dominance. Material life thrives on the strife between production and consumption, ingenuity and dependence. In the midst of celebratory models of human dignity and godlike striving, it was difficult to appreciate the everyday, the commonplace, the mundane.

This difficulty lingered on. It plagued nineteenth-century narratives and it troubled even as committed a Marxist critic as Georg Lukács, who

felt ill at ease with the disappearance of the hero. In time, however, excellence gave way to mediocrity, and tensions mounted between popular and elitist impulses. But for how long could one ignore nonepic and unidealistic mimeses?[33] To put it another way, is existence at street level a worthless *nonada?* To answer this question, we might consider the structure of *Lazarillo de Tormes.* If we read the text sequentially from the *Prólogo* to the last chapter, the ending celebrates the *pregonero*'s mercantile Toledo. Literary talent seems to be subjugated to materialist achievement. Strictly speaking, however, the ending is lodged in the *Prólogo.* Closure turns out to be an issue as contentious as the *caso* itself,[34] and the answer the *pregonero* is asked to give is a *nonada* because it describes the ground zero at which a new author and a new genre have just come into being. At the threshold between the meaningless and the meaningful, *nonada* is the most reductive diminutive that could be given to a generic form as yet "unknown."[35]

In order to protect what he owns, Lázaro makes of his literary *nonada* an investment in self-preservation. However fictional their ordeals, Lazarillo, Pablos, and Guzmán gave voice to social milieus that were plagued by a disheartening lack of productivity.[36] It is revealing that the *pregonero* gets a chance to grow into authorship when he has achieved economic stability. From a narrative point of view, the indictment forces the anonymous author to gain insight into the forces that motivate society as he knows it. Thus he reevaluates the world of material production from the standpoint of literary reproduction.[37] From poetics to economics, the materialist aspects of the *Prólogo* and of the *tratados* meet a twofold challenge in as much as the text confronts both the science of scarce resources and the discourse of intellectual empowerment. A homology can be drawn between production and imitation as well as between reproduction and representation. But it is only when he develops a critical understanding of people's diverse mindsets that the nameless narrator can finally draw together individual maturity and social criticism.

Rhetorically, Lázaro's goal is to persuade; ideologically, his task is to delve into the reasons that have made him what he has become. Whereas the world of production oscillates between "having" and "not having," that of reproduction centers on the quality, depth, and range of one's "being." But could one suggest that Lázaro-as-narrator is a precedent to the Gramscian concept of the "organic intellectual" who, com-

ing as he does from the lower classes, tests the hegemonic powers that be for the sake of the exploited masses?[38] The answer is no, if one keeps in mind that external circumstances brought the new literary form of the picaresque into existence.

It is not by accident that the anonymous *Yo* reminds us of the proverb according to which "one man's meat is another man's poison." In socioeconomic terms, the caste's meat can be the class's poison and vice versa. Applied to the protagonist himself, the moral poison that Lázaro has to swallow in order to meet the demands of economic survival turns into precious meat when the writer reproduces his travails in a literary narrative. And the *Prólogo* foregrounds the psychology of a character who, having bought into a corrupted world, has grown to gain a critical perspective on it.[39] We do not know what the outcome of the *caso* is. But that uncertainty is minor in comparison to the literary "case" that the author makes in his own behalf. To the best of his abilities, he is both meat and poison, victim and victimizer.

Marcos de Obregón wrote, "There is no life of any man who roams the world which does not have the stuff of a great history." The author of *Lazarillo de Tormes* proved him right. Literary creation was the means of Lázaro-Lazarus's transformation into the sire of a prolific genre.[40] By writing and publishing his book, he also made responsibility public. The narrative is both product and production, commerce and merchandise. The town crier cried out a tale of public woes—and created a new literary currency.

EPILOGUE AT THE MARGINS:
WHOSE RENAISSANCE?

What should the artist be concerned with: that his work is accepted by "the whole nation" or just by the sophisticated elite? Yet, could there be any separation between nation and "elite"?
—*Antonio Gramsci*

THE RENAISSANCE SCHOLARSHIP of Jacob Burckhardt and Walter Pater focuses on humanist aestheticism, which gave order, clarity, and form to a common vision of the state as "a work of art." Conversely, the picaresque has shown us that, for the majority of the people, the state was anything but a work of art. In Hapsburg Castile and Medician Tuscany, the state let a few prosper while many toiled. Whatever the cultural achievements of those societies, rich and poor lived drastically different lives within the same city walls, and the wealthy had plenty of reasons to be embarrassed by the strategies that secured much of their wealth.

The way of life of the small but powerful middle class of enterprising bankers and adventurous merchants, who were often wealthier than the nobles themselves, was by no means typical of the way common people lived. Dynasties such as the Medici and the Fugger[1] proved that the middle class covered a socioeconomic spectrum that ranged from the roguish to the royal.[2] We refer for good reason to Medician gestures as acts of exceptional generosity on the part of a professional elite whose upward mobility and materialist credentials offset lack of heritage. Although he took pride in humble origins and an aristocracy of merit, the successful bourgeois ultimately aimed at joining the ranks of the aristocracy.[3]

Under the aegis of "mobility studies," Stephen Greenblatt (2001, 60–62) has written of the need to develop a literary history of "the groups marginalized by the hegemonic cultures of the ruling elites." Such a history should pay greater attention to accidental judgments, carnal and bloody acts, and "the fierce compulsions of greed, longing, and restlessness." In fact, these "disruptive forces, not a rooted sense of cultural legitimacy," shape history. The privileged Renaissance of civic humanism rediscovered the ancient world by excavating the artifacts of Roman antiquity.[4] Now we face a similar task with regard to the under-

privileged Renaissance of popular culture, which, though it left few historical documents and even less artistic evidence, shaped history well beyond what we have cared to investigate. The picaresque narratives about the practice of "life in the making" that we have do show us that the "common man" never tired of taking one more step into the future, warts and all.

Once the concept of a predominant history collapsed, the "grand narratives" that have been identified with liberalism, Christianity, or humanism, had to make room for ordinary counterparts that have steered criticism toward "decentralization," "plurality," and "diversity." As Virgil Nemoianu's study of the "secondary" (1989, xii, 156–57, 173) asserts, "marginality is broader than centrality, diversity broader than clarity." In the world of imperfection, "any theory of the secondary must also be a theory of corruption, subversion, and decay." The first picaresque narrative offers ample evidence of a social condition that often verged on the pathological.

The Renaissance we have inherited is that of the writers. But what do we know about the Renaissance of the readers? Who were they? How much were they inspired by the books that still inspire us? We know that our "image" of the Renaissance is based on what we call "high culture." But below the culture of affluence there was a "popular culture" of indigence about which we still know very little.[5] Would the people who lived during the Renaissance sketch an outline of the age similar to the one that is familiar to us? We might also ask, does the sheer physiology of existence have a right to literary representation? If so, how unfictional can fiction be? Are we to infer that poetics can be absorbed into economics altogether?

On balance, econopoetics has served quite well as a point of entry for probing into the nature of dilemmas that are literary no less than economic and historical. Thus I would like to believe that this study has contributed to a better understanding of the popular culture at the margins of the imperial Golden Age. At the periphery of wealth and privilege, we must ask whether we are confronted with "parallel aspects" of a single Renaissance or whether we should conceptualize "parallel Renaissances." After much discovery and recovery, the task at hand is to continue setting Burckhardtian visions against Bakhtinian re-visions.

NOTES

1. Throughout this study, the book will be referred to as *Lazarillo de Tormes* unless the context calls for the full title. The connection between this text and the emergent tradition of picaresque novels is affirmed in a generic sense. On the subject, see Carreter (1983). For comments on first and later editions of the work, see Guillén (1971, 137–42).

2. See Ferreras (1980, 9).

3. Sieber (1978, 95). Although dated, this is still the outstanding "close reading" of the picaresque text, and my debt to it is apparent.

4. Heller (1978, 157–58) has consistently set the ideal against the real within the humanist tradition itself, arguing that "everyday life was at least as important a theme of Renaissance thought as the problems of ontology, epistemology, art, or ethics."

5. Althusser (1984, 25) writes that the Church held sway on religious functions as well as "on educational ones and a large portion of the functions of communications and culture." It is no accident that much ideological struggle, from the Reformation on, was "concentrated in an anticlerical and antireligious struggle."

6. Unamuno (1976, 45) showed little sympathy for Toledan merchants, and believed that Don Quixote's good intentions were misguided, for he "wanted to make those men, whose moneyed hearts could only see the material kingdom of riches, confess that there is a spiritual kingdom, and thus to redeem them in spite of themselves."

7. See Molho (1977, 92); von Martin (1963, 16); Lynch (1964, 116).

8. In Rome, *grancetti* specialized in purse snatching; *sbasiti* pretended illness; and "barons" begged by pretending to be out of work. See Delumeau (1976, 97).

9. See Villanueva (1968, 91, 136–37).

10. I refer here to Eagleton's categories (1986, 44–45).

11. Although extreme, Baltasar Gracian's assessment is worth quoting: "Spain is today just as God created her, without a single improvement made by its inhabitants, except for the small amount done by the Romans" (*Criticón* 3:9).

12. Cellorigo quoted by Cascardi (1997, 14–24).

13. Within the province of cultural aesthetics, in fact, Braudel and the French school of the Annales have set money and business at the core of historical studies. For a comprehensive analysis of the *monde Bradellien* vis-à-vis historiographical method and economic factors, see Hexter (1979, 61–148). See also Hayden White's discussion of the Annales (1987, 32–45). On matters of Spanish historiography,

Castro (1971, 5–6) has warned against Braudel's concentration on "economico-materialistic reasoning." Although important, the "historicomaterialistic vision" could not account for the unifying forces that made the Reconquest possible. In fact, "the economic dimension came later; it was not the primary and unifying 'logos.'"

14. See Bennassar (1983, 318).

15. At the turn of the seventeenth century, the writer Francisco de Terrazas was one of many who belonged to that nobility which had not shared in the rewards of the Conquest. Cortés's promises did not materialize in the long run, and the poet finally described Mexico itself as "Falling from age to age in greater sadness / In deeper misery, poverty, and hunger." For translation and commentary, see Green (1968, 3:75).

16. Bataillon (1969, 207) insists that *"la sátira de la honorabilidad"* could be called *"la honra de Don Dinero."*

17. Herrero (1978, 876–79).

18. On Raimundo Llull and hunger, see Green (1968, 4:262–63).

19. Croce called the picaresque *l'epica della fame,* which made ironic parallels between the epic and the novel. On Croce's comments on *Lazarillo de Tormes* and *La Celestina,* see Brancaforte (1972, 118–24).

20. See Auburn (1969, 143–52).

21. We deal here with one of those "degraded searches" undertaken by characters plunged into equally degraded milieus; see Goldmann (1975, 1–2).

22. See Castro (1967, 121).

23. I draw here on the fine essays by Ricapito (1992, 74–94; 1987, v).

24. Guillén (1971, 142–44).

25. Johnson (2000, 9).

26. See the glossary of the Bakhtin volume (1981, 425).

27. As in the case of Zola's nineteenth-century characters, the ambitious *pícaro* tests "fitness for life, biological health, the adaptability of the individual; material in his novels is organized as a testing (with negative results) of the heroes' biological worth" (Bakhtin, 1981, 389).

28. I draw here on Holquist's provocative essay (1981, 167).

29. For Herrnstein Smith, criticism ought to "define aesthetic value by contradistinction to all forms of utility or as the negation of all other measurable sources of interest or forms of value— hedonic, practical, sentimental, ornamental, historical, ideological, and so forth." This is, "in effect, to define it out of existence; for when all such utilities, interests, and other particular sources of value have been subtracted, nothing remains" (1988, 33). Later she writes: "What I am suggesting here, rather, is that what all such terms and accounts (*homo economicus, homo ludens,* man as rational creature, cultural creature, biological creature, and so forth) offer to conceptualize is something that might just as well be thought of as our irreducible *scrappiness.* I wish to suggest with this term not only that the elements that interact to constitute our motives and behavior are incomplete and heterogeneous, like scraps of things, but also ('scrap' being a slang term for fight) that they are mutually conflicting or at least always potentially at odds" (148).

30. See also Burke's groundbreaking essay (1976, 69–106).

31. Azorín wrote that *"los grandes hechos son una cosa y los menudos hechos son*

otra. Se historian los primeros. Se desdeñan los segundos. Y los segundos forman la sutil trama de la vida cotidiana" (quoted in Entralgo [1945, 262]). Balzac wrote: "I attach to common, daily facts, hidden or patent to the eye, to the acts of individual lives, and to their causes and principles, the importance which historians have hitherto ascribed to the events of public national life." More recently Marías (1987, 201) has seen the appreciation of everyday life as a characteristic trait of Spanish people: *"La vida es primariamente vida cotidiana. En ella consiste la riqueza principal de la sociedad española. . . . La vida cotidiana española tiene un plus de vitalidad, de temperamento, de incentivo."*

CHAPTER 2

1. Molho (1977, 100).

2. The tradition of the student artist who would eventually better his master dates back to Apelles and includes Giotto, Titian, and Velázquez, to name only a few.

3. *Concordia y Discordia,* as translated in Castro (1977, 169).

4. I quote from Durán (1996, 228). Moreover, Friedman (1981, 63) reminds us that "if Pablos' literary course is a blind alley, Lázaro's is a trap set from the beginning by the author."

5. Guillén (1971, 77) wrote: "The *pícaro* is not an independent hero who may be studied *in vacuo. . . .* The picaresque is based on a situation, or rather, a chain of situations." From the very beginning, its hero is involved in a tangle. "This tangle is an economic and social predicament of the most immediate and pressing nature (not a confrontation with absolute forces), an entanglement with the relative and the contemporaneous."

6. Animal imagery figures promi-

nently in Cervantes's *Colloquy of the Dogs.* Its canine protagonists introduce an array of figures that could metamorphose into beasts. The *novela* opens in the slaughterhouse of Seville and probes the *feritas* of man as beast. For a fine analysis of this text, see Forcione (1984, 108–11).

7. Marin (1986, 118).

8. Sebeok (1981, 111) might suggest that we have here an instance of "commensalism," whereby "man is a parasite or an animal or the other way around."

9. Johnson (2000, 20–21).

10. I paraphrase Maldonado de Guevara (1962, 34), who writes about *"realismo de vivencias en bruto."*

11. In the nineteenth century, the symbolism of the mouse yielded to that of the more ominous rat, as Stallybrass and White (1986, 143) remind us: "The symbolic meaning of the rat was refashioned in relation to the sanitary and medical developments of the nineteenth century. As the connections between physical and moral hygiene were developed and redeployed, there was a new attention to the purveyors of physical and moral 'dirt.' The rat was no longer primarily an economic liability (as the spoiler of grain, for instance); it was the object of fear and loathing, a threat to civilized life."

12. On theriophily and animals in fiction, see Boas (1933) and Scholtmeijer (1993).

13. On the Reign of Terror, see Geyl (1955, 47). Erasmus so phrased his stand against avarice: The "rich man can never regard anyone else without suspicion: he judges every person to be a vulture, greedily eyeing a prospective carrion; he thinks all men are flies, swarming

over him for their own feeding" (1963, chap. 35).

14. Sebeok (1979, 35–60) has done extensive work on the zoosemiotic components of human communication.

15. Serres (1982, 170–71, 195).

16. See Paparelli (1973).

17. Serres (1982, 56, 165, 184) writes that the parasite is "the tactician of the quotidian."

18. Cavillac (1983, 31).

19. Schutz (1967, 187–88).

20. I paraphrase Rivers (1983, 66–67), whose pairing of two counter-genres is worth quoting: "The two sets of fictional conventions underlying these two works constitute a perfect binary opposition. The Spanish pastoral romance, which derives from Garcilaso's eclogues and Sannazaro's *Arcadia* (1504), presents a utopian world of shepherds. Relying on a readily accessible and seldom-mentioned diet of natural foods such as acorns and cheese, they devote themselves to a leisurely life filled with music and with dialogues about love. The shepherds are courtiers in disguise, placed in an idealized world of natural art, which is free of social and economic pressures. Conversely, the Spanish picaresque novel, with roots in exemplary *(ex contrario)* folktales about sly tricks and deceptions, presents an urban society of paupers." Under the constant pressure of hunger and economic necessity, they "learn to defend themselves by hook and crook, trying to rise in a harsh world of free enterprise."

21. Dunn (1993, 305).

22. Guillén (1971, 80) introduced the term "half-outsider," and Colie (1973, 94) insisted on the picaresque's commitment to outsiderism. Of course, Lázaro is a parasite as well as a conformist. Blackburn

(1979, 19–20) tells us that "the pícaro is a conformist with little antisocial tendencies in the affirmative sense. He yearns to enter society, implicitly accepting social values no matter how hostile to his dignity they have proved to be." Loneliness for "the literary *pícaro* is the loneliness of an individual isolated *within* society."

23. Pérez-Firmat (1986, xiv).

24. For a recent study of the subject, see Carroll (1996).

25. Equally relevant at this point are Fuentes's comments on denotation and connotation (1976, 20). Denotative texts such as pastoral novels and novels of chivalry were merely anachronistic sequels of medieval textuality. By contrast, picaresque literature was connotative in that it marked a rupture of the epic order; it introduced a transgression "of the previous norm while, all the time, supporting itself on what it is violating."

26. It has been suggested that the study of "tradition" should lead historians to listen to choruses and to soloists alike. Throughout history, the dominant minority has turned a deaf ear to the chorus of the subservient majority. See Pelikan (1984, 17–18).

27. Balzac's description of the corrupted ethos of Parisian life applies equally to sixteenth-century Toledo: "Here genuine feelings are the exception; they are broken by the play of interests, crushed between the wheel of this mechanical world. Virtue is slandered here. Passions have given way to ruinous tastes and vices; everything is sublimated, is analyzed, bought and sold. It is a bazaar where everything has its price, and the calculations are made in broad daylight without shame. Humanity has only two forms, the deceiver and the deceived. . . . The honest man is the fool; generous

ideas are means to an end; religion is adjudged a necessity of government; integrity becomes a pose; everything is exploited and retailed" (quoted in Fanger [1967, 35–36]). Fanger comments, "We have Balzac's own word that anyone aware of the rules must embrace them in all their evil ramifications, yield to them passively or exist outside society, opposed to it. To this last possibility are dedicated the two cardinal Balzacian myths of the prostitute and the criminal."

28. I refer to the classic study by Foucault (1977).

29. Smith (1988, 107–8).

30. In his comments on *Guzmán de Alfarache,* Blanco Aguinaga (1969, 139) writes, "Just as the picaroon as character is *now* the novelist outside the novel, the judgments and opinions that originated in his life by force of circumstance become transformed into formal and definitive judgments on humanity." Now a solitary novelist, he "no longer pronounces from his lowly origins but rather from a 'watchtower' intellectually and morally superior to the world of others."

31. San Miguel (1971, 118) comments: *"Así llevados de la mano de Guzmán, entramos en contacto con las clases bajas y altas del pueblo (arriero, mesoneros), con las clases bajas y altas de la nobleza (capitán, embajador), con las clases bajas y altas de la iglesia (clérigos, cardenal) y naturalmente también con una clase de gentes, cuya vida se realice al margen de la sociedad (pícaros, mendigos). A esta serie de tipos sociales debemos añadir, además, las rameras, los médicos, los representantes de la justicia, etc. El interés de Guzmán se centra, no en el individuo, en su singularidad, sino en el tipo. De esta multiplicidad de tipos sacará el narrador consecuencias, que le permitan un juicio sobre el hombre en general."*

32. Stonequist (1937, xvii–xviii, 220–22).

33. For a treatment of the *atalaya-tienda* in strictly narrative terms, see Rodriguez Matos (1985, 60–66): *"El subtítulo, Atalaya de la vida humana, sugiere la imagen de la torre desde la cual se vigila, la atalaya, para el libro, 'la vida,' del predicador galeote reformado, el atalaya"* (61).

34. See Condon (1966, 9).

35. In his general discussion of the subject, Maravall (1987, 105) describes the *pícaro* as *"desvinculado"* in the sense that he is unattached to the productive forces that create social privileges.

36. I follow here Damon's (1997) discussion of the parasite in Roman literature.

CHAPTER 3

1. See Hathaway (1995, 1–3).

2. Such a crucial shift is highlighted by Foucault (1970, 240–60). With regard to *Guzmán de Alfarache,* see Smith (1988, 104–5).

3. *La vida y hechos de Estebanillo Gonzáles hombre de buen humor* 1:61, 225.

4. For further comments on the subject, see Titone (1978, 116) and Herrero (1978, 318).

5. Reference and comments by Molho (1972, 40).

6. Johnson (2000, 16–17, 4–5).

7. Atkinson (1975, 252–58) and Molho (1972, 21–23).

8. We need only add that *pícaros* hung around places of food production, exchange, and consumption. See Serres (1982, 144), de Malkiel (1964, 359). On food, clothes, and shelter as symbols of societal standing, see Brown (1984, 8).

9. Many a Spaniard, Castro tells us

(1971, 348), "preferred to die of hunger rather than to lose status—that is, not to 'maintain honor'—in the opinion of their neighbors. Cervantes refers ironically to the situation of people who preferred to fall prisoner to the Barbary pirates rather than set hand to oar so that their galley might proceed more rapidly; 'For to seize an oar in a perilous moment to them appears to be dishonorable.'" Ricapito (1992, 86) points out that *Lazarillo de Tormes* presents an "individual who belongs to a metaeconomy of poverty."

10. With respect to the *escudero's* verbal assets and materialist liabilities, one might agree with Serres (1989, 28) that "poverty is measured not only by bread but by words; not only by the lack of bread but by an excess of words. Language expands when bread is lacking."

11. Ife (1985, 108–9).

12. Shell (1984, 30–36).

13. Gilman (1966) and Forcione (1984).

14. Lutwack (1984, 31).

15. Jeanneret (1991, 8–9).

16. Sieber (1977, 20–21).

17. Guillory (1993, 319–21).

18. Novak (1992, 18–19).

19. Raya (1969, 5), an accomplished student of *famismo* and *prefamismo* in Italian literature, writes that insofar as hunger is concerned, one could replace the metaphysical *cogito ergo sum* with the physiological *edo ergo sum*.

20. Braudel (1977, 11).

21. Godzich and Spadaccini (1986, 50, x).

22. Castro (1977, 129–30) has made incisive comments on this subject.

23. Translated as *The Family in Renaissance Florence,* 150.

24. Vilar (1976, 151).

25. On the issue of anthropological signs, see Burke (1987, 8).

26. Molho (1977, 101).

27. Burke (1987, 10). The *escudero's* performative *élan* trades toothpicks for a whole array of after-meals and leftovers in *El Buscón.* As Quevedo put it, *"Entrará uno a visitarnos en nuestras casas, y hallará nuestros aposentos llenos de guesos de carnero y aves, mondaduras de fruta, la puerta embarazada con plumas y pellejos de gazapos; todo lo cual cogemos de parte de noche por el pueblo, para honrarnos con ello de día"*—"A person can come to our rooms and visit us and he'll find the place full of mutton and poultry bones and fruit peelings, and the door can't be opened because of all the feathers and rabbit skins behind it. Most of this we scrounge from the city dustbins at night and use it to show off the next day" (105, 151).

28. Vives (1968, 90) writes contemptuously, "Most riches—elaborate buildings, numerous and opulent household furnishings, precious stones, gold, silver, and every genus of ornaments—are designed and exhibited as a brag and a spectacle in other men's eyes, rather than for the use of those who possess them."

29. Barthes (1968, 28).

30. The term is used by Marin (1972, 91).

31. Eagleton (1986, 97).

CHAPTER 4

1. The recent monograph on *Velázquez in Seville* (Edinburgh: National Gallery of Scotland, 1996) calls this painting "The Waterseller of Seville." I leave

it to the art historians to reach agreement. This study will refer to the picture as *The Water Carrier*.

2. I draw from Maravall (1990, 75).

3. Steinberg (1965, 282).

4. On emblematic forms of expression, see Krieger (1992, 213–14).

5. I draw on Gramsci (1985, 189–90). In his treatment of the *"noción del 'popular' en literatura,"* Molho (1976, 18–19) paraphrases Gramsci on matters of popular literature. See also Cirese (1976, 68–69); Chevalier (1978); Soriano (1968, esp. 479–91). On the sociocultural symbolism of proverbs in the French Renaissance, see Davis (1975, 227–67).

6. Defourneaux (1970, 219) writes, "A degree above those who lived by begging came the *pícaros,* who, with the aid of a little work sufficient to keep them from the offence of vagabondage, applied themselves to scrounging and petty theft; such as the *pinches de cocina* (scullions), who could always find enough to feed themselves and their friends plentifully at the expense of the kitchens where they were employed, and the *esportilleros* (street porters and errand boys), who being responsible for delivering to the homes of customers goods of all kinds, pinched anything that could be hidden easily under their clothes. Alongside them were the pedlars *(buhonero),* a calling carried on for some time by Estebanillo after being, he says, 'degraded' from his status of pilgrim, and investing his capital in the purchase of knives, combs, rosaries, needles, and other shoddy wares, which he sold in the streets of Seville, an obligatory stage in every picaresque life."

7. Brucker (1986, vii–viii) gives a retrospective overview of that historical school, and writes, "The story of Giovanni and Lusanna fits into a genre of historical writing, microhistory, that has recently achieved some notoriety in the discipline. . . . Other noteworthy examples of the genre that have recently appeared include Ginzburg's (1980) tale of the Friulian miller Menocchio, Davis's (1983) account of the footloose peasant Martin Guerre, and Brown's (1986) poignant story of the nun Benedetta and her tribulations in a Tuscan convent. In addition to their employment of the narrative mode of exposition, these microhistories are characterized, first, by an emphasis on particular individuals and events, not on groups or structures; and second, by a predilection for the study of people and milieux hitherto unknown and unexplored. Thus, the subjects of these books are frequently peasants, artisans, vagabonds, common soldiers, witches, prostitutes, nuns, friars, and parish priests from the lower echelons of the social order."

8. Ricapito (1987, ix).

9. Levin (1963, 33–34, 193).

10. By contrast, such edible items were foreign to the geometric and textured theatricality of those untouchable still lifes that Francisco de Zurbarán or Juan Sánchez Cotán have popularized. For "spiritual" interpretations of these still lifes, see Mullins (1981, 19–21); Soria (1953, 14); Bryson (1990, 60–69).

11. I refer to her landmark study (1983, xxi, xxv).

12. See Lukács's (1970, 130–31) paradigmatic distinction between narration and description. For Lukács, description is the degenerative outcome of capitalism through the nineteenth and twentieth centuries. His general thesis notwithstanding, Lukács's paradigm is nonetheless

provocative even with regard to Renaissance textuality.

13. I expand here on Ayala (1970, 70).

14. See Burt (1982, 57); Sieber (1978, 51–56).

15. Fumerton (1991, 2) raises a question that touches on the picaresque as well: "How did the past itself think its naked facts so that a sense of identity, of selfhood, could arise even amid historical incoherence?"

16. To put it in Marx's terms (1906, 41), such eccentric purchases stem from "fancy," and have nothing to do with the "stomach."

17. Braudel (1973, ix–xii) and Heinzelman (1980, 76).

18. But this development could be related to what Jameson (1981, 152) calls the "objective" function of the novel, which included "the new rhythms of measurable time, the new secular and 'disenchanted' object world of the commodity system, with its post-traditional daily life and its bewildering empirical, 'meaningless,' and contingent *Umwelt*— of which this new narrative discourse will then claim to be the 'realistic' reflection."

19. Sieber (1978, 11) points out that "the relationship between money and speech that the blind man wants Lazarillo to perceive—speech as another kind of money—is stated at the beginning of their life together."

20. The term *estatismo de su estado* has been used by Prieto (1972, 30–33). In this connection, see also Gramsci's Marxist approach (1975, 1–3) to popular literature, and his distinction between *"folclore fossilizzato"* and *"folclore progressivo."*

21. It is worth quoting Castro's assessment of description (1977, 293): "This is life with a minimum of significance, devaluated life—when compared with the lives of those people who created the great cultures of the earth. In this, as in all questions of value, there is gradation. The lowest level corresponds to groups now called primitive, groups that have arrived at dead ends of human self-realization and who mark time down the centuries. For such life as this description is quite adequate. . . . There are no deeds or triumphs of any sort to incite the children of the future. Such primitive people may, in effect, be thought of as residing at the end of blind alleys, as excluded from the broad avenues of future possibility available to others."

22. I follow here the translation and commentary of *Menosprecio de corte y alabanza de aldea* (71–72) in Maravall (1991, 45).

23. As quoted in Martz (1983, 10).

24. Ortega y Gasset (1972, 97) has read the painting as a Titianesque bacchanal. We look at a "drunken debauch. Bacchus is a fraud. There is nothing more than what you can see and touch." See also Braudel (1972, 1:23–24, 27–29).

25. As quoted in Tihanov (2000, 53).

26. Gregory (1982, 11, 18–19).

27. Ortega y Gasset (1957, 15) writes that humanity can be divided into two classes: "those who make great demands on themselves, piling up difficulties and duties; and those who demand nothing special of themselves, but for whom to live is to be every moment what they already are."

28. It may be useful to consider Lazarillo's choices in the context of what Bakhtin (1990, 174–75, 179–80) calls "Classical Character Construction" and "Romantic Character Construction." The first is founded on *fate,* which is "the all-round determinateness of a person's existence that necessarily predetermines all the events of that person's life." The second is founded on the *idea.* The "Romantic type of character is arbitrarily self-active and full of initiatives with respect to value. What is of the utmost importance, moreover, is that the hero *responsibly initiates* the sequence of his life as determined by meaning and values. . . . The value of fate, which presupposes kin and tradition, is useless here for accomplishing artistic consummation." To a significant extent, Lázaro's growth partakes of both; in fact, it thrives on the dialogics of fate and idea.

29. Schrift (1997, 2).

30. Castro (1972, 230) maintains that *"el pícaro ve la vida picarescamente."*

CHAPTER 5

1. The coexistence of spiritualism and materialism in the picaresque challenges Lukács's (1971, 88) contention that the novel is "the epic of a world that has been abandoned by God."

2. Landes (1969, 21).

3. See the dictionary entries in Corominas (1967, 468) and in the *Diccionario de la lengua española* (Real Academia Española, 1040).

4. All quotations from Quevedo (1989, 56–57, 243–45).

5. On humanist God-terms, see Maiorino (1987, 107–12).

6. Burke (1961, 7).

7. I follow here Sieber's study (1978, 44).

8. Mancing (1979, 462).

9. Gelley (1987, 80–81) makes a relevant statement on this matter: "More to my purpose is a literary pragmatics, the determination of literary forms on the basis of social practices that motivate language usage. Taking account of the pragmatic dimension of a text means that we attempt to situate it in terms of its intended application within the literary system; and further, it requires that the literary forms be reassessed in terms of the convergence of literary and extraliterary discourse practices."

10. I follow here the fine study of Balzac's language by Kanes (1975, 168–69, 171), who refers to "germinating-words" and "words-events," which allow Balzac to "focus more sharply than he might otherwise have done on basic themes and motifs, and above all to pinpoint the moment when they enter explicitly into the narration" (176).

11. On the central relationship between author and authority in the picaresque, see Johnson (1996, 159–82, esp. 164).

12. Vernon (1984, 66; 1973, chap. 1).

13. Shipley (1982, 10). With an eye to the *stultus* tradition as well as to the parody of *"de nobilitate,"* see Truman (1975).

14. Veeser (1989, xiv).

15. On the parodic theology of things, Unamuno (1976, 354) would suggest the term "factology," which would take on a spiritual meaning in this context; the critic thus refers to "factological investigations."

16. I refer here to Anderson's thoughtful study (1993, 9).

17. See Blau (1964, 106–12).

18. See Fumerton's treatment (1991, 33–34) of the subject in connection with Elizabethan culture.

19. On anthropological matters of gift-exchange, see Malinowski (1922) and Mauss (1954).

20. Shipley (1982, 179–80) writes that Lázaro's story "is more exactly the chronicle of an arrival in safe part and, later, as a rise to a pinnacle of satisfaction what is scarcely more than a lateral move of incorporation into the debased city of man in the fallen world."

21. Starobinski (1994).

22. Molho (1972, 35–42); Shipley (1983, 231); Sieber (1978, 78).

23. For Pierre Bourdieu (1977, 183), she embodies a form of symbolic capital. On the English development of cuckoldry, see Bruster's chapter "Horns of Plenty: Cuckoldry and Capital" (1992, 47–62).

24. Barthes (1972, 173–74).

25. The concept of family is so vilified as to remind one of Serres's remark (1982, 131) that "a parasite never nourishes its children."

26. Alberto del Monte (1957, 28).

27. Morson (1987, 14).

28. On this issue in Balzac, see Levin (1963, 197).

29. Castro (1977, 286) writes: "The meaningful word (not abstracted or reduced to the level of sound) is not a thing; it is a backward and forward relationship of living experience, never fixed, always problematical."

30. For more on this subject, see Maravall (1991, 85).

31. *Diccionario de la lengua española* (Real Academia Española, 1040).

32. Elliott (1989, 7–9).

33. Tabori (1959, 18).

34. For comments on Angiolieri's family, see Orwen (1979, 44–59). For more poetry dedicated to money, see Martines (1979, 79–85).

35. The urban setting of *La Celestina* introduced a *maquiavelismo del comportamiento* based on opportunity and prudence *(oportunidad y prudencia)*, which thrived on secular experiences that taught lessons about existence at it most basic. See Maravall (1968, 113, 115–16), who found in *La Celestina "un pragmatismo agrio y pesimista, un verdadero maquiavelismo del comportamiento interindividual, desligado de vínculos tradicionales."*

36. Bijornson (1979, 71) points out that Lázaro was "advised to pay less attention to rumors and more to his 'provecho.' Lázaro's honor in this case is his gain."

CHAPTER 6

1. On onomastics and mercantilism, see Kedar (1976, 103).

2. Sasso (1990, 91–93).

3. Spitzer (1988, 142). In this connection, see Stevenson (1911, 145–50). See also Iventosch (1961, 15–32). On Cervantes, see Spitzer's exemplary essay, "Linguistic Perspectivism in *Don Quijote*" (1970, 41–86). For comments on Spitzer, Lida (1931, 169) speaks of *"creacion rabelaisiana de nombres propios"* in the Spanish picaresque. Larson (1991, 62) has written a chapter on the role and symbolism of names in Juan Ruiz de Alarcón's *La verdad sospechosa*. Don Garcia moves freely from one identity into another, and he baptizes himself

anew countless times. Curtius (1963, 495–500) has discussed the relevance of onomastics under the heading of "etymology as a category of thought." See also Fowler's (1982, 86) thoughtful comments on matters of generic names in general, and of authorial namelessness in particular.

4. In his analysis of Poe's *The Facts in the Case of M. Valdemar,* Barthes (1988, 268) argues that "a proper name must always be carefully examined, for it is, so to speak, the prince of signifiers; its connotations are rich, social, and symbolic." As a background introduction, see Starobinski (1979) and Rigolot (1977). Barolsky (1992, esp. 39–51) has made a contribution to onomastics in the context of Vasari's *Lives.* For a critical commentary on the Platonic theory of names, see Baxter (1992). On the subject of Russian Formalism, Tomashevsky (1965, 88) writes, "A character is recognized by his *characteristics.* By characteristics we mean a system of motifs intimately related to a given person. More narrowly, characteristics are the motifs which define the psychology of the person, his 'character.' The simplest characteristic of a person is his name." On Balzac's use of patronymics, see Riffaterre (1990, 33–35).

5. For a critical treatment of Barthes's "frames" and "names," see Brown (1984, 110–51).

6. Gass (1970, 49).

7. *Of Grammatology* (Baltimore: Johns Hopkins University Press, 1998), 3.

8. Culleton (1994, 20–21) suggests that proper names are outranked by "charactonyms."

9. Bijornson (1977, 21).

10. I borrow this concept from Foucault (1993, 121).

11. I follow here the translation by Hesse and Williams (1969).

12. On this point, Barthes (1980, 58–59) writes, "The proper name is in a sense the linguistic form of reminiscence."

13. On the genealogical imperative, see Tobin (1978, esp. 6–7). On onomastic transgression, see Ragussis (1986, 7).

14. Ricapito (1976, 66), in his introduction to his edition of *Lazarillo de Tormes.*

15. In a piece by Alastair Reid, *New York Review of Books,* January 25, 1979.

16. The name "Kafka" is like a Kafkaesque puzzle, given to a great many interpretations. Lázaro-Lazarillo, by contrast, warrants more limited readings. See Koelb (1989, 179), which offers a very useful approach to the interpretation of names.

17. See Maiorino (1990, 88–90) and Guillén (1971, 77–78).

18. As translated by Lucente (1986, 71) in his masterly analysis of the symbolic value of onomastics in this short story (68–97).

19. In the case of Shakespeare's Coriolanus, onomastic rebirth stemmed from deeds of military prowess:

> and from this time
> For what he did before Corioli call him
> With all th'applause and clamour of the host,
> Caius Marcius Coriolanus.
>
> (*Coriolanus* act 1, scene 9, 62–65)

The name proclaimed fame acquired through memorable deeds. In the picaresque, on the contrary, parodies of the chivalric mode led to dishonor. Ironically, even Coriolanus lost his proud name in a

city where words had become their antonyms; heroism was not heroism, names were curtailed, and the self was discredited. I follow here Gordon's provocative and pioneering essay (1975, 203, 219). Todorov (1984, 25–26) quotes Las Casas on Christopher Columbus's heightened awareness of the symbolism of his own name: "But this illustrious man, renouncing the name established by custom, chose to be called Colón, restoring the ancient form less for this reason [that it was the ancient name] than, it would seem, because he was moved by the divine will which had elected him to achieve what his surname and given name signified. Divine providence habitually intends that the persons designated to serve should receive the given names and surnames corresponding to the task entrusted to them, as we see in many a place in the Scripture. . . . This is why he was called Cristóbal, which is to say *Christum Ferens,* which means the bearer of the Christ, and it was thus that he often signed his name; for in truth he was the first to open the gates of the Ocean sea, in order to bear our Savior Jesus Christ over the waves to those remote lands and those realms hitherto unknown. . . . His surname was Colón, which means *repopulator,* a name befitting the man whose enterprise brought about the discovery of these peoples."

20. *Gramática Castellana,* 58: "*Calidad en el nombre es aquello por lo cual el nombre común se distingue del proprio. Proprio nombre es aquel que conviene a uno sólo*" (102). "*Autonomasia es cuando ponemos algún nombre común por el propio, y esto por alguna excelencia que se halla en el propio más que en todo los de aquella especie, como diciendo el Apostol entendemos Pablo.*" See also Rigolot (1977, 235). On the variety of surnames, see Cottle (1983, 127).

21. Ermarth (1983, 66).

22. See Warshaw (1974, esp. 191–93, 196). See also Good (1966, 39–55); Bickerman (1967, 1–50). Forcione takes up matters of societal disarray and fragmentation (1984, esp. 97–98).

23. Hertzler (1965, 271) asserts that "Names of persons, as of all other entities, are devices born of the need to introduce order in human relationships. Among both primitives and moderns, an individual has no definition, no validity for himself, without a name. His name is his badge of individuality, the means whereby he identifies himself and enters upon a truly subjective existence."

24. Barton (1990, 154–55).

25. Castro (1977, 110, 130).

26. It is only in a playful mode that Gongora called Lope de Vega "Lopillo," much as Quevedo applied to Gongora the diminutive of "Gongorillo." See Alonso (1961, 167).

27. In psychological terms, Parker (1947, 60) makes the following comment on the more general character of picaresque dualism: "The *pícaro* is both a product of a particular social environment and, as an individual human being, an autonomous moral person."

28. For a while, at least, Rabelais inscribed himself in the anagram Alcofrybas Nasier, and so did Erasmus when he decided to honor Thomas More's friendship in *Moira Encomium.* Anagrammatic decipherments, however, gave way to outright denial in the Spanish picaresque. Without drawing from the resonant tradition of chivalric names with Amadis at its forefront, the *Prólogo* of *Lazarillo de Tormes* foregrounds the most compact of morphological nut-

shells: the personal pronoun *Yo*. In his own beggars' talk, Erasmus's wealthy Apitius becomes indigent and joins the swelling ranks of "the order of the down-and-out" as Misoponus the beggar.

29. Butor (1964, 87). Shipley (1982, 184) calls Lázaro's master strategy "expedient renaming."

30. Francis (1978, 98).

31. Lejeune (1975, 23–24). On metacritical readings, Friedman (1988, 285) writes: "The voice-over of an implied author may, in turn, convert self-interest into self-incrimination and thus deconstruct the internal authority."

32. Such a historical process of personalization started with Francisco de Rojas's *La Celestina* and moved on to *Lazarillo de Tormes* and *Don Quixote*. See Castro (1965, 75).

33. I borrow from Hartman (1982, 128). Davis's comments (1991, 19) on the *Guzmán de Alfarache* substantiate the semantic connotations of the pronominal category in picaresque narratives: "The 'I' of Guzmán's account . . . has no reality for readers except in the context created by the narrator's words. Its very lack of extraliterary referentiality, however, enables the fictive autobiographer to select the terms that will compose for readers his social being—his status in their world as 'he.'"

34. Greenblatt (1980, 9).

35. For more on this issue, see Castro (1967, 146–47) and Gilman (1966, 166).

36. Ayala (1971, 86–87) writes: *"Lo que en ella se afirma con decisión es la dignidad, fundada en el mérito, de quienes, siéndoles contraria la fortuna, con fuerza y mana remando salieron a buen puerto."*

CHAPTER 7

1. See Burke (1987, 74), Molho (1972, 29–30), and del Monte (1957, 6). For linguistic comments, see Wagner (1968, 186,172).

2. I refer to Wardropper's essay (1977, 203). Garcia de la Concha (1981, 261) confirms that *"De boca del pueblo ha merecido también Lázaro el titulo 'de Tormes.'"*

3. Socrates explains that the meaning of the word name "seems to be a compressed sentence," which could be phrased as "being for which there is a search"; in fact, "real existence is that for which there is seeking" (Plato, *Cratylus* 421a). I follow here Brown's perceptive commentary (1992, 134–35, 151) on Barthes's treatment of names. Even in the case of Foucault, the scholar adds, "the proper name of an author is . . . never entirely proper. It always acts as a frame for a 'certain discursive set.'" The same could be said about authorial anonymity in the picaresque text.

4. I refer here to Cruz (1999, 9–13).

5. Cruz (1992) connects the leper to the *pícaro* through "a new literary archetype, one who replaces the leper in his ritual role as *pharmakos,* the perceived cause and effect of social malaise. The disappearance of the leper in society coincides with the emergence of the *pícaro* in part as a means of satisfying the social need for a new mythical scapegoat whose characteristics would contain the major ills seen to afflict sixteenth-century Spain. The *pícaro* thus assumes the position of a liminal entity, holding a symbolic value for society only so long as his role remains integral to the larger concerns of the dominant social group."

6. Inboden (1987, 72–73, 84).

7. "To live is to go toward death," Casalduero writes (1984, 449), "but for Lázaro it is to die twice. Not between two lives, but between two deaths."

8. On the onomastic subject and its bibliography, see Deyermond's brief essay (1964–65, 351–57) and Cavillac (1983, 38).

9. See Foucault (1977, 198). On the sociological associations of the literary rogue, see Smith (1988, 109–10).

10. Ortega y Gasset (1953–57, 8:1160–61). See also Gusdorf (1948, 283–91).

11. I refer here to works such as Fernandez Navarrete's *Relaciones* and Pérez de Herrera's *Amparo de pobres*. Both works are cited and commented upon in Maravall (1986, 44).

12. See Huppert (1998, 102–3).

13. Mollat (1974, 27–29).

14. See May (1969, 327–33; 1950, 54), Forcione (1984, 99), and Ife (1985, 18).

15. See the landmark study by Brancaforte (1980, 4).

CHAPTER 8

1. On the subject of university life, see Defourneaux (1970, 163–65).

2. Fernandez (1992, 20) closes his study of autobiography in modern Spanish literature by stating: "We arrive to identity by subtraction. Autobiography. Autobio. Auto . . ."

3. Adams (1990, 167–69). As for the clash between "power" in the *tratados* and "aestheticism" in the *Prólogo,* Adams writes: "Every discourse striving for power must be opposed by a discourse struggling against its own tendency to invoke power criteria" (171).

4. Carey (1979, 38–39, 40).

5. I refer to *Economic and Philosophical Manuscripts* written in 1844 and published in 1932, as translated by Trilling (1972, 121).

6. See the short but thought-provoking essay by Rozas (1980, 13).

7. For more general comments on this topos, see Heinzelman (1980, 25–26).

8. Commenting on Vico, Johnson makes a statement that illuminates the context of my argument as well: "In light of Vico's conflation of authority and property, we might rephrase the question as: who owns the discourse? This particular rephrasing locates the question of textual authority within a kind of entry-level Marxism and defines it first as an economic question, and as a theory of production. The ownership of the discourse would be analogous to the ownership of the means of production, or capital. The actual production of discourse would correspond to labor." See Johnson, "Defining the Picaresque: Authority and the Subject in *Guzmán de Alfarache,*" forthcoming.

9. I draw here on Bennington's excellent study (1985, 16–17).

10. Woods (1979, 586–87). See also Castro's comment on Antonio de Guevara (1967, 93).

11. This is one of Jeanneret's main points (1991, esp. 1–10).

12. González Echevarría (1990, 56–57).

13. On the subject of the literary exile in Spanish literature, see Ilie (1980, esp. chap. 6, 59–66) and Guillén (1976, 278).

14. Taylor (1989, 23).

15. This is Sieber's thesis (1978). On Sieber's approach, see González Echevarría (1987, 10–11).

16. Blackburn (1979, 12–13), Gilman (1972, 103–4, 84–85).

17. For Fuentes (1976, 29), the work "is written in and from Salamanca, the greatest seat of learning in Spain." Thus it "reflects the humanistic yearning for Alternatives (as against the growing centralism of the court) and an openness capable of receiving and elaborating a diversified and unprejudiced culture (as against the monolithic culture of the orthodox faith and the purity of blood promoted by the Kings and the Inquisition)."

18. Gilman (1972, 269–72, 280, 282); Reynier (1902, 30).

19. Chandler (1961, 205–9).

20. Frye (1973, 101).

21. I draw here on Vilanova's (1989) thorough study of Erasmus's influence on Cervantes, which contains inclusive and convincing citations from a body of contemporary works, many of which had to be influential on the contemporary context of the picaresque as well. On the parallelism between honor and profit, the critic calls attention to Pedro Mexia's *Silva de varia lección* (Seville, 1540): "Hablando moral y humanamente, dos cosas son principales las que mueven y levantan a los hombres a hazer grandes y señalados hechos en la guerra y en la paz. La primera es honra y fama. Y le segunda, el provecho y interés." The Erasmian text the critic quotes is *Enchiridion*, 221–32. And Vilanova acknowledges that the first to link such a text to the picaresque was Francisco Marquez Villanueva (1968, esp. 67–137).

22. In that sense, one could refer to the illustration on the frontispiece of López de Ubeda's *La pícara Justina* (1607), which also shows people on a ship towed by Lazarillo in a small boat. See also Smith (1988, 80).

23. Mikhail Bakhtin (1968, 50) makes important statements on the geographical reality of modern narratives. Throughout the eighteenth century, landscape was disengaged from abstract contextuality. For Goethe, however, "the locality became an irreplaceable part of the geographically and historically determined world." Thus the event "became an essential and non-transferable moment in the time of this particular human history that occurred in this, and only in this, geographically determined human world." To a significant extent, *Lazarillo de Tormes* also thrived on that recognition.

24. Domínguez Ortiz (1971, 118).

25. Toliver (1974, 365) writes about narrative and the *pícaro*: "The prominence of discontinuity in his story does not mean that it lacks symbols or symbolic gathering points, merely that what is symbolized is often the discrepancy between logic and experience. Such standard tropes and symbols as the journey, the city, and the household become in picaresque not enduring and continuous institutions but sets of rules and decorums to be violated, remnants of an order teeming with conniving and rule-breaking. The *pícaro* knows his society largely from the hostility it manifests on the open road or from outside the shuttered household of more fortunate people." Vernon asserts location and property (1984, 37). Associations between human activities and specific cities are common

in literary texts. Don Quixote located criminality in Barcelona, whereas Pablos identifies Besançon with business deals.

26. To borrow from Sieber (1978, ix), the language of honor juxtaposes the dishonorable life of the town crier with the growth of an honorable author. Sieber weaves his linguistic study of the language of honor with sociological and economic threads.

27. Tillotson (1959, 23). See also Booth (1966, 70–71).

CHAPTER 9

1. Shell (1993, 180–81). Shell also says, "Literary works are composed of small tropic exchanges or metaphors, some of which can be analyzed in terms of signified economic content and all of which can be analyzed in terms of economic form" (1978, 7).

2. Said's comments (1975, 95) on *Great Expectations* shed light on the ideological structure of the picaresque as well: "Pip can neither hold expectations nor realize them without a patron who makes them possible. Thus Pip's freedom is dependent upon an unnamed patron who requires visits to Jaggers, who requires that no questions be asked, and so on. The more Pip believes he is acting on his own, the more tightly he is drawn into an intricate web of circumstances that weighs him down completely; the plot's progressive revelation of accidents connecting the principal characters is Dickens's method of countering Pip's ideology of free upward progress."

3. See Burke (1974), Yamey (1989), Halpern (1991), and Fumerton (1991).

4. It should be clear that my method differs from the more ideological approaches of such critics as Jameson,

Lukács, Said, and Benjamin. Moreover, I still find Spitzer's "linguistic" lesson helpful (1988, 397–420).

5. Riley (1951, 201) points out that "there were not nearly so many Aristotelian preceptists in Spain as in Italy."

6. Guillén (1971, 156).

7. See Maiorino (1990, 92).

8. On Renaissance literary experiments, see Rivers (1983, 39–72). Antonio Gramsci (1985, 132) has found in autobiography elements of the "political" or "philosophical essay," for it describes life in action and not just as dominant moral principles say it should be.

9. Bataillon (1991, 652–53) dismissed Erasmus's influence on the picaresque, which had been vindicated by Menéndez Pelayo (1941, 1:330). For a comprehensive study of scholarship and the "Erasmian connection" after Bataillon's study, see Marquez Villanueva (1968, 67–73) and Vilanova (1989, 237–79).

10. Mikhail Bakhtin (1981) introduced the concept of chronotope, which describes the dynamic coexistence of time and space. Holquist defines chronotope as "Literally 'time-space.' A unit of analysis for studying texts according to the ratio and nature of the temporal and spatial categories represented. The distinctiveness of this concept as opposed to most other uses of time and space in literary analysis lies in the fact that neither category is privileged; they are utterly interdependent. The chronotope is an optic for reading texts as x-rays of the forces at work in the culture system from which they spring" (1981, 425–26).

11. *Gramática Castellana* 1:10–11, 5. For comments on Nebrija's text in con-

nection with sixteenth-century linguistic colonialism, see Greenblatt (1990, 16–17).

12. Nerlich (1986, 62–64).

13. Chevalier (1978).

14. The term "unwritten poetics" was coined by Poggioli (1965, 345) in his discussion of the modern novel. Colie (1973, 29–30) adds that "from 'real' literature as opposed to criticism and theory, of course, we recover what is far more important, the *unwritten* poetics by which writers worked and which they themselves created." For the idea of the audience as the writer's own fiction, see Ong (1975, 9–21). On the concept of implied reader, see Iser (1974). On reception theory, I refer to Jauss (1982). On the novel as an open genre close to reality, see Bakhtin (1981, 38–40). On linguistic and textual experiments, I rely on Rivers (1983, 44–45, 57–58, 66–67).

15. Bakhtin (1978, 30).

16. Reed (1981, 13).

17. Tihanov (2000, 135).

18. Guillén introduced the term "half-outsider" (1971, 80) and Colie (1973, 94) insisted on the picaresque's commitment to "outsiderisms." To clarify the importance of picaresque outsiderism from a sociological standpoint, it ought to be noted that Lázaro is a parasite as well as a conformist. Blackburn (1979, 19–20) writes, "the *pícaro* is a conformist with little antisocial tendencies in the affirmative sense. He yearns to enter society, implicitly accepting social values no matter how hostile to his dignity they have proved to be." Loneliness for "the literary *pícaro* is the loneliness of an individual isolated *within* society."

19. I refer again to the outstanding work on the subject by Reed (1981).

20. Bakhtin (1981, 20) wrote: "In

the high genres all authority and privilege, all lofty significance and grandeur, abandon the zone of familiar contact for the distanced plane (clothing, etiquette, the style of a hero's speech and the style of speech about him). It is in this orientation toward completeness that the classicism of all non-novel genres is expressed."

21. On popular culture, history, and social anthropology, I refer to Ginzburg (1980, viii–xxvi) and Davis (1975, xv–xviii).

22. Shipley (1982, 107).

23. See Bennington's study (1985, xi).

24. According to Wright (1982, 63–65), "this 'charged' quality distinguishes novelistic prose (along with the prose of the modern short story, not essentially different) from good 'ordinary prose.' The words suggest much more than they say, so that the prose emerges from its invisibility and begins to call attention to itself, acquiring linguistic intensity. . . . All the specialized styles have in common the pursuit of a linguistic intensity that in one way or another spotlights the capabilities of a language that would otherwise be self-effacing."

25. Bakhtin (1981, 388–90).

26. Gonzáles Echevarría (1998, 172) writes: "Legal writings deal with legitimacy, enfranchisement, and self-definition in the context of a patrimonial-bureaucratic state that controls writing and hence knowledge, which it safeguards in great storehouses like the Archive at Simancas and the Escorial, both created by Philip II."

27. On matters of ideology and genre, see Beebee (1994, 264).

28. Translation and commentary in Green (1968, 2:61–62).

29. Thompson (1996, 193).

30. I paraphrase Bersani's illuminating comments (1984, 66).

31. In terms of New Historicist criticism, "self-fashioning always involves some experience of threat, some effacement or undermining, some loss of self" Greenblatt (1980, 9).

32. Woolf (1980, 21).

33. In the context of my comparison between the city of gold and the city of letters, Smith (1978, 113–16) makes a comment that bears on the dichotomy between economic reality and utopian escape. He believes that "the image of a type of communication that excludes all strategy, instrumentality, (self)-interest, and, above all, the profit motive, reflects what appears to be a more general recurrent impulse to dream an escape from economy, to imagine some special type, realm, or mode of value." Moreover, "it is understandable that the dream of an escape from economy should be so sweet and the longing for it so pervasive and recurrent. Since it does appear to be inescapable, however, the better (that is, more effective, more profitable) alternatives would seem to be not to seek to go beyond economy but to do the best we can going *through*—in the midst of and perhaps also by means of—it."

34. Rabinowitz (1987, 160) and Torgovnick (1981, 19–20).

35. The Bakhtinian School of historical poetics has linked the novel to the need of grasping life novelistically. It could be suggested that the form and content of the picaresque text does this by flaunting direct contacts with the ebb and flow of human existence. See Medvedev and Bakhtin (1978, 135) and Bakhtin (1981, 39). On historical poetics,

see Swingewood (1987, 103–5) and Goldmann (1975).

36. Cavillac (1983, 44–45).

37. Shell (1984, 9).

38. LaCapra (1985, 68).

39. This critical advantage is missing in the equally autobiographical *Estebanillo Gonzáles,* in which, as Spadaccini (1972, 197) tells us, "there is no distance between the writer and the acting protagonist."

40. Parret (1988, 18–19, 168–69).

CHAPTER 10

1. For more on banking power houses, see Braudel (1977, 4–5).

2. On the use that Braudel and his followers made of monetary, commercial, and economic expressions, see Carrard (1992, 206–7).

3. For hybridization, I refer to Stallybrass and White (1986); for negotiation, see Greenblatt (1988).

4. After the completion of this study, the *PMLA* opened the third millennium with an entire issue dedicated to "Rereading Class" (Jan. 2000, 115 [1]). In a modern and theoretical key the essays take up themes and issues akin to those I raise here. One contributor, Hitchcock writes, "While class is constantly being rethought vis-à-vis the social, it is generally undertheorized in terms of the literary" ("They Must Be Represented? Problems in Theories of Working-Class Representation," 20).

5. I take comfort in Américo Castro's (1977, 281) recommendation: "In addition to describing, narrating and articulating the facts of history, the true historian must also cause his reader to perceive (or to estimate) their *worth* in an effective and plausible fashion."

WORKS CITED

Adams, Hazard. 1990. *Antithetical Essays in Literary Criticism and Liberal Education.* Tallahassee: Florida State University Press.

Agancinsky, S., et al., eds. 1975. *Mimesis: Des Articulations.* Paris: Flammarion.

Alberti, Leon Battista. 1969. *I libri della famiglia.* Trans. Renée Watkins as *The Family in Renaissance Florence.* Columbia: University of South Carolina Press.

———. 1984. *Apologhi ed elogi.* Genoa: Costa & Nolan.

Albornóz, Bartolomé de. 1573. *Arte de los Contratos.* Valencia: Pedro de Huerte.

Alonso, Amado. 1961. *Estudios lingüísticos. Temas españoles.* Madrid: Editorial Gredos.

Alpers, Svetlana. 1983. *The Art of Describing Dutch Art in the Seventeenth Century.* Chicago: University of Chicago Press.

Alter, Robert. 1964. *Rogue's Progress: Studies in the Picaresque Novel.* Cambridge: Harvard University Press.

Althusser, Louis. 1984. *Essays in Self-Criticism.* Atlantic Highlands: Humanities Press.

Alvarez-Altman, Grace. 1978. Literary Onomastics in *Lazarillo de Tormes. Literary Onomastics Studies* 5.

Anderson, Elizabeth. 1993. *Value in Ethics and Economics.* Cambridge: Cambridge University Press.

Auerbach, Erich. 1968. *Mimesis: The Representation of Reality in Western Literature.* Princeton: Princeton University Press.

Atkinson, A. B. 1975. *The Economics of Inequality.* Oxford: Clarendon Press.

Auburn, Charles. 1969. La miseria en España en los siglos xvi y xvii y la novela picaresca. In *Literatura y Sociedad: Problemas de metodología en sociología de la literatura. Colloque international de sociologie de la literature.* Ed. José Ortiz. Barcelona: M. Roca.

Ayala, Francisco. 1970. *Reflexiones sobre la estructura narrativa.* Madrid: Taurus Ediciones.

———. 1971. *El Lazarillo: nuevo examen de algunos aspectos.* Madrid: Taurus Ediciones.

Bakhtin, Mikhail. 1968. *Rabelais and His World.* Cambridge: MIT Press.

———. 1968. *Speech Genres and Other Late Essays.* Austin: University of Texas Press.

———. 1978. *The Formal Method in Literary Scholarship: A Critical Introduction to Sociological Poetics.* Baltimore: Johns Hopkins University Press.

———. 1981. *The Dialogic Imagination: Four Essays.* Austin: University of Texas Press.

———. 1990. *Art and Answerability: Early Philosophical Essays by M. M. Bakhtin.* Ed. Michael Holquist. Austin: University of Texas Press.

Balzac, Honore de. 1900. *Honoré de Balzac in Twenty-Five Volumes: The First Complete Translation into English.* New York: P. F. Collier and Son.

Barolsky, Paul. 1992. *Why Mona Lisa Smiles and Other Tales by Vasari*. University Park: Pennsylvania State University Press.

Barthes, Roland. 1968. *Elements of Semiology*. New York: Hill and Wang.

———. 1972. *The Structuralists: From Marx to Levi-Strauss*. Ed. Richard de George and Fernande de George. Garden City: Anchor Books.

———. 1972. *Critical Essays*. Evanston: Northwestern University Press.

———. 1974. *S/Z*. New York: Hill and Wang.

———. 1980. *New Critical Essays*. New York: Hill and Wang.

———. 1988. *The Semiotic Challenge*. New York: Hill and Wang.

Barton, Ann. 1990. *The Names of Comedy*. Toronto: University of Toronto Press.

Bataillon, Marcel. 1969. *Pícaros y picaresca*. Madrid: Taurus.

———. 1991. *Erasme et l'Espagne*. Geneva: Droz.

Baxter, Timothy M. S. 1992. *The Cratylus: Plato's Critique of Naming*. Leiden: E. J. Brill.

Beebee, Thomas O. 1994. *The Ideology of Genre: A Comparative Study of Generic Instability*. University Park: Pennsylvania State University Press.

Bennassar, Bartolomé. 1967. *Valladolid au siècle d'or: Une ville de Castille et sa campagne au xvi siècle*. Paris: Mouton.

———. 1979. *The Spanish Character: Attitudes and Mentalities from the Sixteenth to the Nineteenth Century*. Berkeley and Los Angeles: University of California Press.

———. 1983. *La España del Siglo de Oro*. Barcelona: Critica.

Bennington, Geoffrey. 1985. *Sententiousness and the Novel: Laying Down the Law in Eighteenth-Century French Fiction*. Cambridge: Cambridge University Press.

Bersani, Leo. 1984. *A Future for Astyanax: Character and Desire in Literature*. New York: Columbia University Press.

Beverly, John. 1993. *Literature Against Itself*. Minneapolis: University of Minnesota Press.

Bickerman, Elias. 1967. *Four Strange Books of the Bible*. New York: Schocken Books.

Bijornson, Richard. 1977. *The Picaresque Hero in European Fiction*. Madison: University of Wisconsin Press.

———. 1979. Lazarillo "Arrimándose a los Buenos." *Romance Notes* 19.

Blackburn, Alexander. 1979. *The Myth of the Pícaro: Continuity and Transformation of the Picaresque Novel, 1554–1954*. Chapel Hill: University of North Carolina Press.

Blanco Aguinaga, Carlos. 1969. Cervantes and the Picaresque Mode: Notes on Two Kinds of Realism. In *Cervantes: A Collection of Critical Essays*. Ed. Lowry Nelson Jr. Englewood Cliffs: Spectrum Books.

Blau, Peter M. 1964. *Exchange and Power in Social Life*. New York: J. Wiley.

Bloch, Howard R. 1983. *Etymologies and Genealogies: A Literary Anthropology of the French Middle Ages*. Chicago: University of Chicago Press.

Boas, George. 1933. *The Happy Beast in French Thought of the Seventeenth Century*. Baltimore: Johns Hopkins University Press.

———. 1969. *Vox Populi: Essays in the History of an Idea*. Baltimore: Johns Hopkins University Press.

Bonnefis, Philippe, and A. Buisine. 1981. Le Nom rattache et detache dans le mêfme

temps: Scènes typiques avec legendes. In *La chose capitale*. Lille: Université de Lille.

Booth, Wayne C. 1966. *The Rhetoric of Fiction*. Chicago: University of Chicago Press.

Bourdieu, Pierre. 1977. *Outline of a Theory of Practice*. Cambridge: Cambridge University Press.

Brancaforte, Benito. 1972. *Benedetto Croce y su crítica de la literatura española*. Madrid: Editorial Gredos.

———. 1980. *Guzmán de Alfarache: Conversion or proceso de degradacion?* Madison: Hispanic Seminary of Medieval Studies.

Braudel, Fernand. 1972. *The Structures of Everyday Life*. Vol. 1. New York: Harper & Row.

———. 1972. *The Mediterranean and the Mediterranean World in the Age of Philip II*. Vol. 2. New York: Harper & Row.

———. 1973. *Capitalism and Material Life, 1400–1800*. London: Weidenfeld and Nicolson.

———. 1977. *Afterthought on Material Civilization and Capitalism*. Baltimore: Johns Hopkins University Press.

Brombert, Victor. 1988. *The Hidden Reader: Stendhal, Balzac, Hugo, Baudelaire, Flaubert*. Cambridge: Harvard University Press.

Brown, Andrew. 1992. *Roland Barthes: The Figures of Writing*. New York: Oxford University Press.

Brown, James W. 1984. *Fictional Meals and Their Function in the French Novel, 1789–1848*. Toronto: University of Toronto Press.

Brown, Judith. 1986. *Immodest Acts: The Life of a Lesbian Nun in Renaissance Italy*. New York: Oxford University Press.

Brucker, Gene. 1986. *Giovanni and Lusanna: Love and Marriage in Renaissance Florence*. Berkeley and Los Angeles: University of California Press.

Bruni, Leonardo. 1978. Panegyric to the City of Florence. In *The Earthly Republic: Italian Humanists on Government and Society*. Ed. B. G. Kohl and R. G. Witt. Philadelphia: University of Pennsylvania Press.

Bruster, Douglas. 1992. *Drama and the Market in the Age of Shakespeare*. Cambridge: Clarendon Press.

Bryson, Norman. 1990. *Looking at the Overlooked: Four Essays on Still Life Painting*. Cambridge: Harvard University Press.

Burckhardt, Jacob. 1958. *The Civilization of the Renaissance in Italy*. New York: Harper & Row.

Burke, Kenneth. 1961. *The Rhetoric of Religion: Studies in Logology*. Boston: Beacon Press.

Burke, Peter. 1974. *Venice and Amsterdam: A Study of Seventeenth-Century Elites*. London: Temple Smith.

———. 1976. Oblique Approaches to the History of Popular Culture. In *Approaches to Popular Culture*. Ed. C. W. E. Bigsby. London: E. Arnold.

———. 1978. *Popular Culture in Early Modern Europe*. New York: New York University Press.

————. 1987. *The Historical Anthropology of Early Modern Italy: Essays on Perception and Communication.* New York: Cambridge University Press.

Burt, John R. 1982. *Selected Themes and Icons from Medieval Spanish Literature: Of Beards, Shoes, Cucumbers, and Leprosy.* Potomac, Md.: Studia Humanitatis.

Butor, Michel. 1964. *Essais sur le roman.* Paris: Gallimard.

Calvino, Italo. 1986. *Sotto il sole del giaguaro.* Milan: Garzanti.

Camporesi, Piero. 1978. *Il paese della fame.* Bologna: Il Mulino.

————. 1989. *Bread of Dreams: Food and Fantasy in Early Modern Europe.* Oxford: Basil Blackwell.

Camus, Albert. 1955. *The Myth of Sisyphus and Other Essays.* New York: Knopf.

Carey, Douglas M. 1979. *Lazarillo de Tormes* and the Quest for Authority. *PMLA* 94.

Carrard, Philippe. 1992. *Poetics of the New History: French Historical Discourse from Braudel to Chartier.* Baltimore: Johns Hopkins University Press.

Carreter, Fernando Lázaro. 1983. *Lazarillo de Tormes en la picaresca.* Barcelona: Ariel.

Carroll, William C. 1996. *Fat King, Lean Beggar: Representations of Poverty in the Age of Shakespeare.* Ithaca: Cornell University Press.

Casalduero, Joaquín. 1984. *Estudios de literatura española.* Madrid: Gredos.

Cascardi, Anthony. 1997. *Ideologies of History in the Spanish Golden Age.* University Park: Pennsylvania State University Press.

Cassirer, Ernst. 1953. *Language and Myth.* New York: Harper & Bros.

Castiglione, Baldassar. 1959. *The Book of the Courtier.* Trans. C. Singleton. New York: Anchor Books.

Castro, Américo. 1949. *Aspectos del Vivir Espánico: Espiritualismo, Mesianismo, Actitud personal en los siglos XIV al XVI.* Santiago del Chile: Cruz del Sur.

————. 1965. *La Celestina como contienda literaria (castas y casticismo).* Madrid: Revista de Occidente.

————. 1967. *Hacia Cervantes.* Madrid: Taurus.

————. 1971. *The Spaniards: An Introduction to Their History.* Berkeley and Los Angeles: University of California Press.

————. 1972. *El pensamiento de Cervantes.* Barcelona: Noguera.

————. 1977. Concordia y Discordia. In *An Idea of History: Selected Essays of Américo Castro.* Ed. S. Gilman and E. L. King. Columbus: Ohio State University Press.

Cavillac, Michel. 1983. *Gueux et Marchands dans le Guzmán de Alfarache (1599–1604): Roman picaresque et mentalité bourgeoise dans l'Espagne du Siècle d'Or.* Bordeaux: Institut d'études iberiques et ibero-americaines de l'Université de Bordeaux.

Cellorigo, Marín Gonzáles de. 1600. *Memorial de la política necesaria y útil restauración de España.* Madrid: Instituto de Cooperacion Iberoamericana.

Cervantes, Miguel de. 1950. *Don Quixote.* Trans. J. M. Cohen. New York: Penguin Books.

————. 1982. *Exemplary Novels.* New York: Penguin Books.

Chandler, Frank W. 1961. *Romances of Roguery: An Episode in the History of the World.* New York: B. Franklin.

Chevalier, Maxime. 1978. *Cuentecillos tradicionales en la España del Siglo de Oro.* Madrid: Editorial Gredos.

Cirese, Mario. 1976. *Intellettuali, folklore, istinto di classe: Note su Verga, Deledda, Scotellaro, Gramsci*. Turin: Einaudi.

Clayton, Jay. 1993. *The Pleasures of Babel: Contemporary American Literature and Theory*. New York: Oxford University Press.

Colie, Rosalie. 1973. *The Resources of Kind: Genre-Theory in the Renaissance*. Berkeley and Los Angeles: University of California Press.

Condon, John C. 1966. *Semantics and Communication*. New York: Macmillan.

Corominas, Joan. 1967. *Breve Diccionario Etimológico de la lengua castellana*. Madrid: Editorial Gredos.

Cottle, Basil. 1983. *Names*. London: Thames and Hudson.

Cros, Edmond. 1971. La mendicidad como campo de gravitación. In *Mateo Alemán: Introducción a su vida y a su obra*. Salamanca: Anaya.

———. 1988. *Theory and Practice of Sociocriticism*. Minneapolis: Minnesota University Press.

Cruz, Anne J. 1985. The Picaresque as Discourse of Poverty. *Ideologies and Literature* 1: 75–97.

———. 1992. Lacerado de mí: Lazarillo's Discourse on Poverty. Lecture delivered at Conference on Renaissance Displacements: The Enduring Marginality of the Picaresque, Indiana University, Bloomington.

———. 1999. *Discourses of Poverty: Social Reform and the Picaresque Novel in Early Modern Spain*. Toronto: University of Toronto Press.

Culleton, Claire A. 1994. *Names and Naming in Joyce*. Madison: University of Wisconsin Press.

Curtius, Ernst Robert. 1963. *European Literature and the Latin Middle Ages*. New York: Harper & Row.

Damon, Cynthia. 1997. *The Mask of the Parasite: A Pathology of Roman Patronage*. Ann Arbor: University of Michigan Press.

Davis, Natalie Zemon. 1975. *Society and Culture in Early Modern France: Eight Essays*. Stanford: Stanford University Press.

———. 1983. *The Return of Martin Guerre*. Cambridge: Harvard University Press.

———. 1992. Stories and the Hunger to Know. *Yale Journal of Criticism* 5.

Davis, Nina Cox. 1991. *Autobiography as Burla in the Guzmán de Alfarache*. Lewisburg: Bucknell University Press.

De Certeau, Michel. 1988. *The Practice of Everyday Life*. Berkeley and Los Angeles: University of California Press.

Defourneaux, Marcelin. 1970. *Daily Life in Spain in the Golden Age*. London: Praeger Publishers.

De Grazia, Sebastian. 1989. *Machiavelli in Hell*. Princeton: Princeton University Press.

Delumeau, Jean. 1976. *Rome au 16me siècle*. Paris: Hachette.

Del Monte, Alberto. 1957. *Itinerario del romanzo picaresco spagnolo*. Florence: Sansoni.

De Maddalena, Aldo. 1986. La republica internazionale del danaro; un'ipotesi infondata o una tesi sostenibile? In *La repubblica internazionale del danaro tra il XV e il XVII secolo*. Ed. Aldo De Maddalena and Hermann Kellenbenz. Bologna: Il Mulino.

De Malkiel, Maria Roda Lida. 1964. La función del cuento popular en el *Lazarillo de*

Tormes. In *Actas del Primer Congreso Internacional de Hispanistas*. Ed. Frank Pierce and Cyril A. Jones. Oxford: Clarendon Press.

De Man, Paul. 1984. *The Rhetoric of Romanticism*. New York: Columbia University Press.

Derrida, Jacques. 1986. *Glas*. Lincoln: University of Nebraska Press.

———. 1994. *Given Time: I. Counterfeit Money*. Chicago: University of Chicago Press.

———. 1998. *Of Grammatology*. Baltimore: Johns Hopkins University Press.

De Rivandeira, Pedro. 1589. *Treatise on Tribulation*. Salamanca: Ruiz.

Deyermond, A. D. 1964–65. Lazarus and Lazarillo. *Studies in Short Fiction 2*.

Domínguez Ortiz, Antonio. 1971. *The Golden Age of Spain, 1516–1659*. London: Weidenfeld and Nicholson.

Donato, Eugenio. 1984. The Crypt of Flaubert. In *Flaubert and Postmodernism*. Ed. Naomi Schor and Henry F. Majewski. Lincoln: University of Nebraska Press.

———. 1984. Who Signs Flaubert? *Modern Language Notes 99*.

D'Ors, Eugenio. 1950. Pobreza y Miseria. In *La palabra en la onda*. Buenos Aires: Sudamericana.

———. 1964. *La Ciencia de la Cultura*. Madrid: Gredos.

Dunn, Peter. 1993. *Spanish Picaresque Fiction: A New Literary History*. Ithaca: Cornell University Press.

Durán, Manuel. 1996. Picaresque Elements in Cervantes's Works. In *The Picaresque: Tradition and Displacement*. Ed. Giancarlo Maiorino. Minneapolis: University of Minnesota Press.

Eagleton, Terry. 1976. *Criticism and Ideology: A Study in Marxist Literary Theory*. Atlantic Highlands: Humanities Press.

———. 1986. *William Shakespeare*. Oxford: Basil Blackwell.

Eakin, John Paul. 1992. *Touching the World: Reference in Autobiography*. Princeton: Princeton University Press.

Earle, Peter G. 1966. Unamuno: *Historia and Intra-historia*. In *Spanish Thought and Letters in the Twentieth Century: An International Symposium Held at Vanderbilt University to Commemorate the Centenary of the Birth of Miguel de Unamuno, 1864–1964*. Ed. German Bleiberg and E. Inman Fox. Nashville: Vanderbilt University Press.

Elliott, J. H. 1989. *Spain and Its World, 1500–1700: Selected Essays*. New Haven: Yale University Press.

Entralgo, Pedro Laín. 1945. *Generación del Noventa y Ocho*. Madrid: Espasa Calpe.

Espinel, Vicente. 1972. *Vida del escudero Marcos de Obregon*. Ed. S. Carrasco Urgoiti. Madrid: Castalia.

Erasmus, Desiderius. 1963. *Enchiridion*. Trans. Raymond Himelick. Bloomington: Indiana University Press.

———. 1965. *The Colloquies of Erasmus*. Vol. 1. Chicago: University of Chicago Press.

Ermarth, Elizabeth Deeds. 1983. *Realism and Consensus in the English Novel*. Princeton: Princeton University Press.

Fanger, Donald. 1967. *Dostoevsky and Romantic Realism: A Study of Dostoevsky in Relation*

to Balzac, Dickens, and Gogol. Chicago: University of Chicago Press.

Fernandez, James D. 1992. *Apology to Apostrophe: Autobiography and the Rhetoric of Self-Representation in Spain.* Durham: Duke University Press.

Ferreras, Juan Ignacio. 1980. *Fundamentos de sociología de la literatura.* Madrid: Cátedra.

Fishelov, David. 1993. *Metaphors of Genre: The Role of Analogies in Genre Theory.* University Park: Pennsylvania State University Press.

Flaubert, Gustave. 1973. *Correspondence, 1830–1851.* Vol. 1. Ed. Jean Bruneau. Paris: Gallimard.

Forcione, Alban K. 1984. *Cervantes and the Mystery of Lawlessness: A Study of El casamiento engañoso y El coloquio de los perros.* Princeton: Princeton University Press.

Foucault, Michel. 1970. *The Order of Things: An Archeology of the Human Sciences.* New York: Vintage Books.

———. 1977. *Discipline and Punish: The Birth of the Prison.* New York: Pantheon Books.

———. 1993. *Language, Counter-Memory, Practice: Selected Essays and Interviews.* Ithaca: Cornell University Press.

Fowler, Alastair. 1982. *Kinds of Literature: An Introduction to the Theory of Genres and Modes.* Cambridge: Harvard University Press.

Francis, Alan. 1978. *Picaresca, Decadencia, Historia: aproximación a una realidad histórico-literaria.* Madrid: Gredos.

Friedman, Edward. 1981. Chaos Restored: Authorial Control and Ambiguity in *Lazarillo de Tormes. Crítica Hispánica* 3.

———. 1988. The Fortunes of Irony: A Metacritical Reading of *Lazarillo de Tormes. Essays in Literature* 15.

Frye, Northrop. 1973. *The Critical Path: Essays on the Social Context of Literary Criticism.* Bloomington: Indiana University Press.

Fuentes, Carlos. 1976. *Don Quixote, or the Critique of Reading.* Austin: University of Texas Press.

Fumerton, Patricia. 1991. *Cultural Aesthetics: Renaissance Literature and the Practice of Social Ornament.* Chicago: University of Chicago Press.

Garcia de la Concha, Victor. 1981. *Nueva lectura del Lazarillo.* Madrid: Castalia.

Gass, William H. 1970. *Fiction and the Figures of Life.* New York: Knopf, 1970.

Gelley, Alexander. 1987. *Narrative Crossings.* Baltimore: Johns Hopkins University Press.

Geremek, Bronislaw. 1988. *La stirpe di Caino: L'immagine dei vagabondi e dei poveri nelle letterature europee dal XVI al XVII secolo.* Milan: Il Saggiatore.

———. 1994. *Poverty: A History.* Oxford: Blackwell.

Geyl, Pieter. 1955. *Uses and Abuses of History.* New Haven: Yale University Press.

Gibson, Charles. 1971. *The Black Legend: Anti-Spanish Attitudes in the Old World and the New.* New York: Knopf.

Gilman, Stephen. 1966. The Death of Lazarillo de Tormes. *PMLA* 81.

———. 1972. *The Spain of Fernando de Rojas: The Intellectual and Social Landscape of La Celestina.* Princeton: Princeton University Press.

Ginzburg, Carlo. 1980. *The Cheese and the Worms: The Cosmos of a Sixteenth-Century Miller*. Baltimore: Johns Hopkins University Press.

Godbout, Jacques T. 1992. *L'esprit du don*. Paris: Editions La Découverte.

Godzich, Wlad, and Nicholas Spadaccini. 1986. Popular Culture and Spanish Literary History. In *Literature Among Discourses: The Spanish Golden Age*. Ed. Wlad Godzich and Nicholas Spadaccini. Minneapolis: University of Minnesota Press.

Goldmann, Lucien. 1975. *Towards a Sociology of the Novel*. London: Tavistock Publications.

Goldthwaite, Richard. 1987. The Economy of Renaissance Italy. The Preconditions for Luxury Consumption. In *I Tatti Studies: Essays in the Renaissance*. Vol. 2. Ed. Walter Kaiser. Florence: Harvard University Center for Italian Renaissance Studies.

González Echevarría, Roberto. 1934. *La vida y hechos de Estebanillo Gonzáles hombre de buen humor*. Vol. 1. Madrid: Aguillar.

———. 1987. The Life and Adventures of Cipion: Cervantes and the Picaresque. In *Cervantes*. Ed. Harold Bloom. New York: Chelsea.

———. 1990. *Myth and Archive: A Theory of Latin American Narrative*. Cambridge: Cambridge University Press.

———. 1993. *Celestina's Brood: Continuities of the Baroque in Spanish and Latin American Literatures*. Durham: Duke University Press.

———. 1998. *Myth and Archive: A Theory of Latin American Narrative*. Durham: Duke University Press.

Good, Edwin M. 1966. *Irony in the Old Testament*. Philadelphia: Westminster Press.

Gordon, D. J. 1975. *The Renaissance Imagination*. Berkeley and Los Angeles: University of California Press.

Gould, Stephen Jay. 1977. *Ever Since Darwin: Reflections in Natural History*. New York: Norton.

Graciam, Baltasar. 1980. *Criticon*. 3 vols. Madrid: Cátedra.

Gramsci, Antonio. 1950. Osservazioni sul folklore. In *Opere*. Vol. 6. Turin: Einaudi.

———. 1971. *Il Risorgimento*. Rome: Editori Riuniti.

———. 1975. *Quaderni dal carcere*. Vols. 2–3. Turin: Einaudi.

———. 1985. *Antonio Gramsci: Selections from Cultural Writings*. Ed. David Forgacs and Geoffrey Nowell-Smith. Trans. William Boelhower. Cambridge: Harvard University Press.

Green, Martin. 1979. *Dreams of Adventure, Deeds of Empire*. New York: Basic Books.

Green, Otis H. 1968. *Spain and the Western Tradition: The Castilian Mind in Literature from El Cid to Calderón*. Vols. 2–4. Madison: University of Wisconsin Press.

Greenblatt, Stephen. 1980. *Renaissance Self-Fashioning: From More to Shakespeare*. Chicago: University of Chicago Press.

———. 1988. *Shakespearean Negotiations*. Berkeley and Los Angeles: University of California Press.

———. 1990. *Learning to Curse: Essays in Early Modern Culture*. New York: Routledge.

———. 2001. Racial Memory and Literary History. *PMLA* 116.

Gregory, C. A. 1982. *Gifts and Commodities*. New York: Academic Press.

Grice, Paul. 1975. Logic and Conversation. In *Syntax and Semantics III: Speech Acts*. Ed. Peter Cole and Jerry Morgan. New York: Academic Press.

Grice-Hutchinson, Marjorie. 1978. *Early Economic Thought in Spain, 1177–1740*. London: G. Allen & Unwin.

Guicciardini, Francesco. 1942. *Francesco Guicciardini, Opere*. Vol. 2. Ed. Roberto Palmarocchi. Milan: Mursia.

Guillén, Claudio. 1971. *Literature as System: Essays Toward the Theory of Literary History*. Princeton: Princeton University Press.

———. 1976. On the Literature of Exile and Counter-Exile. *Books Abroad* 50.

Guillory, John. 1993. *Cultural Capital: The Problem of Literary Canon Formation*. Chicago: University of Chicago Press.

Gusdorf, Georges. 1948. *La Découverte de Soi*. Paris: Presses Universitaires de France.

Halpern, Richard. 1991. *The Poetics of Primitive Accumulation: English Renaissance Culture and the Genealogy of Capital*. Ithaca: Cornell University Press.

Hartman, Geoffrey. 1982. *Saving the Text: Literature/Derrida/Philosophy*. Baltimore: Johns Hopkins University Press.

Hathaway, Robert. 1995. *Not Necessarily Cervantes: Readings of the Quixote*. Newark: Juan de la Cuesta.

Heinzelman, Kurt. 1980. *The Economics of the Imagination*. Amherst: University of Massachusetts Press.

Heller, Agnes. 1978. *Renaissance Man*. London: Routledge and Kegan Paul.

———. 1984. *Everyday Life*. London: Routledge and Kegan Paul.

Herrero, Javier. 1978. The Ending of *Lazarillo:* The *Wine* Against the *Water*. *Modern Language Notes* 93.

———. 1979. Renaissance Poverty and Lazarillo's Family: The Birth of the Picaresque Genre. *PMLA* 94.

Hertzler, Joyce O. 1965. *A Sociology of Language*. New York: Random House.

Hexter, J. H. 1979. *On Historians*. Cambridge: Harvard University Press.

Hitchcock, Peter. They Must Be Represented? Problems in Theory of Working-Class Representation. *PMLA* 115 (2000): 20–32.

Holquist, Michael. 1981. The Politics of Representation. In *Allegory and Representation: Selected Papers from the English Institute, 1979–1980*. Ed. Stephen Greenblatt. Baltimore: Johns Hopkins University Press.

Huizinga, Johan. 1924. *The Waning of the Middle Ages*. London: E. Arnold and Co.

Huppert, George. 1998. *After the Black Death*. Bloomington: Indiana University Press.

Ife, B. W. 1985. *Reading and Fiction in Golden-Age Spain: A Platonic Critique and Some Picaresque Replies*. Cambridge: Cambridge University Press.

Ilie, Paul. 1967. *Unamuno: An Existential View of Self and Society*. Madison: University of Wisconsin Press.

———. 1980. *Literature and Inner Exile: Authoritarian Spain, 1939–1975*. Baltimore: Johns Hopkins University Press.

Inboden, Roberta. 1987. *From the Cross to the Kingdom: Sartrean Dialectics and Liberation Theology*. San Francisco: Harper & Row.

Iser, Wolfgang. 1974. *The Implied Reader: Patterns of Communication in Prose Fiction from Bunyan to Beckett.* Baltimore: Johns Hopkins University Press.

Iventosch, Herman. 1961. Onomastic Invention in the *Buscón. Hispanic Review* 29: 15–32.

Jameson, Fredric. 1981. *The Political Unconscious: Narrative as a Socially Symbolic Act.* Ithaca: Cornell University Press.

Jauss, Hans Robert. 1982. *Toward an Aesthetic of Reception.* Minneapolis: University of Minnesota Press.

Jeanneret, Michel. 1991. *A Feast of Words: Banquets and Table Talk in the Renaissance.* Chicago: University of Chicago Press.

Johnson, Carroll B. 1996. Defining the Picaresque: Authority and the Subject in *Guzmán de Alfarache.* In *The Picaresque: Tradition and Displacement.* Ed. Giancarlo Maiorino, 159–82. Minneapolis, University of Minnesota Press.

———. 2000. *Cervantes and the Material World.* Urbana: University of Illinois Press.

Jordan, William B. 1985. *Spanish Still Life in the Golden Age, 1600–1650.* Fort Worth: Kimbell Art Museum.

Kanes, Martin. 1975. *Balzac's Comedy of Words.* Princeton: Princeton University Press.

Kavolis, Vytautas. 1968. *La expresion artistica: un estudio sociologico.* Buenos Aires: Amorrortu Editores.

Kedar, Benjamin Z. 1976. *Merchants in Crisis: Genoese and Venetian Men of Affairs and the Fourteenth-Century Depression.* New Haven: Yale University Press.

Kaiser, Walter. 1963. *Praisers of Folly: Erasmus, Rabelais, Shakespeare.* Cambridge: Harvard University Press.

Kellner, Hans. 1989. *Language and Historical Representation: Getting the Story Crooked.* Madison: University of Wisconsin Press.

Koelb, Clayton. 1989. *Kafka's Rhetoric: The Passion of Reading.* Ithaca: Cornell University Press.

Krieger, Murray. 1992. *Ekphrasis: The Illusion of the Natural Sign.* Baltimore: Johns Hopkins University Press.

Kristeller, Paul Oskar. 1956. *Studies in Renaissance Thought and Letters.* Rome: Edizioni di storia e letteratura.

Kubler, George. 1962. *The Shape of Time: Remarks on the History of Things.* New Haven: Yale University Press.

LaCapra, Dominick. 1985. *History and Criticism.* Ithaca: Cornell University Press.

Landes, David S. 1969. *The Unbound Prometheus: Technological Change and Industrial Development in Western Europe from 1750 to the Present.* London: Cambridge University Press.

Larson, Catherine. 1969. *Lazarillo de Tormes.* Trans. Everett W. Hesse and Harry F. Williams. Madison: University of Wisconsin Press.

———. 1976. *Lazarillo de Tormes.* Ed. Joseph Ricapito. Madrid: Cátedra.

———. 1991. *Language and the Comedia: Theory and Practice.* Lewisburg: Bucknell University Press.

Lefebvre, Henri. 1968.*La vie quotidiènne dans le monde moderne*. Paris: Gallimard.

———. 1968. *The Sociology of Marx*. New York: Pantheon Books.

Le Goff, Jacques. 1984. *The Birth of Purgatory*. Chicago: University of Chicago Press.

Lejeune, Philippe. 1975. *Le pacte autobiographique*. Pari: Seuil.

Léon, Luis de. 1984. *The Names of Christ*. New York: Paulist Press.

Levin, Harry. 1938. *Selected Works of Ben Jonson*. New York: Random House.

———. 1963. *The Gates of Horn: A Study of Five French Realists*. New York: Oxford University Press.

Lewis, R. W. B. 1961. *The Picaresque Saint: Representative Figures in Contemporary Fiction*. Philadelphia: Lippincott Co.

Lida, Raimundo. 1931. Estilistica, un estudio sobre Quevedo. *Sur* 4.

Lucente, Gregory L. 1986. *Beautiful Fables: Self-Consciousness in Italian Narrative from Manzoni to Calvino*. Baltimore: Johns Hopkins University Press.

Lukács, Georg. 1964. *Studies in European Realism*. New York: Grosset and Dunlap.

———. 1970. *Writer and Critic and Other Essays*. New York: Dutton.

———. 1971. *The Theory of the Novel: A Historico-Philosophical Essay on the Forms of Great Epic Literature*. Cambridge: MIT Press.

Lutwack, Leonard. 1984. *The Role of Place in Literature*. Syracuse: Syracuse University Press.

Lynch, John. 1964. *Spain Under the Habsburgs*. New York: Oxford University Press.

Machiavelli, Niccolò. 1961. *The Letters of Machiavelli*. Trans. Allan Gilbert. New York: Capricorn Books.

———. 1965. *Machiavelli: The Chief Works and Others*. Vol. 3. Trans. Allan Gilbert. Durham: Duke University Press.

MacMullen, Ramsay. 1974. *Roman Social Relations, 50 B.C. to 284 A.D.* New Haven: Yale University Press.

Maiorino, Giancarlo. 1987. *Adam "New Born and Perfect": The Renaissance Promise of Eternity*. Bloomington: Indiana University Press.

———. 1990. *The Cornucopian Mind and the Baroque Unity of the Arts*. University Park: Pennsylvania State University Press.

———. 1996. Renaissance Marginalities. In *The Picaresque: Tradition and Displacement*. Ed. Giancarlo Maiorino. Minneapolis: University of Minnesota Press.

Maldonado de Guevara y Andres, Francisco. 1962. *Tiempo de niño y tiempo de viejo con otros ensayos*. Madrid: Editiones Gredos.

Malinowski, Bronislaw. 1922. *Argonauts of the Western Pacific: An Account of Native Enterprise and Adventure in the Archipelagoes of Melanesian New Guines*. New York: E. P. Dutton.

Mancing, Howard. 1979. El pesimismo radical del "Lazarillo de Tormes." In *La picaresca: Origenes, Textos y Estructuras: Actas del I Congreso Internacional sobre la Picaresca organizado por el Patronato "Archipreste de Hita."* Ed. Manuel Criado Val. Madrid: Fundacíon universitaria española.

Maravall, José Antonio. 1968. *El mundo social de "La Celestina."* Madrid: Gredos.

———. 1972. *Estado moderno y mentalidad social*. Madrid: Revista de Occidente.

———. 1987. *La literatura picaresca desde la historia social*. Madrid: Taurus.

———. 1990. *Teatro y literatura en la sociedad barroca.* Barcelona: Editorial Crítica.

———. 1991. *Utopia and Counterutopia in the Quixote.* Detroit: Wayne State University Press.

Marías, Julian. 1987. *Ser Español.* Barcelona: Planeta.

Marin, Louis. 1972. *Études Semiologiques.* Paris: Klincksieck.

———. 1986. *Food for Thought.* Baltimore: Johns Hopkins University Press.

Martines, Lauro. 1979. *Power and Imagination: City-States in Renaissance Italy.* New York: Knopf.

Martz, Linda. 1983. *Poverty and Welfare in Habsburg Spain: The Example of Toledo.* Cambridge: Cambridge University Press.

Marx, Karl. 1906. *Capital.* Vol. 1. Chicago: University of Chicago Press.

———. 1973. *Grundrisse: Foundations of the Critique of Political Economy.* New York: Vintage Books.

Mauss, Marcel. 1954. *The Gift: Forms and Functions of Exchange in Archaic Societies.* Glencoe: Free Press.

May, T. E. 1950. Good and Evil in the "Buscón": A Survey. *Modern Language Review* 45.

———. 1969. A Narrative Conceit in "La Vida del Buscón." *Modern Language Review* 64.

Medvedev P., and M. Bakhtin. 1978. *The Formal Method in Literary Scholarship.* Baltimore: Johns Hopkins University Press.

Meeker, Joseph W. 1997. *The Comedy of Survival: Studies in Literary Ecology.* Tucson: University of Arizona Press.

Menéndez Pelayo, Marcelino. 1941. Cultura literaria de Miguel de Cervantes y elaboración del *Quijote.* In *Estudios y discursos de crítica histórica y literaria.* Vol. 1. Santader: Consejo Superior de Investigationes cientifica.

Mercado, Tomás de. 1977. *Suma de tratos y contratos.* Vol. 1. Madrid: Instituto de Estudios Fiscales.

Merleau-Ponty, Maurice. 1964. A Note on Machiavelli. In Maurice Merleau-Ponty, *Signs.* Evanston: Northwestern University Press.

Miller, J. Hillis. 1979. The Critic as Host. In *Deconstruction and Criticism,* ed. Geoffrey Hartman. New York: Seabury Press.

Molho, Anthony. 1969. *Social and Economic Foundations of the Italian Renaissance.* New York: Wiley.

Mohlo, Maurice. 1972. *Introducción al pensamiento picaresco.* Salamanca: Anaya.

———. 1977. *Semántica y Poética.* Barcelona: Critica.

———. 1976. *Cervantes: Raíces Folklóricas.* Madrid: Gredos.

Mollat, M. 1974. *Études sur l'histoire de la pauvreté.* Paris: Publications de la Sorbonne.

Montanari, Massimo. 1994. *The Culture of Food.* New York: Oxford University Press.

Morson, Gary Saul. 1994. *Narrative and Freedom: The Shadows of Time.* New Haven: Yale University Press.

———. 1987. *Hidden in Plain View: Narrative and Creative Potentials in* War and Peace. Stanford: Stanford University Press.

Mullins, Edwin. 1981. *Great Paintings.* New York: St. Martin's Press.

Nebrija, Antonio. 1981. *Grámatica Castellana*. Madrid: Editora Nacional.

Nemoianu, Virgil. *A Theory of the Secondary: Literature, Progress, and Reaction*. Baltimore: Johns Hopkins University Press.

Nerlich, Michael. 1986. Toward a Nonliterary Understanding of Literature: Reflections on the Notion of the "Popular." In *Literature Among Discourses: The Spanish Golden Age*. Ed. Wlad Godzich and Nicholas Spadaccini. Minneapolis: University of Minnesota Press.

Nietzsche, Friedrich. 1969. *On the Genealogy of Morals*. Trans. Walter Kaufmann and R. J. Hollingdale. New York: Vintage Books.

Novak, Stanley J. 1992. The Squire as an Incarnation of Pride in *Lazarillo de Tormes*. *Modern Language Studies* 22.

Ong, Walter. 1975. The Writer's Audience Is Always a Fiction. *PMLA* 90.

Ortega y Gasset, José. 1953–57. *Obras Completas*. Vol. 6. Madrid: Revista de Occidente.

———. 1957. *The Revolt of the Masses*. New York: Norton.

———. 1972. *Velázquez, Goya, and the Dehumanization of Art*. New York: Norton.

Orwen, Gifford P. 1979. *Cecco Angiolieri: A Study*. Chapel Hill: University of North Carolina Press.

Paparelli, Gioacchino. 1973. *Feritas, Humanitas, Divinitas*. Naples: Guida.

Parker, A. A. 1947. The Psychology of the "Pícaro" in "El Buscón." *Modern Language Review* 42.

Parret, Herman. 1988. *Le sublime du quotidien*. Paris: Hades.

Pearl, Jeffrey M. 1984. *The Tradition of Return: The Implicit History of Modern Literature*. Princeton: Princeton University Press.

Pelikan, Jaroslav. 1984. *The Vindication of Tradition*. New Haven: Yale University Press.

Pérez-Firmat, Gustavo. 1986. *Literature and Liminality: Festive Readings in the Hispanic Tradition*. Durham: Duke University Press.

Petrarca, Francesco. 1991. *Petrarch's Remedies for Fortune Fair and Foul*. Vol. 3. Trans. Conrad H. Rawski. Bloomington: Indiana University Press.

Poggioli, Renato. 1965. *The Spirit of the Letter: Essays in European Literature*. Cambridge: Harvard University Press.

———. 1975. *The Oaten Flute: Essays on Pastoral Poetry and the Pastoral Ideal*. Cambridge: Harvard University Press.

Pratt, Pary Louise. 1986. Ideology and Speech-Act Theory. *Poetics Today* 7.

Prieto, Antonio. 1972. *Ensayo semiológico de sistemas literarios*. Barcelona: Planeta.

Quevedo, Francisco de. 1932. *Obras en verso*. Madrid: Aguillar.

———. 1989. *Dreams and Discourses*. Warminster: Aris and Phillips.

Rabinowitz, Peter J. 1987. *Before Reading: Narrative Conventions and the Politics of Interpretation*. Ithaca: Cornell University Press.

Ragussis, Michael. 1986. *Acts of Naming: The Family Plot in Fiction*. New York: Oxford University Press.

Raya, Gino. 1969. *Crítica fisiológica: Principi, Applicazioni, Polemiche*. Rome: Bulzoni.

Real Academia Española. 1939. *Diccionario de la lengua española*. Madrid: Real Academia Española.

Reed, Walter L. 1981. *An Exemplary History of the Novel: The Quixotic Versus the Picaresque*. Chicago: University of Chicago Press.

Reid, Alastair. 1979. Translating Borges. *New York Review of Books*, Jan. 25.

Reynier, Gustave. 1902. *La vie universitaire dans l'ancien Espagne*. Paris: A. Picard.

Ricapito, Joseph. 1976. *La vida de Lazarillo de Tormes*. Madrid: Cátedra.

———. 1987. *Tri-Linear Edition of "Lazarillo de Tormes" of 1554 Burgos, Alcala de Henares, Amberes*. Madison: Hispanic Seminary of Medieval Studies.

———. 1992. The Politics of Editions: The Case of *Lazarillo de Tormes*. In *The Politics of Editing*. Ed. Nicholas Spadaccini and Jenaro Talens. Minneapolis: University of Minnesota Press.

Rico, Francisco. 1984. *The Spanish Picaresque Novel and the Point of View*. Cambridge: Cambridge University Press.

Riffaterre, Michael. 1990. *Fictional Truth*. Baltimore: Johns Hopkins University Press.

Rigolot, François. 1977. *Poétique et Onomastique. L'example de la Renaissance*. Geneva: Droz.

Riley, E. C. 1951. The Dramatic Theories of Don Jusepe Antonio Gonzáles de Salas. *Hispanic Review* 19.

Rivers, Elias L. 1982. Language and Reality in Quevedo's Sonnets." In *Quevedo in Perspective: Eleven Essays for the Quadricentennial*. Ed. James Iffland. Newark: Juan de la Cuesta.

———. 1983. *Quixotic Scriptures: Essays on the Textuality of Hispanic Literature*. Bloomington: Indiana University Press.

Rodríguez, Juan Carlos. 1994. *La literatura del pobre*. Granada: Editorial Comares.

Rodríguez Matos, Carlos Antonio. 1985. *El narrador-pícaro: Guzmán de Alafarache*. Madison: University of Wisconsin Press.

Rozas, Juan Manuel. 1980. *Intrahistoria y Literatura*. Salamanca: Universidad de Salamanca.

Said, Edward. 1975. *Beginnings: Intention and Method*. New York: Basic Books.

Salinas, Pedro. 1932. *Obras en verso*. Madrid: Aguillar.

San Miguel, Ángel. 1971. *Sentido y estructura del "Guzmán de Alfarache" de Mateo Alemán*. Madrid: Editiones Gredos.

Sartre, Jean-Paul. 1991. *Critique of Dialectical Reason: Theory of Practical Ensembles*. London: Verso.

Sasso, Luigi. 1990. *Il nome nella letteratura: L'interpretazione dei nomi negli scrittori italiani del medioevo*. Genoa: Marietti.

Schama, Simon. 1987. *The Embarrassment of Riches: An Interpretation of Dutch Culture in the Golden Age*. New York: Knopf.

Schilling, Bernard N. 1968. *The Hero as Failure: Balzac and the Rebempré Cycle*. Chicago: University of Chicago Press.

Scholtmeijer, Marian. 1993. *Animal Victims in Modern Fiction: From Sanctity to Sacrifice*. Toronto: University of Toronto Press.

Schrift, Alan D. 1997. *The Logic of the Gift: Toward an Ethic of Generosity*. London: Routledge.

Schutz, Alfred. 1967. *The Phenomenology of the Social World*. Evanston: Northwestern University Press.

Sebeok, Thomas A. 1979. Zoosemiotic Components of Human Communication. In *The Sign and Its Masters*. Austin: University of Texas Press.

———. 1981. *The Play of Musement*. Bloomington: Indiana University Press.

Serres, Michel. 1982. *The Parasite*. Baltimore: Johns Hopkins University Press.

———. 1989. Panopticon Theory. In *The Limits of Literature*. Ed. Thomas M. Kavanagh. Stanford: Stanford University Press.

Shell, Marc. 1984. *The Economy of Literature*. Baltimore: Johns Hopkins University Press.

———. 1993. *Money, Language, and Thought: Literary and Philosophic Economies from the Medieval to the Modern Era*. Baltimore: Johns Hopkins University Press.

Shipley, George A. 1982. The Critic as Witness for the Prosecution: Resting the Case Against Lázaro de Tormes. *PMLA* 97.

———. 1983. Lazarillo and the Cathedral Chaplain: A Conspiratorial Reading of *Lazarillo de Tormes*, Tratado VI. *Symposium* 37.

———. 1986. Lazarillo de Tormes Was Not a Hardworking, Clean Living Water Carrier. In *Hispanic Studies in Honor of Alan D. Deyermond: A North American Tribute*. Ed. John S. Miletich. Madison: Hispanic Seminary of Medieval Studies.

Shklovsky, Victor. 1965. Art as Technique. In *Russion Formalist Criticism: Four Essays*. Ed. Lee T. Lemon and Marion J. Reis. Lincoln: University of Nebraska Press.

Sieber, Harry. 1977. *The Picaresque*. London: Methuen.

———. 1978. *Language and Society in* La vida de Lazarillo de Tormes. Baltimore: Johns Hopkins University Press.

Simmel, Georg. 1978. *The Philosophy of Money*. Cambridge: MIT Press.

Smith, Barbara Herrnstein. 1978. *On the Margins of Discourse: The Relation of Literature to Language*. Chicago: University of Chicago Press.

———. 1988. *Contingencies of Value: Alternative Perspectives for Critical Theory*. Cambridge: Harvard University Press.

Smith, Paul Julian. 1988. *Writing in the Margin: Spanish Literature of the Golden Age*. Oxford: Clarendon Press.

Soria, Martin S. 1953. *The Paintings of Zurbarán*. London: Phaidon Press.

Soriano, Marc. 1968. *Les Contes de Perraul: Culture savante et traditions populaires*. Paris: Gallimard.

Spadaccini, Nicholas. 1972. *Estebanillo Gonzáles and the New Orientation of the Picaresque Novel*. Ann Arbor: University of Michigan Press.

———. 1977. Clues and Sources: Imperial Spain and the Secularization of the Picaresque Novel. In *Ideologies and Literature*. Ed. Nicholas Spadaccini. Minneapolis: Institute for the Study of Ideology and Literature.

Spitzer, Leo. 1970. Linguistic Perspectivism in *Don Quijote*. In *Linguistics and Literary History: Essays in Stylistics*. Princeton: Princeton University Press.

———. 1978. Zur Kunst Quevedos in seinem *Buscón*. In *Romanische Stil- und*

Literaturstudien. Vol. 2. Trans. as Sobre el arte de Quevedo en el *Buscón*. In *Francisco de Quevedo*, ed. Gonzalo Sobejano. Madrid: Taurus.

———. 1988. A Central Theme and Its Structural Equivalent in Lope's *Fuenteovejuna*. In *Leo Spitzer: Representative Essays*. Eds. A. K. Forcione, H. Lindenberger, and M. Sutherland. Stanford: Stanford University Press.

Stallybrass, Peter, and Allon White. 1986. *The Politics and Poetics of Transgression*. Ithaca: Cornell University Press.

Starobinski, Jean. 1979. *Words upon Words: The Anagram of Ferdinand de Saussure*. New Haven: Yale University Press.

———. 1989. *The Living Eye*. Cambridge: Harvard University Press.

———. 1994. *Largesse*. Paris: Reunion des Museés Nationaux.

Stein, Gertrude. 1974. *How Writing is Written*. Los Angeles: Black Sparrow Press.

Steinberg, Leo. 1965. José López-Rey's Velázquez: A Catalogue Raisonne of His Oeuvre, with an Introductory Study. *Art Bulletin* 47.

Stewart, Susan. 1978. *Nonsense: Aspects of Intertextuality in Folklore and Literature*. Baltimore: Johns Hopkins University Press.

Stonequist, Everett V. 1937. *The Marginal Man: A Study in Personality and Culture Conflict*. New York: Russell and Russell.

Swingewood, Alan. 1987. *Sociological Poetics and Aesthetic Theory*. New York: St. Martin's Press.

Tabori, Paul. 1959. *The Natural Science of Stupidity*. Philadelphia: Chilton Co.

Taylor, Charles. 1989. *Sources of the Self: The Making of the Modern Identity*. Cambridge: Cambridge University Press.

Thompson, James. 1996. *Models of Values: Eighteenth-Century Political Economy and the Novel*. Durham: Duke University Press.

Tihanov, Galin. 2000. *The Master and the Slave: Lukács, Bakhtin, and the Ideas of Their Time*. Oxford: Clarendon Press.

Tillotson, Kathleen. 1959. *The Tale and the Teller*. London: Rupert Hart-Davis.

Titone, C. 1978. *La società italiana sotto gli spagnuoli*. Palermo: Palumbo.

Tobin, Patricia Drechsel. 1978. *Time and the Novel*. Princeton: Princeton University Press.

Todorov, Tzvetan. 1984. *The Conquest of America: The Question of the Other*. New York: Harper & Row.

Toliver, Harold. 1974. *Animate Illusions: Explorations of Narrative Structure*. Lincoln: University of Nebraska Press.

Tomashevsky, Boris. 1965. Thematics. In *Russian Formalist Criticism: Four Essays*. Lincoln: University of Nebraska Press.

Torgovnick, Marianna. 1981. *Closure in the Novel*. Princeton: Princeton University Press.

Trilling, Lionel. 1972. *Sincerity and Authenticity*. New York: Harcourt Brace.

Truman, R. W. 1975. *Lazarillo de Tormes*, Petrarch's *De remediis adversae fortunae*, and Erasmus' *Praise of Folly*. *Bulletin of Hispanic Studies* 52.

Turner, Victor. 1974. *Fields, Dramas, and Metaphors: Symbolic Action in Human Society*. Ithaca: Cornell University Press.

Unamuno, Miguel de. 1954. *Tragic Sense of Life*. New York: Dover.

———. 1958. *Obras Completas*. Vol. 16. Ed. Garcia Blanco. Madrid: A. Aguado.

———. 1976. *Our Lord Don Quixote: The Life of Don Quixote and Sancho, with Related Essays*. Princeton: Princeton University Press.

Valdes, Juan de. 1940. *Diálogo de la lengua*. Madrid: Libreria Perlado.

Veeser, Aram. 1989. *The New Historicism*. New York: Routledge.

Vernon, John. 1973. *The Garden and the Map: Schizophrenia in Twentieth-Century Literature and Culture*. Urbana: University of Illinois Press.

———. 1984. *Money and Fiction: Literary Realism in the Nineteenth and Early Twentieth Centuries*. Ithaca: Cornell University Press.

Vico, Giambattista. 1970. *The New Science*. Trans. T. Bergia and Max Fisch. Ithaca: Cornell University Press.

Vilanova, Antonio. 1989. *Erasmo y Cervantes*. Barcelona: Editorial Lumen.

Vilar, Pierre. 1964. *Crecimiento y Desarrollo*. Barcelona: Ariel.

———. 1976. *A History of Gold and Money, 1450–1920*. Atlantic Highlands: Humanities Press.

Villanueva, Marquez Francisco. 1968. *Espiritualidad y literatura en el siglo XVI*. Madrid: Alfaguara.

Vives, Luis. 1967. Fabula de homine. In *The Renaissance Philosophy of Man*. Ed. E. Cassirer, P. O. Kristeller, and J. H. Randall. Chicago: University of Chicago Press.

———. 1968. *Vives' Introduction to Wisdom: A Renaissance Textbook*. Ed. M. L. Tobriner. New York: Teachers College Press.

Von Martin, Alfred. 1963. *Sociology of the Renaissance*. New York: Harper & Row.

Wagner, Geoffrey. 1968. *On the Wisdom of Words*. Princeton: Princeton University Press.

Wallerstein, Immanuel Maurice. 1974. *The Modern World-System*. New York: Academic Press.

Wardropper, Bruce. 1977. The Strange Case of Lázaro Gonzáles Pérez. *Modern Language Notes* 92.

Warshaw, Thayer S. 1974. The Book of Jonah. In *Literary Interpretations of Biblical Narratives*. Ed. Kenneth R. R. Gros Louis, James S. Ackerman, and Thayer S. Warshaw. Nashville: Abingdon.

Weber de Kurlat, Frida. 1963. *Lo cómico en el teatro de Fernan Gonzáles de Eslava*. Buenos Aires: Universidad de Buenos Aires.

Weinstein, Arnold. 1981. *Fictions of the Self: 1550–1800*. Princeton: Princeton University Press.

White, Hayden. 1987. *The Content of the Form: Narrative Discourse and Historical Representation*. Baltimore: Johns Hopkins University Press.

Woods, M. J. 1979. Pitfalls of the Moralizer in "Lazarillo de Tormes." *Modern Language Review* 74.

Woolf, Stuart J. 1980. *The Poor in Western Europe in the Eighteenth and Nineteenth Centuries*. London: Methuen.

Wright, Austin M. 1982. *The Formal Principle in the Novel.* Ithaca: Cornell University Press.

Yamey, Basil S. 1989. *Art and Accounting.* New Haven: Yale University Press.

Ziolkowski, Theodore. 1972. *Fictional Transfigurations of Jesus.* Princeton: Princeton University Press.

Zola, Emile. 1960. *Les Rougon-Macquart.* Vol. 1. Paris: Gallimard.

———. 1964. *The Experimental Novel and Other Essays.* New York: Haskell House.

INDEX